ABSA

CAPE TOWN
THE CAPE PENSINSULA NATIONAL PARK
AND WINELANDS

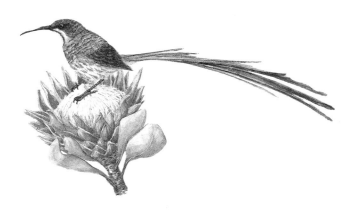

RESEARCHED, DEVELOPED AND
CREATED BY JACANA

DISCOVER THE MAGIC

Jacana

Sabena Nationwide is one of the major domestic carriers in South Africa, flying from Johannesburg to Cape Town, George and Durban.

Sabena Nationwide also offers an extensive charter service, offering flights to many exotic destinations including Game Reserve areas.

As one of the major carriers to holiday destinations in South Africa, Sabena Nationwide is proud to be associated with this exciting eco-tourism publication.

For flight information contact
Johannesburg International Airport:
Tel: (011) 390-1660
Fax: (011) 970-1556

Durban International Airport:
Tel: (031) 450-2087/8/9
Fax: (031) 450-2092

Cape Town International Airport:
Tel: (021) 936-2050/2/4/6
Fax: (021) 936-2053

George Airport:
Tel: (044) 801-8412/4
Fax: (044) 801-8416

Published by:
✗ Jacana

PO Box 2004, Houghton 2041
Johannesburg, South Africa
Tel: (011) 648-1157
Fax: (011) 648-5516

Created and developed by Jacana

Lithographic repro: Remata Bureau, Johannesburg

Printing: Fishwick Printers, Durban

ISBN 1-874955-99-9

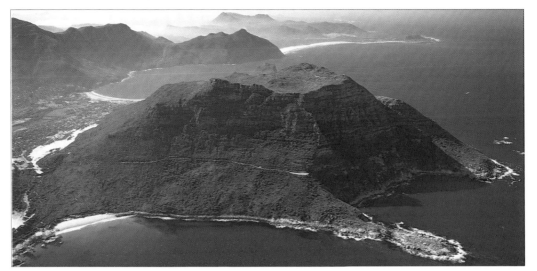

Hout Bay and Llandudno

ABSA

As one of the largest banking groups of its kind in Africa, the ABSA Group is proud to be associated with this definitive series on top holiday destinations in South Africa. ABSA is committed to South Africans and the culture we as a country have created. Our mission statement, "to be partners in growing South Africa's prosperity", reflects this commitment to continuously improve the socio-economic factors of all the people that make up this diverse country. By harnessing the wealth of our country's talent, the ABSA Group is constantly living up to its goal.

The Group plays a significant role in the economic and social fabric of South Africa. ABSA's extensive retail banking network throughout the country offers a full range of personal and commercial banking services. Addressing grass-roots issues is an important part of the ABSA Group's activities. The ABSA Foundation runs a variety of communal development projects at both provincial and national level, and is an enthusiastic supporter of programmes designed to uplift the nation. ABSA Bank is also the leading provider of affordable home finance to the underprivileged.

This publication in the Discover the Magic series examines Cape Town and the Cape Peninsula National Park. This extraordinary area is home to a unique range of flora and fauna, and is a favourite holiday destination for many. We'll be taking a closer look at how this delicate eco-system interacts with the human world, as well as the rich history of the area, secluded getaways and famous tourist attractions, like the well-known wine route.

It is with pleasure that the ABSA Group details the Cape Town and Cape Peninsula National Park area. We trust that this issue will enable you to experience the many attractions of the area to the fullest.

Brendan O'Donnell
General Manager ABSA Group Marketing

ACKNOWLEDGEMENTS

DISCOVER THE MAGIC

Jacana has adapted the log spiral, which represents universal energy found throughout nature, to brand its series of eco-guides. Its pathway is traced by whirlwinds and whirlpools, in sea shells and in the centres of daisies. It is also the pattern cut by ocean waves that create bays along the coast.

Without the combined energy and commitment of the following people, this eco-guide would not have been possible.

Design
Lisl Barry
Nix Hampel

Artwork
Lisl Barry
Sally MacLarty
Penny Noall
Heidi Streitberger

Photography
Anka Agency International
Lisl Barry
Rodger Diamond
Museum Africa
Geoff Spiby
Peter Thomas
Mark van Aardt
Gary van der Merwe
Lanz von Horsden

DTP Origination
Anne Centner
Stephen Clutty
Nix Hampel
Jacana

Text Development
Dr Jannette Deacon
Noor Ebrahim
Jim Hallinan
Dr Toni Milewski
Simon van Noodt
Dorothy Ntone
Gary van der Merwe
Jacana

Text Editors, Checking and Evaluation
James Jackelman, Reneé Selikowitz, Howard Langley - South African National Parks, Kirstenbosch; Mike Bruton - Two Oceans Aquarium; Dr Chris Chimimba, Dr Martin Whiting - Transvaal Museum; John Manning - NBI Kirstenbosch; Geoff Lockwood - Bird Life South Africa; Dr Isak Rust - Koeringberg Tours; Terry Trinder Smith - Department of Botany, UCT; Dr Kim Prochazka - Dept of Zoology, UCT; Glynnis Clacharty - Clacherty and Associates; Marius Burger; Owen Hendry; Jan Vlok.

Map Development
Cartographics

Jacana Team
We are proud to acknowledge the work of the entire Jacana Team who have contributed in their specialised fields to produce **Cape Town, the Cape Peninsula National Park and Winelands**: Lisl Barry, Maren Bodenstein, Carol Broomhall, Ryan Francois, Liz Godfrey, Dr Rina Grant, Nix Hampel, Zann Hoad, Nafeesa Karrim, Mirela Kerns, Maisie Mbali, Andrea Meeson, Obed Molobe, Debbie Munro, Fortune Ncube, Mpume Ncube, Davidson Ndebele, Jannett Ndebele, David Ngwenya, Conor O'Neal, Jenny Prangley, Angela Price, Joan Sibiya, Natasha Stretton, Mariette Strydom, Peter Thomas, Val Thomas, Pamela Thompson, Gary van der Merwe, Jenny van der Walt and Debbie White.

SOUTH AFRICAN NATIONAL PARKS

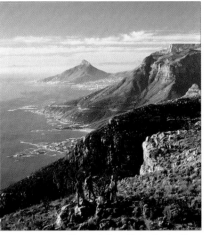

Toward Cape Point in the Cape Peninsula National Park

People value biological resources in different ways: spiritually, economically, aesthetically, culturally and scientifically. Collective and individual values significantly influence patterns of natural resource use to form the foundation of biodiversity conservation. For most of us in Africa, biodiversity is not an abstract or theoretical issue – it is critical to life at the grassroots level. A matter of survival.

A new approach to the challenge of biodiversity conservation is alive in South African National Parks, one that respects, incorporates and celebrates our rich diversity of values, knowledge systems and points of view. One that involves local people in the management and use of biological resources, treats biodiversity conservation and economic development as integral aspects of the same process of sustainable development, while continuing to see the importance of controlling or reversing the loss of biodiversity.

The Cape Peninsula is recognised nationally and internationally as an area of outstanding natural beauty and unique diversity. The Cape Floral Kingdom being one of only six floral kingdoms in the world, with the Cape Peninsula home to a quarter of the species of the entire kingdom – 2 285 in all. When South African National Parks began negotiations with different stakeholders early in 1996, the ownership of the land was spread among no less than 14 different authorities. Building the Cape Peninsula National Park in a complex urban context required close co-operation and partnership. In 1998, Capetonians witnessed with pride the realisation of a long held vision – the consolidation of this land into a national park, stretching from the base of Signal Hill right down to Cape Point, to be managed on behalf of all South Africans, by South African National Parks.

The Cape Peninsula National Park hosts a collection of habitats that are home to a wider diversity of plant species than the tropical rain forests. It is the stronghold of the Cape Floral Kingdom with over 174 of its plants on the threatened list and a well renowned natural beauty that will provide the sound foundation for its World Heritage Site application in June 1999.

Awareness raising – using both formal and informal mechanisms of education, training and human resource development is a necessary step in the implementation of strategies for conserving biodiversity. Once again, Jacana has clearly demonstrated its ability to carefully structure complex information, respect competing narratives, and work in real partnerships with both the end users and the commmunity of experts to create a coherent account, accessible to a broad audience.

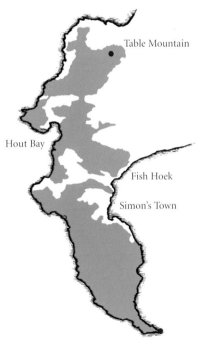

Reneé Selikowitz
Manager Social Ecology
Cape Peninsula National Park

CONTENTS

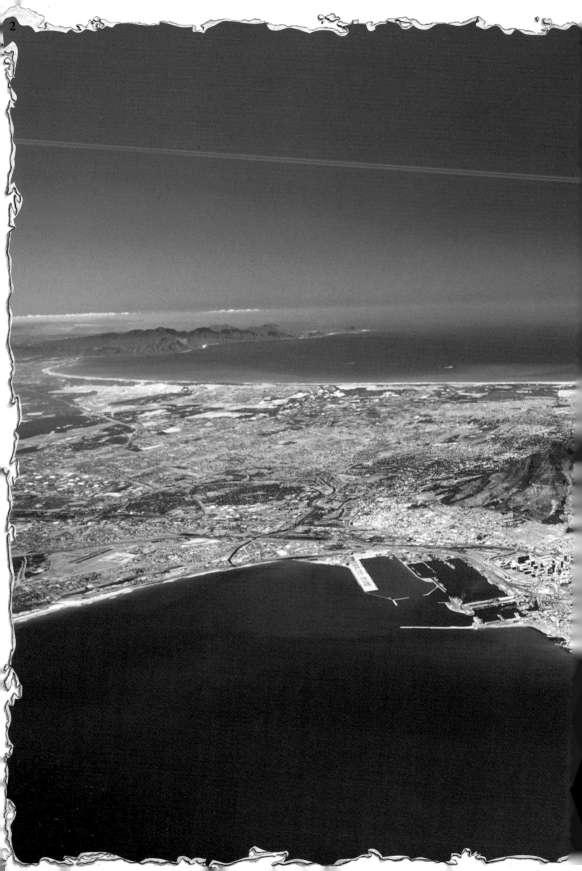

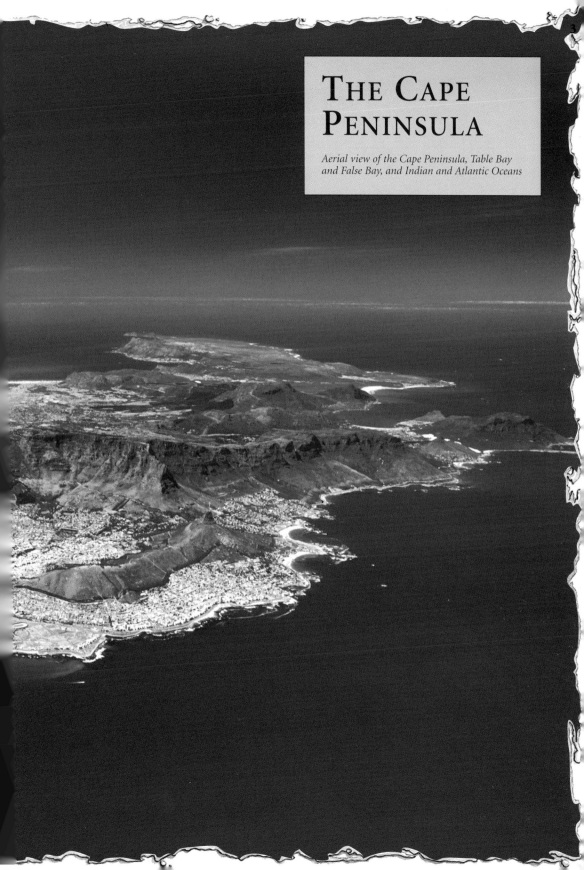

THE CAPE PENINSULA

Aerial view of the Cape Peninsula, Table Bay and False Bay, and Indian and Atlantic Oceans

A

GENERAL MAP

This map shows the most south-western tip of the African continent. To the north, the semi-desert coast stretches into the Kalahari Desert. To the north-east are the citrus farms of the Hex River Valley. The whale-watching mecca of Hermanus lies further to the east. The colour-coded areas are enlarged on the following pages. Cross-referenced grids appear on pages 22-49.

ATLANTIC OCEAN

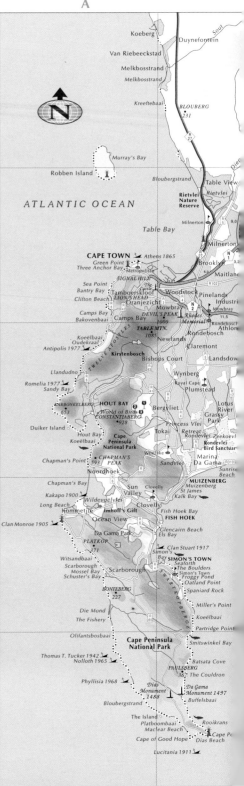

MAP KEY

National road	
Arterial road	
Main road	
Nature Reserve	
River/Dam	
Airport	
Monument	
Golf course	
Wine estates	
Lighthouse	
Rocks	
Wreck	
Whale watching site	

Scale 0 5 10 Km

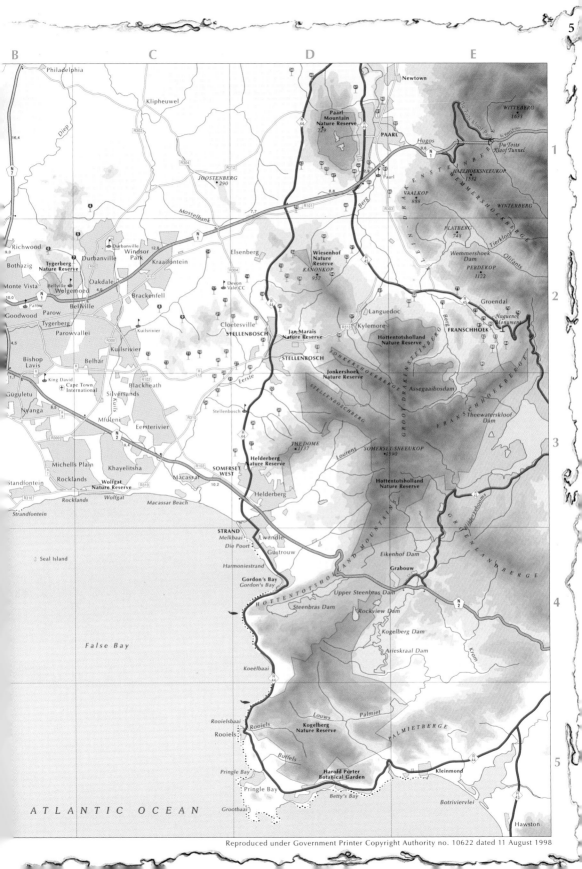

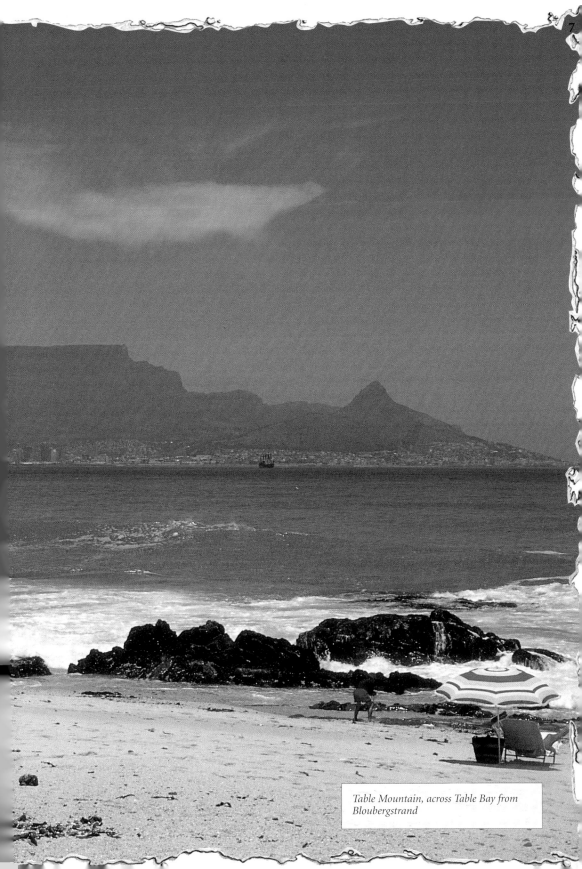

Table Mountain, across Table Bay from Bloubergstrand

MAP 1

Table Mountain dominates Cape Town and its nearest suburbs. The drive to Hout Bay, via Camps Bay, follows a coast littered with huge granite boulders. Once away from the city and the Peninsula, you cross the Cape Flats to the Winelands and the Hottentots-Holland Mountains beyond. Refer to pages 22-49 for cross-referenced grids of activities and destinations.

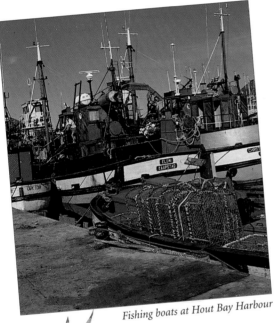

Fishing boats at Hout Bay Harbour

MAP KEY

National road	N 1
Arterial road	R 27
Main road	R102
Point to point distance	2,7
Nature Reserve	
River/Dam	
Monument	
Golf course	
Wine estates	50
Lighthouse	
Rocks	
Wreck	
Whale watching site	

Scale 0 1 2 3 4 5 Km

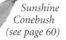

Sunshine
Conebush
(see page 60)

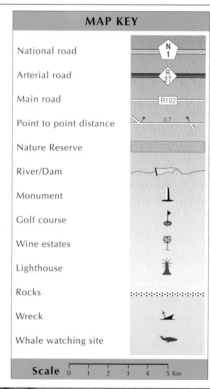

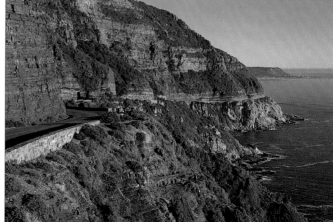

Chapman's Peak Drive

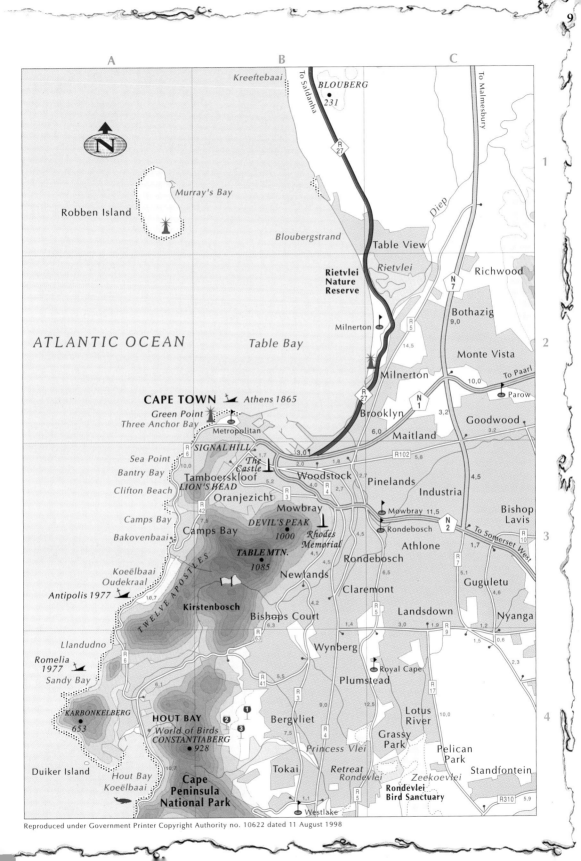

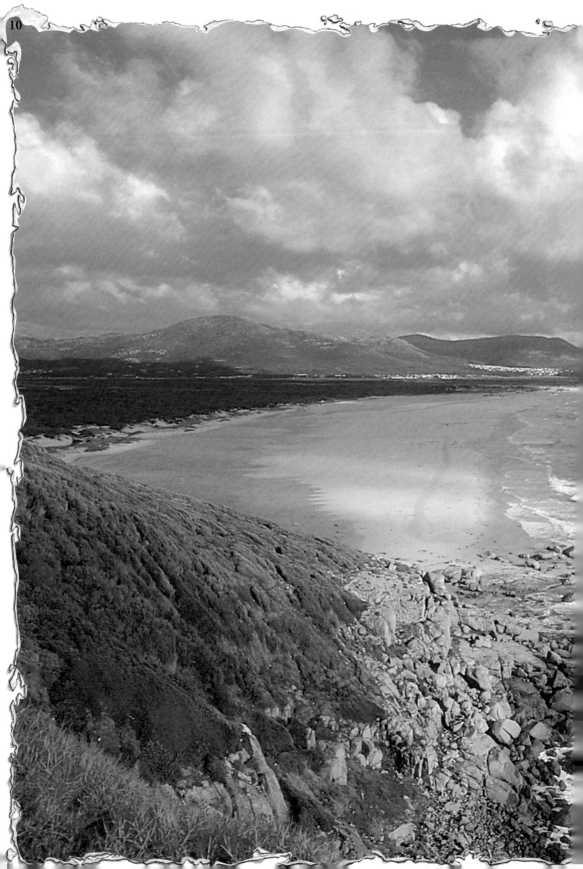

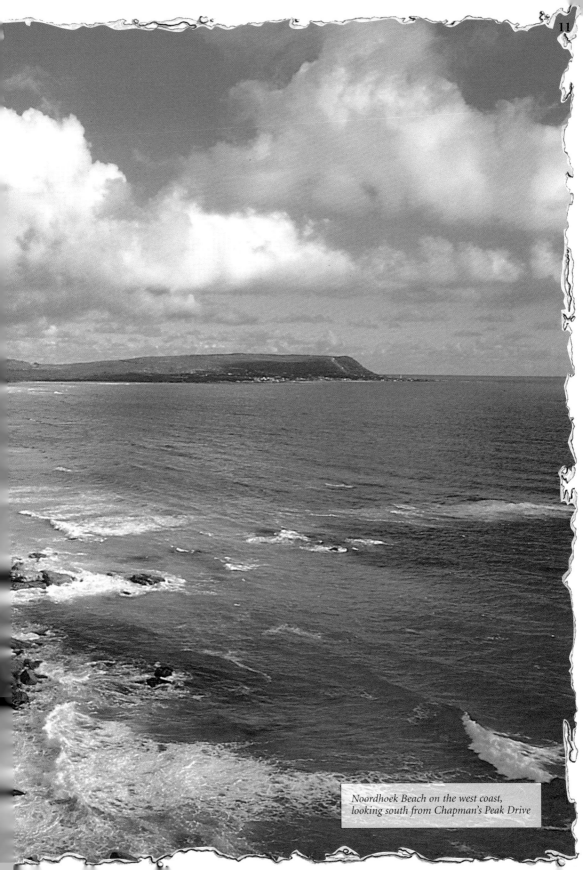

*Noordhoek Beach on the west coast,
looking south from Chapman's Peak Drive*

MAP 2

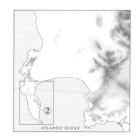

This map shows most of the Cape Peninsula National Park. The roads along the east and west coasts lead south to Cape Point, and follow rugged, picturesque scenery. Both roads turn inland at several points and provide access to good Fynbos areas and distant, exciting sea views. You will find cross-referenced grids of activities and destinations on pages 22-49.

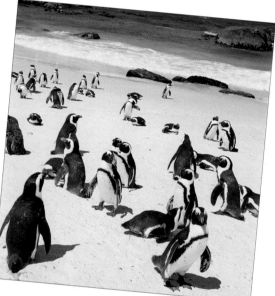

Penguins at Boulders Beach

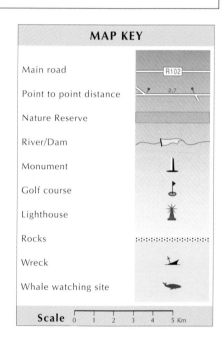

MAP KEY

Main road

Point to point distance

Nature Reserve

River/Dam

Monument

Golf course

Lighthouse

Rocks

Wreck

Whale watching site

Scale 0 1 2 3 4 5 Km

Changing-rooms at Muizenburg

Cape Urchins
(see pages 110, 113)

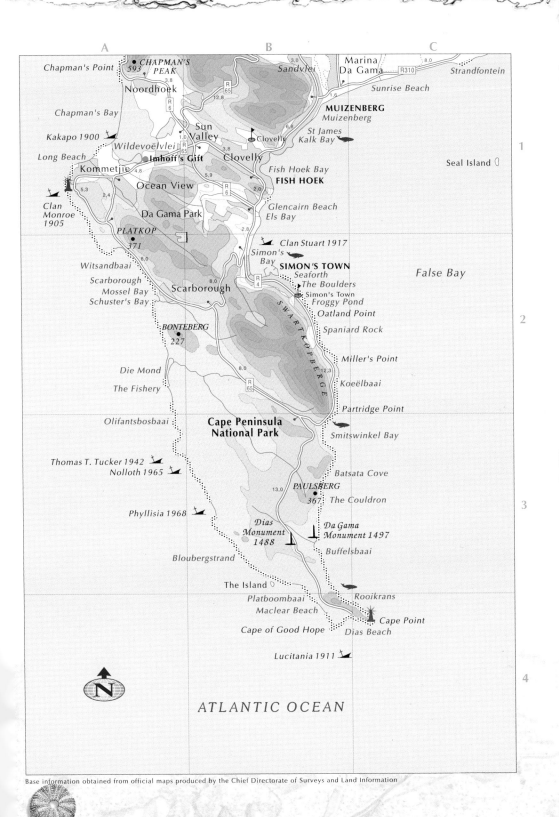

A B C

Chapman's Point ● **CHAPMAN'S** Marina *Strandfontein*
 593 **PEAK** *Sandvlei* Da Gama R310

Noordhoek

Chapman's Bay *Sunrise Beach* **MUIZENBERG**
 Sun *Muizenberg*

Kakapo 1900 **Valley**

Wildevoëlvlei *Clovelly* *St James* **1**
 Clovelly *Kalk Bay*

Long Beach **Imhoff's Gift** *Seal Island*

Kommetjie *Fish Hoek Bay*

 Ocean View **FISH HOEK**

Clan **Da Gama Park**
Monroe *Glencairn Beach*
1905 *Els Bay*

 PLATKOP
 371 *Clan Stuart 1917*

Witsandbaai *Simon's* **False Bay**
 Bay **SIMON'S TOWN**

Scarborough *Seaforth*
Mossel Bay **Scarborough** *The Boulders*
Schuster's Bay *Simon's Town*
 Froggy Pond
 Oatland Point

 BONTEBERG *Spaniard Rock*
 227 **2**

 Miller's Point

Die Mond

The Fishery *Koeëlbaai*

 Partridge Point

Olifantsbosbaai **Cape Peninsula**
 National Park *Smitswinkel Bay*

Thomas T. Tucker 1942 *Batsata Cove*
Nolloth 1965

 PAULSBERG **3**
 367 *The Couldron*

Phyllisia 1968

 Dias *Da Gama*
 Monument *Monument 1497*
 1488

Bloubergstrand *Buffelsbaai*

 The Island

 Rooikrans
 Platboombaai
 Maclear Beach *Cape Point*
 Cape of Good Hope *Dias Beach*

 Lucitania 1911 **4**

N

ATLANTIC OCEAN

Base information obtained from official maps produced by the Chief Directorate of Surveys and Land Information

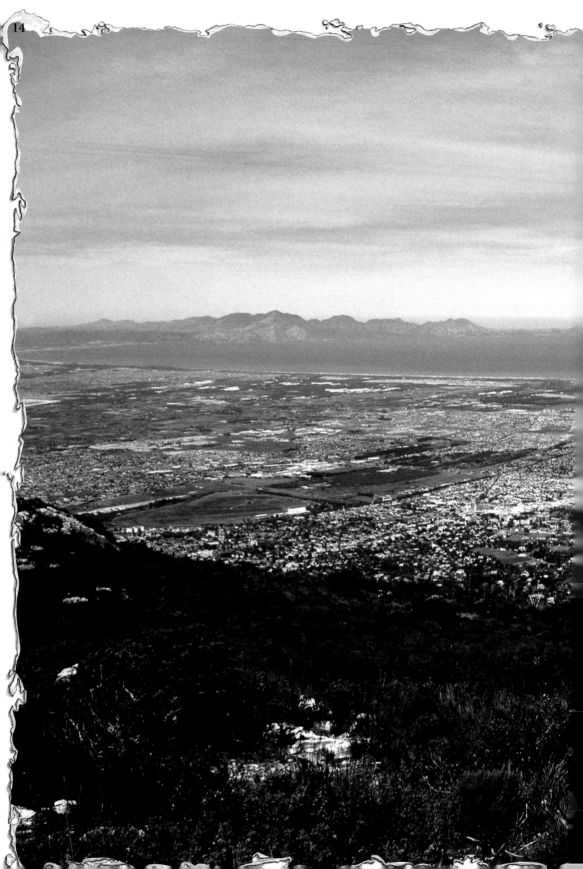

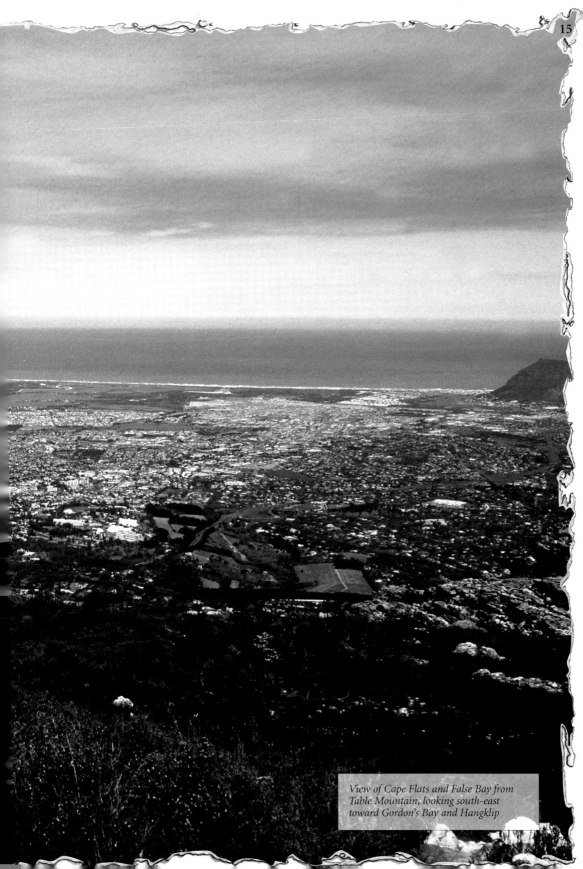

View of Cape Flats and False Bay from Table Mountain, looking south-east toward Gordon's Bay and Hangklip

ATLANTIC OCEAN

Map 3

The area covered by this map is predominantly nature reserves. Stellenbosch marks the beginning of the true Winelands. Along the False Bay coast are some fine fishing beaches, and an interesting stretch of cave-riddled sand cliffs. A scenic coastal drive to Kleinmond and Hermanus begins at the Strand. The cross-referenced grids on pages 22-49 give a listing of activities.

Stellenbosch - Oom Samie se winkel

MAP KEY

National road	N 1
Arterial road	R 27
Main road	R102
Point to point distance	2,7
Nature Reserve	
River/Dam	
Airport	✈
Golf course	⛳
Wine estates	50

Scale 0 1 2 3 4 5 Km

Whimbrel
(see page 90)

Gordon's Bay Harbour

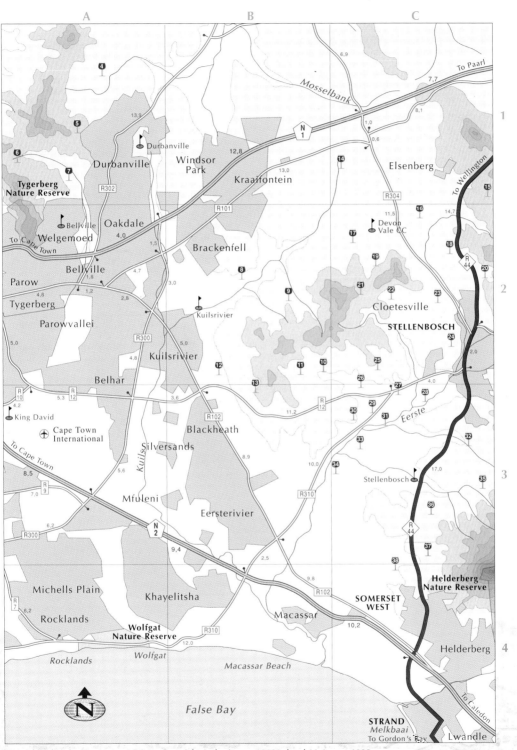

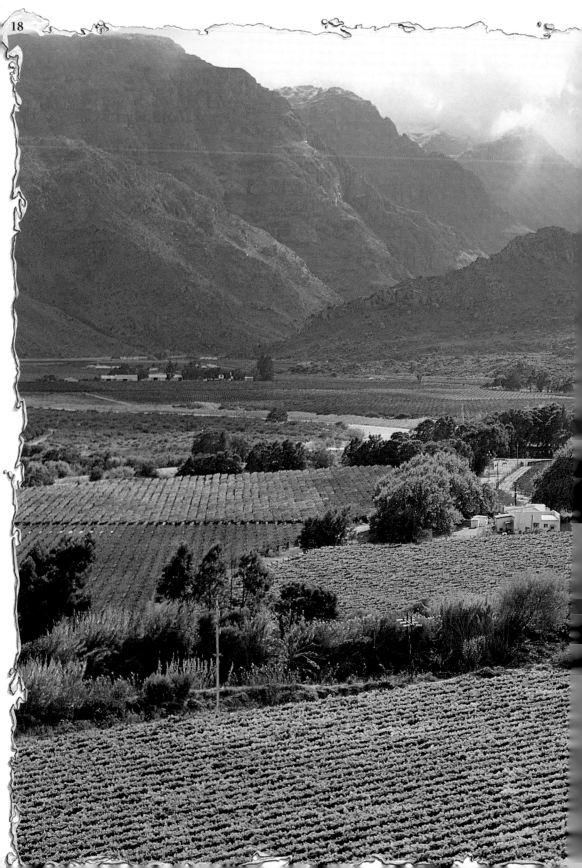

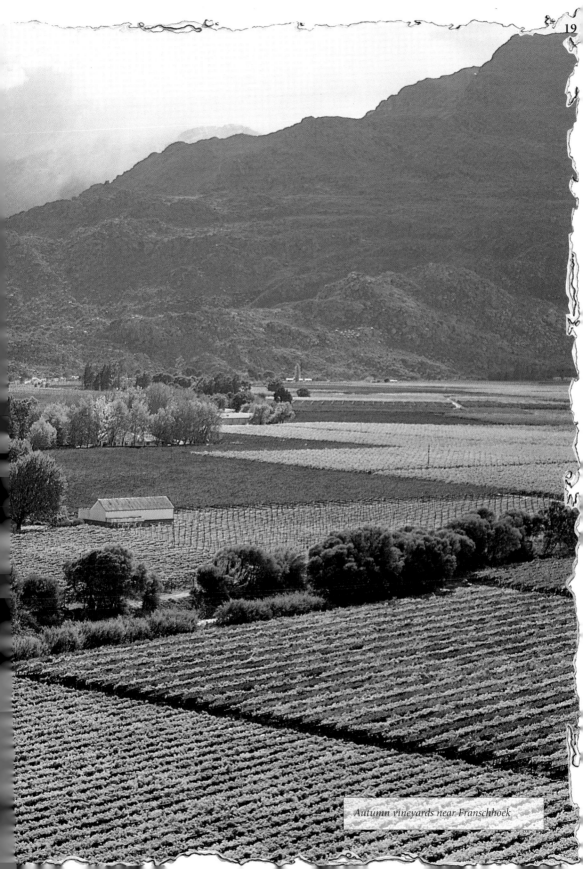

Autumn vineyards near Franschhoek

MAP 4

Beautiful valleys, rolling hills and scenic mountain drives characterise this, the heart of South Africa's Winelands. Travelling east along either the N1 or the R45 you will cross the mountains into the citrus-growing valleys beyond. There is a listing of vineyards on pages 48-49, together with cross-referenced grids of other places of interest and further destinations, pages 22-49

ATLANTIC OCEAN

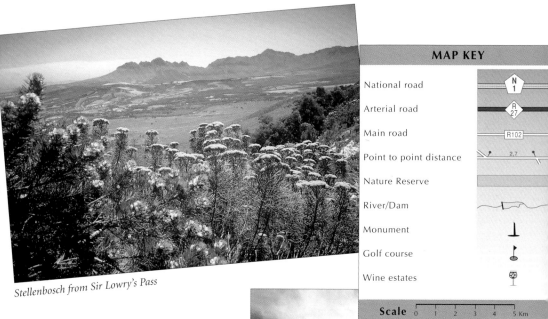

MAP KEY

National road	N 1
Arterial road	R 27
Main road	R102
Point to point distance	2,7
Nature Reserve	
River/Dam	
Monument	
Golf course	
Wine estates	50

Scale 0 1 2 3 4 5 Km

Stellenbosch from Sir Lowry's Pass

Grapes (see page 131)

Back road in Franschhoek

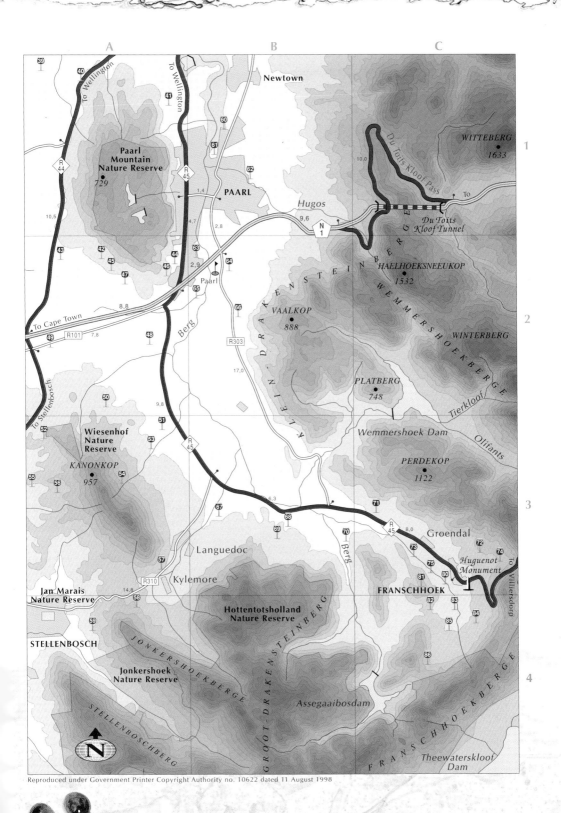

TRAVEL & TOURIST INFO

Cape Town and its surrounding areas offer visitors and locals alike a fantastic variety of outdoor activities and services, many at no cost. To discover the magic of the Mother City, consult the grids on the following pages. Entries are colour-coded to correspond with the various maps on the previous pages. Entries also have a map reference for easy location.

KEY TO ACTIVITIES AND MAPS:

Map 1
(*see page 9*)

Map 2
(*see page 13*)

Map 3
(*see page 17*)

Map 4
(*see page 21*)

Any information that relates to the General map on pages 4-5, is depicted in white.

Looking over the Cape Flats towards Table Mountain

EMERGENCY NUMBERS

Ambulance	10177
Automatic Phone Weather Service	40881
Crime Stop	0800 111 213
SA Police Flying Squad	10111
Metro Emergency Rescue Service	10177

SOUTHERN AFRICA TOURISM
SERVICES ASSOCIATION

SERVICE	CONTACT NO.	MAP REF
Automobile Association of SA:		
Breakdowns	0800 01 01 01 Toll Free	
Mayday Medical Rescue	0800 11 19 95 Toll Free	B3
Metrorail Train Emergency	(021) 449-2443 (8am - 5pm)	B3
Mountain Fires – Kloofnek Control Centre	(021) 23-3210	B3
National Sea Rescue Institute NSRI	(021) 434-5625	B2
SA Police	(021) 405-5111 (All hours)	B3
SA Police Service Tourist Assistance Unit	(021) 418-2852/3 (Office hours)	B3
Western Cape Secretariat for Safety and Security	(021) 483-5700	B3
Fire Brigade Stellenbosch	(021) 808-8888	C2
Ambulance (Paarl)	(021) 883-3444	B1

The Southern Africa Tourism Services Association is the leading body representi the private sector of the tourism industry. The SATSA logo is a sign of commitment to service excellence for the touri *Asterisks mark all companies that are registered with SATSA For more information contact (021) 761-4555

TOURIST INFORMATION CENTRES AND SERVICES

SERVICE	CONTACT NO.	MAP REF
Automobile Association of SA	(021) 462-3026	B3
British Airways Travel Clinic	(021) 419-3172	B3
*Captour Cape Town Tourism	(021) 418-5214/5	B3
Waterfront Visitor's Centre	(021) 418-2369	B2
Western Cape Tourism Board	(021) 421-6274	B3
Fish Hoek Publicity	(021) 782-5135	B1
Simon's Town Publicity	(021) 784-2436	B2
Brackenfell Municipality	(021) 981-5571	B2
Durbanville Municipality	(021) 96-3453	A1
Info Africa	(021) 914-2992	A3
Stellenbosch Tourism and Info Bureau	(021) 883-3584	C2
Tygerberg Information Centre	(021) 948-4993	A2
Paarl Publicity	(021) 872-3829	B1
Vallee Tourisme Franchhoek Info Office	(021) 876-3603	C3

Erica multumbellifera
(see page 59)

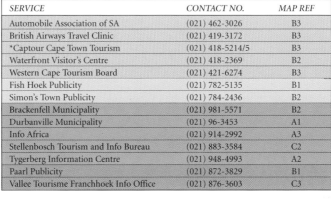

Beautiful Erica
Erica pulchella
(see page 59)

ABSAGROUP

AUTHORITY	CONTACT NO.	MAP REF
ABSA Western Cape Regional Office	(021)405-8222	B3

AUTHORITIES (PERMITS)

AUTHORITY	CONTACT NO.	MAP REF
Gordon's Bay Municipality	(021) 856-2135	D4
Cape Nature Conservation (CNC)	(021) 483-4051	B3
Cape Town City Council	(021) 400-2507	B3
Department of Home Affairs	(021) 462-4970	B3
*South African National Parks	(021) 762-9620	B3
Brackenfell Municipality	(021) 981-5571	B2
Durbanville Municipality	(021) 96-3453	A1

FOREIGN EXCHANGE

Banking Hours: Monday - Friday 09h00 - 15h30;
Saturday 08h30 - 11h00

SERVICE	CONTACT NO.	MAP REF
American Express		
Cape Town Central	(021) 21-5586	B3
Claremont	(021) 683-2125	B3
Waterfront	(021) 419-3917	B2
Stellenbosch	(021) 887-0818	C2
Nedbank Foreign Exchange	(021) 488-2808	B3
Rennies	0 800 11177(toll free)	
City	(021) 418-1206	B3
Southern Suburbs	(021) 761-1778	B4
Waterfront	(021) 418-3744	B2
Green Point	(021) 439-7529	B2
Stellenbosch	(021) 886-5259	C2
Master Currency	(021) 419-2664 / 26-2010	B3
Thomas Cook Stellenbosch	(021) 886-5259	C2

Hairy Erica
Erica hispidula
(see page 59)

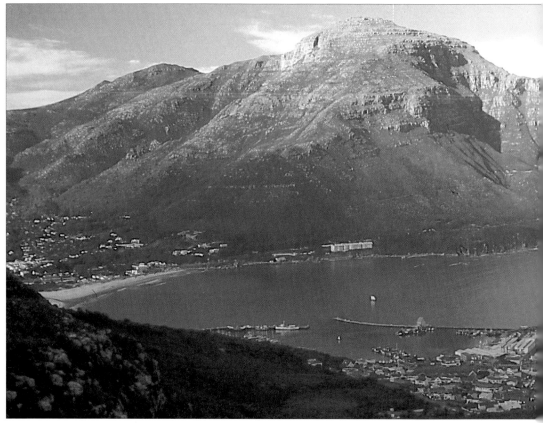

Across Hout Bay to Chapman's Peak Drive

Vehicle Hire

SERVICE	CONTACT NO.	MAP REF	Car	Coach	Microbus	Scooter / Motor bike	Truck	4 x 4
Africar and Truck Hire	0800 033 199	B3	•				•	
Buffalo Bikes	(021) 45-0718	B3				•		
Economy Car Hire	(021) 934-2326	B2	•					
*Hertz Car Rental	0800 021 515	B3	•					
Premier Car Rental	(021) 689-1275	B3	•					
Rent-A-Scooter	(021) 230-823	B3				•		
Sunshine Bikes	(021) 462-1955 082 855 7185	B3				•		•
Value Microbus Hire	(021) 683-8770 082 579 4801	B3	•		•			
*Budget Rent-a-Car	(021) 782-6636	B1	•					
Europcar	(021) 934-2263	A3	•					
*Intercape Mainliner	(021) 386-4444	A3		•				
STELLENBOSCH								
Budget	(021) 887-6935	C2	•					
Hertz	(021) 886-5206	C2	•					
Imperial	(021) 883-8140	C2	•					
Premier	(021) 883-9103	C2	•					

Southern Rock Agama (see page 98)

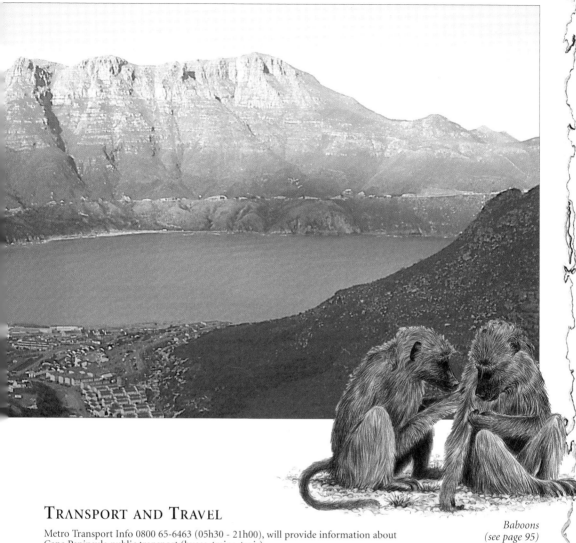

*Baboons
(see page 95)*

TRANSPORT AND TRAVEL

Metro Transport Info 0800 65-6463 (05h30 - 21h00), will provide information about
Cape Peninsula public transport (buses, trains, taxis).

SERVICE	CONTACT NO.	MAP REF
Baz Bus	(021) 439-2323	B3
Metro Rail Information	0800 210081	B3
Rikki's Microbus Taxis	(021) 23-4888	B3
Sea Point Radio Taxis	(021) 434-4444	A3
*Translux	(021) 449-3333	B3
Rikki's Simon's Town	(021) 786-2316	B2
Airport Shuttle Service	(021) 934-5455 082 804 5016	A3
*Intercape Mainliner	(021) 386-4444 / 419-0000	A3
Magic Bus (Airport)	(021) 934-5455	A3
STELLENBOSCH		
Rail	(021) 449-2111	C2
Rikki's	(021) 887-2203	C2
Roland's Taxis	(021) 834-0708	C2
Stellenbosch Taxis	(021) 886-5808	C2

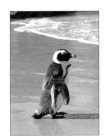

IN AND AROUND WATER

The Cape Peninsula is arguably the most beautiful coastline in South Africa. It is home to a wonderful variety of sea and shoreline species (see pages 108-121). Whether you are a boating enthusiast, an avid fisherman, diver or beachcomber, there are unique and exciting places to discover and explore.

WATER ADVENTURE

SERVICE PROVIDER	CONTACT NO.	ADVENTURE TYPE, LOCATIONS, DESTINATIONS	MAP REF	Seawater	Freshwater
Table Bay Diving	(021) 418-5806	Dive Charters around Cape Peninsula Wrecks; Seals; Pinnacles; Night Dives; Water Skiing	B2	•	
Coastal Kayak Trails	(021) 551-8739	2hrs - 30 days around Cape coast and inland; Dolphin Trail – West Coast; Seal Trail – Hout Bay; Sunset Trip – Three Anchor Bay; Two Oceans Rock Trail – Cape Point	A4	•	
*Felix Unite River Adventures	(021) 419-0337	1 and 2 day canoe trails in Winelands	B3		•
Two Ocean Diving	(021) 438-9317 083 275 2878	Scuba Courses, Wreck and Reef Dives, Boat Dives, Great White Shark Dives, Aquarium Predator Dives, Seal Island Snorkelling, Deep Sea Game Fishing	A3	•	

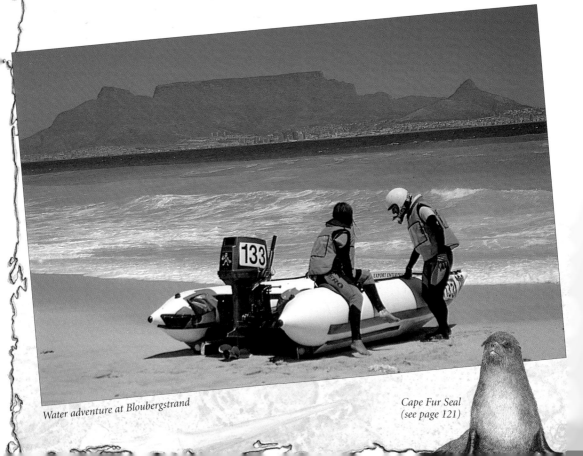

Water adventure at Bloubergstrand

Cape Fur Seal (see page 121)

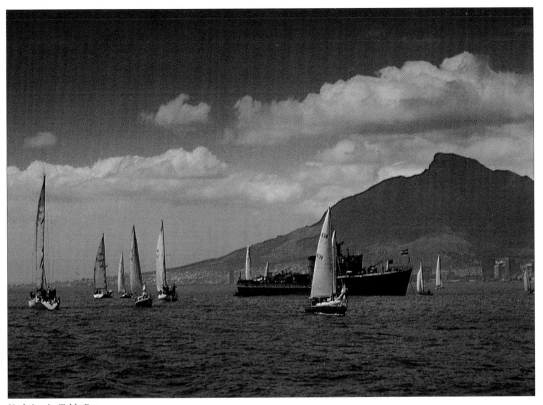

Yachting in Table Bay

BOATS (PLEASURE TRIPS)

COMPANY/TOUR OPERATOR	CONTACT NO.	TRIPS AND DESTINATIONS	MAP REF
Table Bay Diving	(021) 418-5806	Dive Charters – Cape Peninsula Wrecks, Seals, Pinnacles, Nite Dives	B2
Warren Marine (Hout Bay Harbour)	(021) 790-1040	Noordhoek – Llandudno, Hout Bay – Cape Town, Duiker Island, Hout Bay Harbour, Sunset Cruises	A4
Drumbeat Launches (Hout Bay Harbour)	(021) 438-9208 (021) 790-4859	Seal Island, Hout Bay, Duiker Island, Chapmans Peak, Champagne Cruises	A4
Makana (V&A Waterfront)	(021) 419-2875	Robben Island Boat Trip Specialised tours of Island – Bird Watching, Mountain Biking, World War 2 Sites, Historic Villages Tour, Penguin Tour	B3
Spirit of Victoria (V&A Waterfront Pierhead)	(021) 419-1780 082 554 6058	Table Bay, Robben Island, Champagne Cruises, Sunset Cruises, Private Charters	B3
Water Front Charters	(021) 418-0134 (021) 425-3804 (021) 425-4292	Robben Island 2½ hr Sunset Champagne Cruise; 1½ hr Fun Cruise; 1 hr Harbour and Table Bay; Hout Bay; West Coast; Private Charters	B3
False Bay Charters (Simon's Town Municipal Jetty)	(021) 759-819 082 575 5655	Full-day charter – False Bay; Half-day charter – False Bay; Cape Point; 2½ hr – Seal Island; Simon's Town Harbour Tour	B2
Yacht Charter (Noordhoek)	(021) 782-7346 083 675 4165	Day Trips – Cape Point, Seal Island, Overnight Trips – Hout Bay, Gordon's Bay, Dassen Island, Langebaan Lagoon	A1

Beaches

Life-guards are on duty at most beaches close to the city, or with full amenities.

Municipal beaches have notice boards at entry points giving details on where and whether dogs are allowed.

LOCATION	MAP REF	Toilet / Shower	Restaurant	Braai facilities	Shop/Kiosk	Swimming	Body board surfing	Tidal pool	Life guard	Snorkelling / Diving
Big Bay (Melkbosstrand)	B1					•	•			
Die Poort	D4									
Gordon's Bay Main Beach – Bikini Beach	D4	•	•			•	•		•	
Grootbaai	D6					•	•			•
Harmoniestrand	D4					•	•			
Koeëlbaai	D5				•	•				
Pringle Bay	D6						•	•		
Rooi Els	D6									
Bloubergstrand	B1					•	•			
Camps Bay	A3	•	•		•	•			•	•
Clifton	A3	•				•			•	
Koeëlbaai	A3					•				
Llandudno	A4	•				•	•		•	
Oudekraal	A3		•		•	•				
Princess Beach (Hout Bay)	A4	•				•			•	
Sandy Bay	A4					•				
Sea Point	A3	•	•		•		•	•		
Bakovenbaai	A3	•				•		•		•
Boulders	B2	•	•			•				•
Buffelsbaai	B3	•				•				•
Dias Beach	B4									
Fishhoek	B1		•		•	•				
Froggy Pond	B2					•				•
Glencairn	B1					•	•			
Kalk Bay	B1	•	•		•			•		•
Koeëlbaai	B2					•	•			•
Kommetjie	A1	•				•	•			•
Maclear Beach	B4									
Miller's Point	B2	•	•			•		•		•
Muizenberg	B1	•	•			•	•	•	•	
Noordhoek	A1	•				•	•			
Platboombaai	B3									
Scarborough	A2	•				•	•		•	
Seaforth	B2			•	•	•				
Smitswinkel Bay	B3									
St James	B1	•			•			•		•
Strandfontein	C1	•	•			•	•		•	•
Sunrise Beach	C1	•				•	•			
Witsandbaai	A2					•				
Macassar Beach	B4	•				•	•		•	
Melkbaai	C4					•	•			
Rocklands Beach	A4	•				•				
Wolfgat	A4	•	•					•	•	

Surf report:	(021) 788-1350	Wind Report:	
Weatherman Pete:	(021) 488-4311	Muizenberg	(021) 788-8226;
Surf / Tide Hotline:	082 234 6370	Bloubergstrand	(021) 56-1723;
	082 658 2503	Kommetjie	(021) 783-2442;
Weather Report:	40881	Strand	(021) 854-7593
Wind Surfing Report:	082 234 6390	Cape Point Lighthouse Report:	083 234 6324

Saddle-shaped Keyhole Limpet
(see pages 111, 112)

Fishing	Boat launch	Access – Parking	Access – Foot	COMMENTS
	•			surfing, watersports, kiting
	•	•		secluded beach backed by the Hottentots-Holland Mountains
	•	•	•	yachting, side lawns and walkway through Milkwood trees
	•			swimming is dangerous
				safe swimming
	•			good scuba diving; shallow caves can be dangerous depending on sea conditions
	•	•	•	swimming is dangerous
	•			swimming is dangerous
				kiting, cold, dangerous water, good view of Table Mountain
				organised beach volleyball and football (in season), popular sun-downer beach
		•	•	access by steep stairs, candlelight / moonlight bathing, popular sundowner beach
				excellent whale watching site with picnic facilities
		•		steep path leading to beach surrounded by rocks
			•	entrance fee
		•		sandy beach adjoining the pituresque Hout Bay harbour
			•	nudist beach
		•		pavillion, 4 km promenade, municipal sea water pool, Graafs rock pool (men only), sunset walks, jogs, dog walks, rollerblading, kiddies park, lawns, organised football (in season)
				popular beach next to Camps Bay
		•		entrance fee, penguin colony, informal traders in parking lot
•			•	walks in nature reserve
			•	the southern-most beach on the Cape Peninsula
		•		pay parking, sea kayaking, joggers walk, kiting
				small and very secluded beach just south of Simon's Town
				windsurfing
•	•		•	scuba diving training (Dive Shack)
				good scuba diving site
•		•		crayfishing and perlemoen diving
			•	good sea bird location ; currents can be dangerous
•		•		caravan park
•		•		bathing houses, funfair, pavillion, playgrounds, organised beach football (in season), municipal swimming pool
		•		horse riding, kiting
				windsurfing
•		•		tidal lagoon, wind surfing, caravan and campsites
			•	extensive lawns adjoining very protected beach
•		•	•	access only by steep footpath
				walkway from St James to Muizenberg
•		•		fresh fish, municipal pool, 3 caravan parks, kiting
•		•		kiting
		•		windsurfing
•				kiting
•				one of the main beaches of the Strand
				next to Sea Point promenade, downstairs, power boat / jet ski launch
	•			bird sanctuary nearby, campsite

Periwinkels (see pages 111, 112)

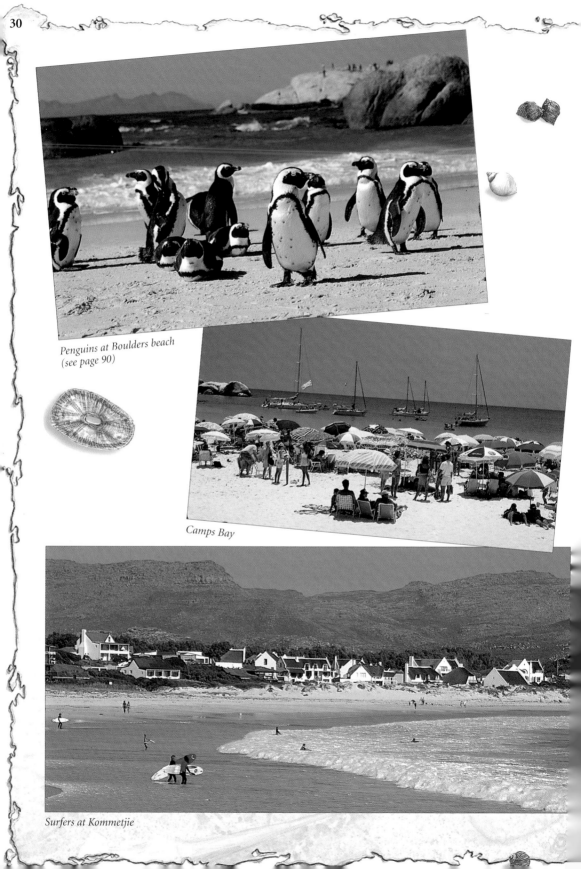

Penguins at Boulders beach
(see page 90)

Camps Bay

Surfers at Kommetjie

BIG GAME FISHING

SERVICE PROVIDER	CONTACT NO.	MAP REF
Adventure Safaris	(021) 438-5201	A3
Bahari Charters	(021) 790-1644	A4
Big Game Fishing Safaris	(021) 64-2203 083 655 6500	A4
Illusive Misty Pearl Fishing Safaris	(021) 64-2203	B3
Wild Thing	(021) 438-8270 082 557 7885	B2
Neptune Deep Sea Angling	082 658 1458	B1
Volante Big Game Fishing and Charters	(021) 783-2906	A1

FRESH SEAFOOD

PLACE	CONTACT NO.	MAP REF
Die Melkbosskerm	(021) 553-2583	B1
Die Krantz Restaurant (Hout Bay)	(021) 790-2330	A4
Fisherman's Wharf (Hout Bay Harbour)	(021) 790-1100	A4
Brass Bell (Kalk Bay Harbour)	(021) 788-5456	B1
La Mer (Muizenberg)	(021) 788-3251	B1
Pampoenskraal Seafood Braai (Durbanville)	(021) 689-9642	A1

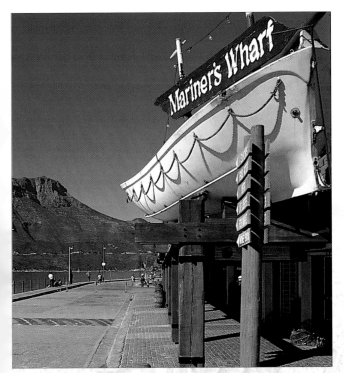

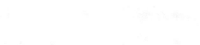

Snoek (see page 119)

Specialist seafood restaurant at Hout Bay Harbour

ANGLING

Department of Sea Fisheries: (021) 402-3911

Rules: The Coastal resources are to be utilised as laid down in the Sea Fisheries Act 12 of 1988, and the Sea Shore Act 21 of 1935. Details on use of the Marine Reserve areas and the crayfish permit system are available from the Department of Sea Fisheries.

ASSOCIATION	CONTACT NO.	MAP REF
Western Province Freshwater Angling Association	(021) 886-4234	B3
Western Province Shore Angling Association	(021) 551-2045	B3
Zeekoeivlei Yacht Club	(021) 705-3373	C4

Sea angling at moonrise

White Mussels (see page 109)

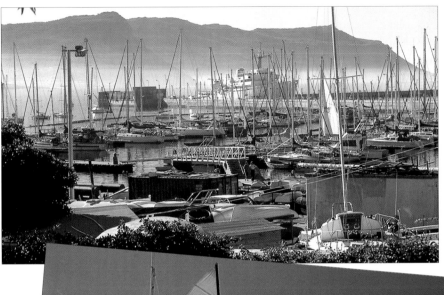

Royal Cape Yacht Club

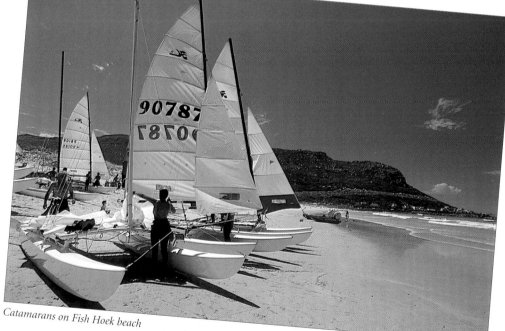

Catamarans on Fish Hoek beach

Mediterranean Mussels (see page 110)

SEA BOAT LAUNCH SITES

SITE	CONTACT NO.	MAP REF
Oceana Power Boat Club	(021) 419-1322	A3
Royal Cape Yacht Club	(021) 21-1354	B2
False Bay Yacht Club (Simon's Town)	(021) 786-1703	B2
Fish Hoek Beach Sailing Club	(021) 782-3205	B1
Fish Hoek Surf Lifesaving Club	(021) 782-1433	B1
Kalk Bay Harbour	(021) 788-1038	B1
Kommetjie Boat Club	(021) 783-2287	A1
Miller's Point Caravan Park	(021) 786-1142	B2

Sea Fishing (Surf/Rock Fishing)

LOCATION	FISH TYPES	MAP REF	Rock bait gathering	Harbour wall	Spoon fishing	Onshore rock fishing	Onshore surf (beach fishing)
Hangklip	Galjoen, Geelbek, Kob, Steenbrass	D6	•			•	
Harbour Wall, Gordon's Bay	Elf, Kob, Mackerel, Steenbrass	D4		•			
Harmoniestrand	Kob	D4					•
Melkbosstrand	Galjoen, White Mussels	B1	•				
Rooi Els	Elf, Kob, Mackerel, Steenbrass – very dangerous fishing	D6				•	
Bloubergstrand	Galjoen, White Mussels	B1	•				
Buffelsbaai	Kob, Steenbrass, Stumpnose	B3				•	•
Cape Point	Galjoen	C4				•	•
Kalk Bay	Kob, Mackerel, Steenbrass, Stumpnose	B1			•		
Kommetjie	Perlemoen fishing, Crayfish	A1				•	
Miller's Point	Kob, Steenbrass, Stumpnose	B2				•	
Muizenberg	Kob, Steenbrass	B1				•	
Rooikrantz	Elf, Kob, Mackerel, Steenbrass – very dangerous fishing	B4	•			•	
Scarborough	Galjoen	A2				•	
Smitswinkel Bay	Kob, Steenbrass, Stumpnose	B3				•	
Strandfontein	Belman, Kob	C1			•		•
Macassar Beach	Galjoen, Kob, Shark, Steenbrass, Wildeperd	B4			•		•
Strand	Kob – wade 200 m into surf to reefs	C4			•		

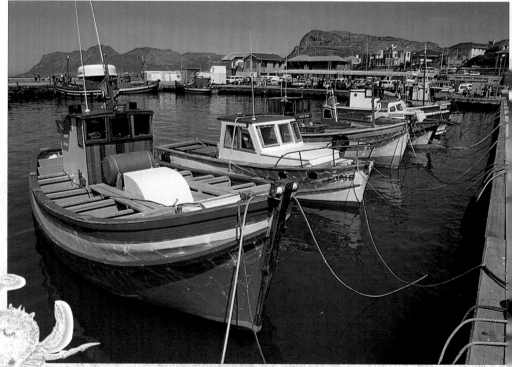

Three-spot Swimming Crab
(see page 109)

Kalk Bay Harbour

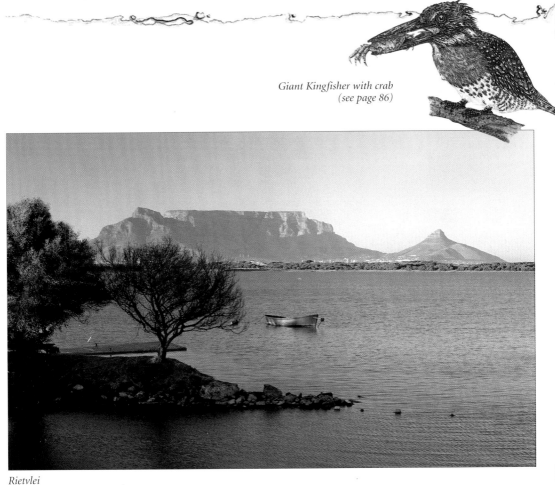

Giant Kingfisher with crab
(see page 86)

Rietvlei

FRESHWATER FISHING

LOCATION	CONTACT NO.	NOTES	MAP REF	Carp	Elf	Trout	Dam / Still water	Fly fishing	River / Running water	Inland salt water
Steenbrass Dam	(021) 400-2507 (021) 856-2135	Permit required from Gordon's Bay Municipality	E5			•	•			
Adventure Safaris and Sports Tours	(021) 438-5201	Camps Bay	A3				•		•	
Princessvlei		Retreat	B4	•			•			
Trout Adventures Africa	(021) 26-1057	Cape Town Central	B3			•	•		•	
Rietvlei			C2	•			•			
Zeekoevlei		Muizenberg	C4				•			
Marina Da Gama			C1	•	•			•		•
Sandvlei		Muizenberg	B1	•	•			•		•
Idas Valley Trout Farms	082 452 3745	Stellenbosch	C2			•	•	•		
Jonkershoek Nature Reserve	(021) 889-1512	10 km east of Stellenbosch	A4			•	•	•	•	
Upper Olifants River		Franchhoek	C3			•			•	
Wemmerhoek Reservoir		Franchhoek	C2			•	•			

THINGS TO DO, PLACES TO SEE

If organised touring is your preference, Cape Town offers you everything from shark diving to wine tasting. Consult one of the tour companies listed in this section. There are also many activities listed that you can discover and experience on your own.

ECO-ADVENTURE TOURS

TOUR OPERATOR	CONTACT NO.	DESCRIPTION	MAP REF
Adventure Safaris and Tours	(021) 438-5201	(Afrikaans / English / German / Spanish) Diving, Deep Sea Fishing, Blackwater Tubing, Mountain Biking, Golf Tours, Scuba Diving, Whale Watching	B3
African Adrenalin	(021) 25-4332	Day trips – Abseiling, Bungee Jumping, Sky Diving, Mountain Biking, Sand Boarding, Shark Diving, Diving Courses, Freshwater Rafting	B3
Bundi Adventures	(021) 418-1708	Scuba Diving, Kloofing, Parasailing, Dune Boarding, Power Kiting	B3
Coastal Kayak Trails	(021) 551-8739 083 310 1253	Dolphin Trail (1 - 5 day), West Coast Seal Trail, Hout Bay Sunset Trip, Three Anchor Bay, Cape Point	A4
Downhill Adventures	(021) 422-0388	Rendezvous: 113a Bree St, Hopkins Cycle Inn, Cape Town – Sand Boarding Day Trips	B3
Envirodivers	(021) 712-9448	Recreational Dives, Speciality Courses	B4
Pure Thrill Tours	(021) 434-6950	1 - 4 day adventure tours – Kloofing, Abseiling, Rubber Duck Wave Jumping, Tandem Skydiving, Parasailing, Flying Fox, Dune Boarding, Power Kiting	B3
Southcoast Seafari's	082 822 6290	Cage Diving (great white sharks near Gansbaai), Whispra Wale Watching, Hiking through Fynbos, Cave Exploration, Diving, Fishing, Seal Expeditions	
Sungazer Adventures	(021) 782-1285 sungazer@iafrica.com	Natural History Tours; Reptiles, Amphibians, Birds and Rock Paintings	B3
Dream Days Adventures	(021) 988-7963	Helicopter Trips, Tandem Sky Diving, Paragliding, Microlighting, Tandem Paragliding, Aerobatic Flights, Intro to Flight, Hot Air Ballooning, Mountain Climbing, Horse Riding, Kloofing, Shark Diving, Scuba Diving, Sea Kayaking, Sailing Courses, Yachting Charters, Water Sports, Big Game Fishing	A1

SPECIALISED TOURS

TOUR OPERATOR	CONTACT NO.	DESCRIPTION	MAP REF
Bo-Kaap Museum	(021) 24-3846	Kramat Route – visit to sacred shrines of Islam	B3
Breakfast Train	(021) 405-2991/2	Train ride (breakfast served) – City,-Simon's Town	B2
Flamingo Disabled Venture	(021) 557-4496	Specialise in disabled tourists	C1
Gay Escape	083 458 4226	Lesbigay travel service	B2
Grass Route Tours	(021) 248-480 082 951 1016	Half- and full-day cross cultural tours – "Beyond the Rainbow Curtain", Mitchells Plain, Bokaap, District Six, Parliament, Robben Island, Langa, Samora Machell Housing Project, Jazz Route	B3
Makana	(021) 419-2875	Robben Island Boat Trip. Specialised tours of island – Bird Watching, Mountain Biking, World War 2 Sites, Historic Village Tour, Penguin Tour	B2
Our Pride Tours	(021) 633-8495 082 446 7974	3 - 4 hour Township Tours, Jazz Tours by Night, District Six, Bonteheuwel, Gugulethu, KTC and Crossroads, Nyanga, Khayelitsha	C3
Spier Vintage Train	(021) 419-5222	Steam train ride – City-Spier	B3
Topless Tours – Elwierda	(021) 418-5888	Bus ride – City and Peninsula Sight Seeing	B3
Sontage Tours	(021) 633-4589	Townships	C3
Koringberg Tours	(021) 876-2659 083 273 7529	Exclusive, tailor-made geology and landscape tours. Geology of the Cape, Winelands, Hot Springs, Cape Peninsular, Five Passes, Cedarberg, Garden Route, etc.	C3

OTHER TOURS

Dial-a-Guide 082 967-1560 (all hours)
Driving Destinations: Guide, Driver and Car Facilities (021) 762-4111

TOUR OPERATOR	CONTACT NO.	DESCRIPTION	MAP REF
*African Eagle	(021) 419-8520	Half- and full-day tours – City, Table Mountain, Peninsula, Winelands	B3
Bundes Tours	(021) 92-0475	(German) City, Bloubergstrand, Franschhoek	C2
CA Shuttle and Tours	(021) 52-6028	Table Mountain, City Waterfront, Winelands, Peninsula and Cape Point	B3
*Cape Rainbow Tours	(021) 551-5465	Half- and full-day – City, Cape Peninsula, Winelands, Township	B3
Cape Town Combi Services	(021) 658-6660 083 325 6059	Peninsula, Winelands, Table Mountain	B3
Cape Town Night and Day Tours	(021) 61-2837 083 270 7933	Half- and full-day tours – City, Cape Point, Peninsula, Stellenbosch, Paarl	B3
Cosmos Tours	(021) 910-1677	Winelands, Peninsula, Sport Tours, Culture, Whales, Flowers	B3
*Felix Unite	(021) 419-0337	Day tours – Cape Point, Peninsula, Winelands	B3
Green Cape Tours	(021) 797-0166 082 891 5266	Half- and full-day – Bird Watching, Table Mountain, Peninsula, Winelands, Whale Watching, Kirstenbosch	B4
*Legend Tours	(021) 697-4056 082 456 2014	Half- and full-day tours – Cape Point, Cape Peninsula, Winelands, City, Table Mountain, Waterfront, Ostrich Ranch, Bo Kaap, District Six, Township and CapeFlats, Robben Island	C3
Mother City Tours	(021) 551-2580	Half- and full-day – Cape Point, Winelands, Table Mountain, Ostrich Farm	B3
Myoli Tours	(021) 556-1432 082 961 0244	Peninsula, Waterfront, Cape Point, Table Mountain	B1
Redwood Tours	(021) 591-7237 082 443 6480	Tours to Stellenbosch	C2
Seaview Tours	(021) 790-3438 082 573 9840	Peninsula, Winelands, Four Passes, City, Heritage Tour, Table Mountain, When Night Falls	A4
Talana Tours	(021) 434-1969	Cape Point, City, Winelands, West Coast	B3
Ubuhlobo Tours	(021) 553-2285 082 579 6555	Winelands, Culture, History, Koeberg, Cape Point, Peninsula	B1
Windward Tours	(021) 419-3475 083 309 0529	(Multilingual) City, Cape Point, Peninsula, Table Mountain, Winelands	B3
Yizani Tours	(021) 24-3520 083 675 4110	Half- and full-day – Cape Point, Winelands, City, West Coast	B3
*Southern Cross Safaris and Tours	(021) 782-7522 082 951145	(French / English) – Winelands, Peninsula, Cultural, Cape Town,	B1
Es State Tours	(021) 96-8337	Day tours Winelands, West Coast, Cape Town	A1
Kap Ausflüge	(021) 975-3431 082 550 1311	(English / German) Peninsula, West Coast, Winelands, City History	A1
Landscape Tours	(021) 851-7706	Tours to Stellenbosch	C4
Tours Western Province	(021) 904-2036 082 920 7482	Half- and full-day tours and hikes – Cape Point, Wine and Apple, Wine and Game, City History, West Coast, Mountain, Waterfront	C4
Tremendous Tours	083 325 7390	Half- and full-day tours – Cape Point, Peninsula, Winelands, Table Mountain, Groot Constantia, Kirstenbosch; Specialist Brandy Tours	A1
Vintage Cape Tours (Paarl)	(021) 862-1484 082 533 8928 (021) 872-9252	Half- and full-day tours – Winelands	B1

RECOMMENDED DAY TRIPS FROM CAPE TOWN

DIRECTION	APPROX ROUND TRIP	DESCRIPTION
North	300 km 3 - 7 hours	Approx 100 km north of Cape Town, lies the West Coast National Park. The wetlands and lagoons here are world-renowned for their bird and sealife. During spring the landscape, particularly near Darling, is transformed by the most spectacular show of wild flowers.
North-east	300 km 3 - 7 hours	Follow the scenic N1 from Cape Town up Du Toits Kloof Pass, avoiding the tunnel route. Beyond, there are spectacular mountain views and delightful roadside picnic spots. This is the main citrus growing region in South Africa and you can buy fruit from the many farm stalls as you wind your way through the valleys.
East	300 km 4 - 7 hours	Follow the coast road along False Bay towards Kleinmond. Be sure to take binoculars and stop at the many lookout points along the way to spot dolphins and seals year-round, and whales from June to December. Beyond Kleinmond, and its Marine Reserve, the signposts will guide you to quaint Hermanus where you can explore the spectacular views from the mountain overlooking the town.

Southern Right Whale (see page 120)

AIR TRIPS AND FLIPS

SERVICE PROVIDER	CONTACT NO.	LOCATION, DESTINATIONS, TRIP TYPE	MAP REF
Civair Helicopters	(021) 419-5182	Helicopter Charter	B2
*Court Helicopters	(021) 425-2966/9	Waterfront – Helicopter Charters and Helitours – Atlantic Coast, Sandy Bay, Hout Bay, Two Oceans, Peninsula, Winelands	B2
Sport Helicopters	(021) 419-5907	15 - 60 minute tours of Peninsula	B2
Cape Atlantic Air	(021) 934-6619	Plane Charter	A3
*Executive Aerospace	(021) 462-0399 082 772 2733	Plane Charter	A3
Good Hope Flying Club	(021) 934-0257	Cape Town International Airport – 1 hr trips – Peninsula, West Coast, Winelands, Whale Route, Photographic Flights, Tuition	A3
Stellenbosch Flying Club	(021) 880-0294	Stellenbosch – R44 Aircraft Hire	C2

AIR ADVENTURE

SERVICE PROVIDER	CONTACT NO.	ADVENTURE TYPE, LOCATION	MAP REF
Cape Parachute Club	(021) 58-8514 082 852 1322 082 800 6290	First Time Jump Training, Tandem Diving	B1
Skydive Tandem	(021) 701-1669 082 800 6290	Tandem Skydiving, Stellenbosch Flying Club	C2
Winelands Ballooning	(021) 863-3192	Hot air ballooning, Stellenbosch	C2

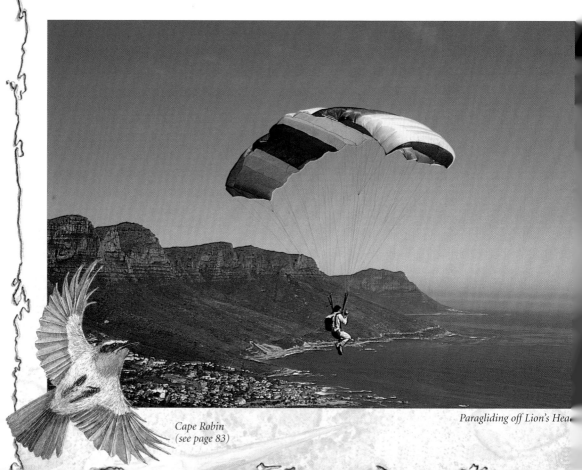

Cape Robin
(see page 83)

Paragliding off Lion's Hea

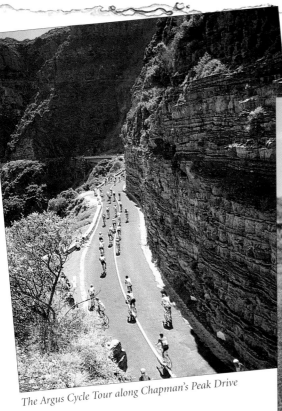

The Argus Cycle Tour along Chapman's Peak Drive

Cyclists at Cape Point

BIKE TRIPS AND TOURS

SERVICE	CONTACT NO.	MAP REF
Day Trippers	(021) 531-3274	C3

BIKE HIRE

SERVICE	CONTACT NO.	MAP REF
Rent and Ride (Cape Town)	(021) 434-1122	B3
Flandria (Stellenbosch)	(021) 887-1533	C2
Village Cycles (Stellenbosch)	(021) 887-0779	C2
Hopkins Cycle Inn (Paarl)	(021) 23-2527	B1

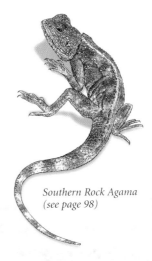

Southern Rock Agama
(see page 98)

MOUNTAIN BIKING

LOCATION	CONTACT NO.	DETAILS	MAP REF
Groote Schuur Estate	(021) 762-9620	Jeep Tracks	B3
Silvermine	(021) 762-9620	Defined gravel tracks	B4
Tafelberg Road (from Kloof Nek to Mowbray Ridge)	(021) 762-9620	Jeep Tracks	B3
Tokai Forest	(021) 762-9620	Paths and forestry roads	B4
Cape of Good Hope	(021) 762-9620	Use hardened surfaces only	B3
Jonkershoek Nature Reserve	(021) 889-1560	Use hardened surfaces only	A4

Sacred Ibis
(see page 86)

HORSE AND PONY RIDING

STABLE	CONTACT NO.	MAP REF
Imhofs Gift (Noordhoek)	(021) 783-1168 082 774 1191	A1
Sleepy Hollow Horse Riding (Noordhoek)	(021) 789-2341 083 261 0104	A1
Amoi Horse Trails (Stellenbosch)	(021) 887-1623 082 681 4285	C2
Horse and Pony Rides (Stellenbosch)	082 550 5780	C2
Mont Rochelle Equestrian Centre (Franchhoek)	083 300 4368	C3
Wine Valley Horse Trails (Paarl)	(021) 981-6331 083 226 8735	B1

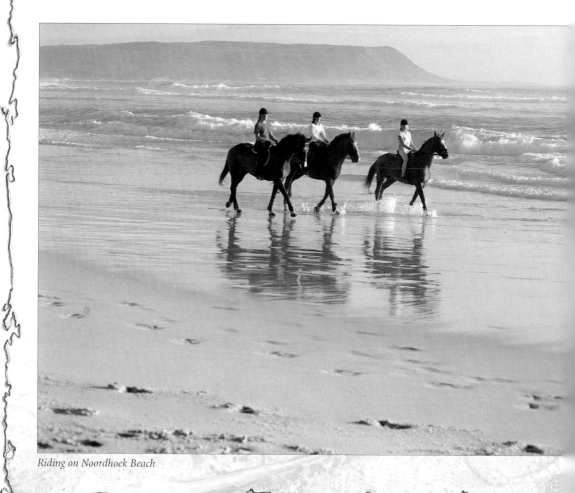

Riding on Noordhoek Beach

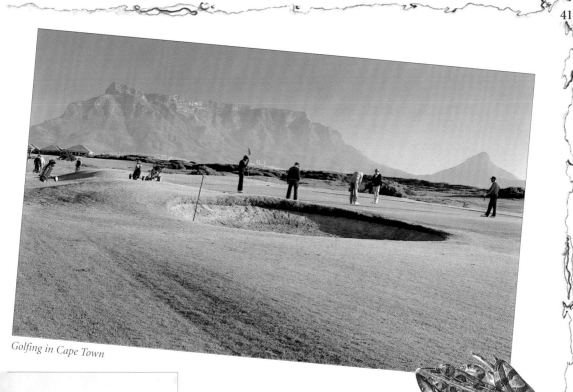

Golfing in Cape Town

Clicking Stream Frog
(see page 101)

GOLF

Ascot Tours (Golfing Tours) (021) 75-9708
Golf Western Province (021) 686-1668
083 458 6420

GOLF COURSES	CONTACT NO.	MAP REF
Metropolitan Golf Club	(021) 434-7808	B2
Milnerton Golf Club	(021) 52-1047	C2
Mowbray Golf Club	(021) 685-3018	C3
Rondebosch Golf Club	(021) 689-4176	C3
Royal Cape Golf Club	(021) 761-6551	C4
Clovelly Country Club	(021) 782-1118	B1
Simon's Town Country Club	(021) 786-1233	B2
Westlake Golf Club	(021) 788-2020	B4
Bellville Golf Club	(021) 913-3100	A2
Devon Vale Country Club	(021) 882-2080	C2
Durbanville Golf Club	(021) 96-8121	A1
King David Country Club	(021) 934-0365	A3
Kuils River Golf Club	(021) 903-0222	B2
Parow Golf Club	(021) 930-2160	C2
Stellenbosch Golf Club	(021) 880-0103	C3
Paarl Golf Club	(021) 863-1120	B2

NATURE RESERVES

PARK / RESERVE	CONTACT NO.	NOTES ON ANIMALS, FACILITIES ETC.	MAP REF
Harold Porter Botanical Gardens (Betty's Bay)	(028) 272-9311	Pristine coastal Fynbos; paved walkways; restaurant	E6
Koegelberg Nature Reserve	(028) 272-9425	Day trails; coastal and mountain fynbos, indigenous forest, riverine vegetation	E6
Kirstenbosch National Botanical Garden	(021) 762 9120	South Africa's oldest and largest botanical garden. Beautiful walks and views. Wheelchair access	B3
Cape Peninsula National Park (this Park lies in two map areas)	(021) 762-9620	Table Mountain and the Peninsula Mountains can be accessed via many hiking trails. Interesting insects, reptiles, small mammals and birds also inhabit this floral wonderland – Lynx, Grysbok, Porcupines, Dassies, Grey Rhebok, Baboon, Mongoose, Genet, Tortoise, Amphibians	A-B, 3-4 / A-B, 1-4
Imhoff's Gift (Noordhoek)	(021) 783-1168	Bird Breeding, Bunny, Pet and Pony Park, Camel Rides	A1
Helderberg Nature Reserve	(021) 851-6982	Over 150 ha of natural fynbos and 200 different bird species	C4
Tygerberg Nature Reserve	(021) 913-4695	Short day trails; picnic area	A2
Jan Marais Nature Reserve	(021) 883-3584	Park and Botanical Gardens located in central Stellenbosch	A4
Jonkershoek Nature Reserve	(021) 889-1560	Mountain fynbos; picnic area; day trails; scenic drives	A4
Paarl Mountain Nature Reserve	(021) 872-3658	Picnic spots, scenic drives through mountain fynbos, day trips	A1
Wiesenhof Game Reserve	(021) 875-5181	Beautiful views. Varied game including Cheetah	A3

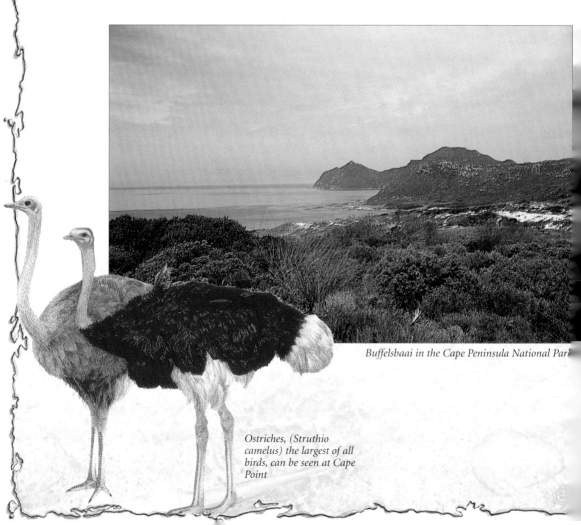

Buffelsbaai in the Cape Peninsula National Park

Ostriches, (Struthio camelus) the largest of all birds, can be seen at Cape Point

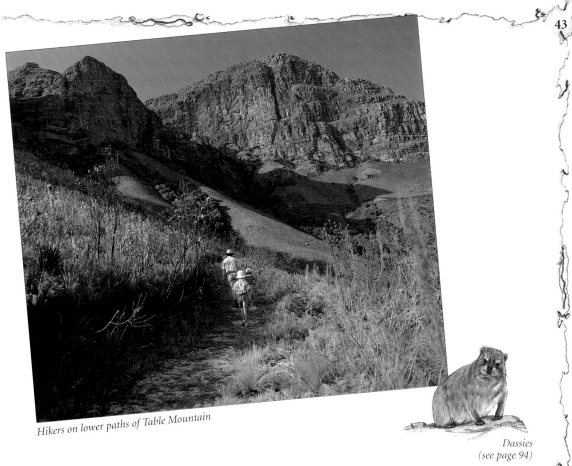

Hikers on lower paths of Table Mountain

*Dassies
(see page 94)*

BIRD WATCHING

Bird Watch Cape (021) 762-5059 082 772 6245
Integrated tours at all major Peninsula birding locations.

OPEN BIRDING LOCATIONS	MAP REF
Melkbosstrand Coast	A1
Duiker Island	A4
Rietvlei Nature Reserve	B2
Robben Island	A1
Table Mountain	B3
Zeekooivlei	C4
Boulders Beach	B2
Seal Island	C1
Paarl Bird Sanctuary	A1

ANIMAL PARKS AND BIRD SANCTUARIES

PARK	CONTACT NO.	MAP REF
Rondevlei Bird Sanctuary	(021) 706-2404	C4
*Two Oceans Aquarium	(021) 418-3823	B2
World of Birds Sanctuary (Hout Bay)	(021) 790-2730	A4
Cape Town Snake Park	(021) 783-3573	A2
Tygerberg Zoo	(021) 884-4494	A2
Butterfly World	(021) 875-5628	B1
Die Vonds Snake Centre (Paarl)	(021) 863-8309	B1
Le Bonheur Crocodile Farm (Paarl)	(021) 836-1142	B1
Weisenhof Wild Park	(021) 875-5181/5231	B1

MUSEUMS/NATIONAL MONUMUENTS

MUSEUMS/MONUMENTS	CONTACT NO.	MAP REF
Bertram House	(021) 24-9381	B3
Bo-Kaap Museum	(021) 24-3846	B3
Cape Medical Museum	(021) 418-5663	B2
Castle of Good Hope	(021) 469-1111/1060	B3
District Six Museum	(021) 461-8745	B3
Education Museum	(021) 762-1622	B4
Groot Constantia Museum	(021) 794-5067	B4
Groote Kerk	(021) 461-7044	B3
Houses of Parliament	(021) 403-2537/2911	B3
Hout Bay Museum	(021) 790-3270	A4
Irma Stern Museum	(021) 685-5686	B3
Jewish Museum	(021) 451-546	B3
Koopmans De Wet House	(021) 24-2473	B3
Military Museum (The Castle)	(021) 469-1136	B3
Parow Museum	(021) 938-8020	A2
Planetarium	(021) 24-3330	B3
Rhodes Memorial Monument	(021) 689-9151	B3
*Robben Island Museum	(021) 419-1300	A1
Rugby Museum	(021) 685-3038	B3
SA Cultural History Museum	(021) 461-8280	B3
SA Airforce Museum	(021) 508-6377	B3
SA Library	(021) 24-6320	B3
SA Maritime Museum	(021) 419-2505	B2
SA Missionary Meeting House Museum	(021) 23-6755	B3
SA Museum	(021) 24-3330	B3
SA National Arts Museum	(021) 45-1678	B3
SA National Gallery	(021) 45-1628	B3
SA Naval Museum	(021) 787-4635	B2
SS Fisheries Museum	(021) 418-2312	B2
St Georges Cathederal	(021) 24-7360	B3
Telkom Exploratorium	(021) 419-5957	B2
The Company's Gardens	(021) 400-2521	B3
Fish Hoek Valley Museum	(021) 782-1752	B1
Muizenberg Museum Complex	(021) 788-7035	B1
Muizenberg Toy Museum	(021) 788-1569	B1
Natale Labia Museum	(021) 788-4106	B1
Rhodes Cottage	(021) 788-1816	B1
SA Police Museum	(021) 788-7031	B1
Sempastorie Museum for National Emblems	(021) 786-3226	B2
Simon's Town Museum	(021) 786-3046	B2
Warrior Toy Museum	(021) 786-1395	B2
Durbanville Clay Museum	(021) 96-4691	A1
Eskom Electricity Centre	(021) 915-9111	A2
Libertas Parva Cellar – Stellenryck Wine Museum (Stellenbosch)	(021) 888-3588	C2
Libertas Parva – Rembrandt van Rijn Art Museum	(021) 866-4340	C2
Mayibuye Centre	(021) 959-2954	A2
Afrikaans Language Monument	(021) 876-3062	B1
Huguenot Museum	(021) 876-2532	C3
Sasol Art Museum (Stellenbosch)	(021) 808-3695	C2
Village Museum (Stellenbosch)	(021) 887-2902	C2

Wild Lobelia
(see page 67)

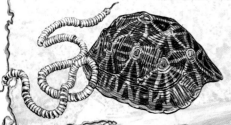

Tortoise shell and necklace
(see page 125)

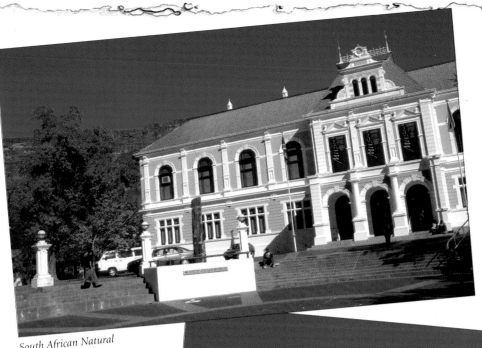

South African Natural
History Museum

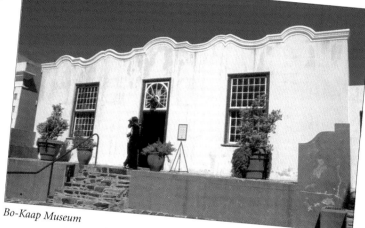

Bo-Kaap Museum

Houses of Parliament

HISTORICAL SITES

SITE	DESCRIPTION	MAP REF
Castle of Good Hope	(1666) The Castle is the oldest European building in South Africa and is still a working barrack.	B3
Church Square	Originally a meeting place for the congregation of nearby Groote Kerk.	B3
Company Gardens	In April 1652, Jan van Riebeek established a permanent provisions station for the Dutch East India Company (VOC), supplying fresh water and produce to the large sailing ships. The Gardens in Parliament Avenue form part of the original company garden.	B3
District Six	Site of forced removals during apartheid era. See District Six Museum.	B3
First Mud Fort	(1652) The first building in Table Bay was the Mud Fort. Its outline can be seen preserved on the Parade Ground next to Castle of Good Hope.	B3
Hout Bay Fort	(1781) Ruins of a Dutch defence post overlooking Hout Bay - see page 122	A4
Robben Island	Site of infamous prison where Nelson Mandela spent 27 years. See Robben Island Museum.	A1
Tuynhuys	Office of the State President.	B3
Muizenberg Defences	(1793 - 1796) The early VOC defence at Muizenberg is still visible on the rocks near Bailey's Cottage. The later British defence can be found on the hillside across the road.	B1
Simon's Town Lower North Battery	(1793) Oldest armed site in South Africa.	B2

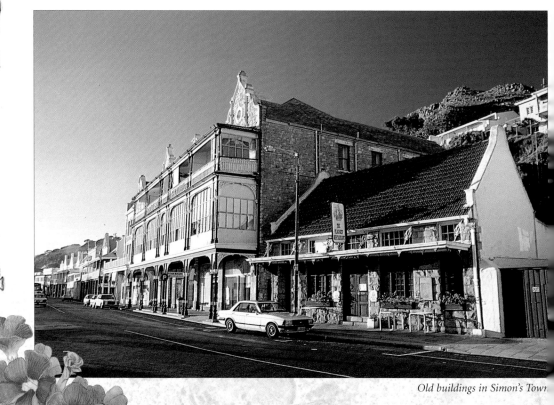

Old buildings in Simon's Town

Sorrel (see page 67)

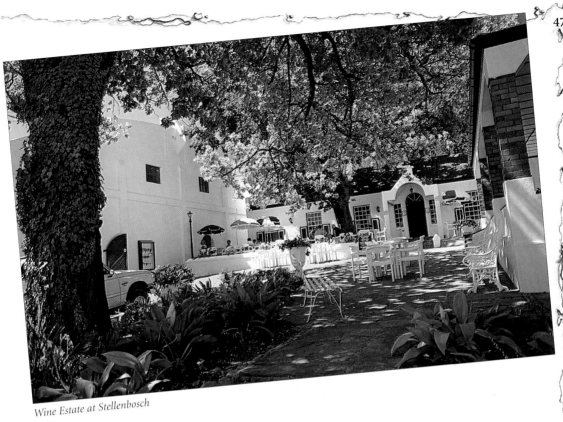

Wine Estate at Stellenbosch

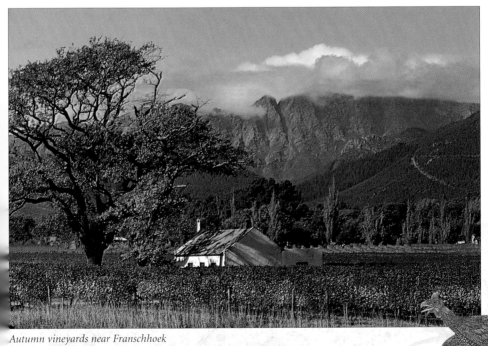

Autumn vineyards near Franschhoek

Helmeted Guineafowl
(see page 84)

WINE ESTATES

INFO:
http://WWW.africa.com:80/wape/wine/stell.htm
Http://WWW.wineroute.co.za

	CONTACT NO.	Icon no.	Map reference	Tasting	Tasting by appointment	Wine sales	Restaurant	Videos	Cellar tours	Cellar tours by appointment	Vineyard tours	Vineyard tours by appointment
CAPE TOWN AND CONSTANTIA VALLEY												
Buitenverwachting	(021) 794-5190	3	B4	•		•	•					
Groot Constantia	(021) 794-5128	1	B4	•		•	•		•		•	
Klein Constantia	(021) 794-5188	2	B4	•		•				•		
Altydgedacht	(021) 961-295	7	A1	•		•						-
Bloemendal	(021) 962-682	6	A1	•		•						
Dimersal	(021) 96-3361	4	A1	•		•			•			
Meerendal	(021) 975-1655	5	A1	•		•						
FRANSCHHOEK												
Vignerons (Franschhoek Wine Route Information)	(021) 876-3062		C3									
Bellingham	(021) 874-1011	68	B3	•		•						
Boschendal	(021) 874-1031	67	B3	•		•						•
Cariere Estate	(021) 876-2630	70	B3	•		•			•		•	
Chamonix	(021) 876-3241	74	B3	•		•			•		•	
Dieu Donne	(021) 876-2493	72	C3	•		•				•		
Franschhoek Vineyards Co-op	(021) 876-2086/7	80	C3	•		•						
Haute Provence	(021) 876-3195	75	C3	•		•						
L'Ormarins	(021) 874-1026	69	B3	•		•				•		
La Bourgogne	(021) 876-2115	82	C4		•							
La Bri	(021) 876-2593	83	C4		•							
La Motte Estate	(021) 876-3119	71	C3	•		•						
La Provence	(021) 876-2163	73	C3	•		•						
Mont Rochelle	(021) 876-3000	81	C3	•		•						
Mouton – Excelsior	(021) 876-3316	85	C4	•		•			•			
Oude Kelder	(021) 876-3666	86	C4	•		•						
Plaisir du Merle	(021) 874-1071	54	A3	•	•	•		•	•			•
Stony Brook	(021) 876-2182	84	C4			•						•
STELLENBOSCH												
Stellenbosch Wine Route Office Open Mon - Fri 08h30-13h00 & 14h00-17h00	(021) 886-4310		C2									
Avontuur	(024) 55-3450	37	C3	•		•						
Bergkelder	(021) 887-2440 X2300	24	C2	•					•			
Blaauwklippen	(021) 880-0133/4	32	C3	•		•	•		•		•	
Bottelary	(021) 882-2204	17	C2	•		•		•				
Clos Malverne	(021) 882-2022	22	C2	•		•						
De Helderberg	(021) 842-2374	38	C3	•	•	•						
Eersterivier	(021) 881-3870/1	30	C3	•		•				•		
Eikendal	(021) 85-1422	36	C3	•		•				•		
Hartenberg	(021) 882-2541	19	C2	•		•			•			
Hazendal	(021) 903-5034/5	8	B2	•		•	•		•			
Jordan	(021) 881-3441	11	B2	•		•				•		
Kaapzicht	(021) 906-1620	9	B2		•		•	•				
Kanonkop	(021) 844-4656	15	C1	•		•				•		
L'Avenir	(021) 899-5001	18	C2	•		•				•		
Louisenhof	(021) 889-7309	23	C2	•		•				•		
Louisvale	(021) 882-2422	21	C2	•		•				•		
Morgenhof	(021) 889-5510	20	C2	•		•	•		•			
Neethlingshof	(021) 883-8988	25	C2	•		•				•		•
Overgraauw	(021) 881-3815	26	C2	•		•				•		

Grapes (see page 131)

STELLENBOSCH (continued)	CONTACT NO.	Icon no.	Map reference	Tasting by appointment	Tasting	Wine sales	Restaurant	Videos	Cellar tours	Cellar tours by appointment	Vineyard tours	Vineyard tours by appointment
Rust-En-Vrede	(021) 881-3881	35	C3	•		•				•		
Saxenburg	(021) 903-6113	13	B2	•		•	•					
Simonsig	(021) 882-2044	16	C2	•		•			•			
Spier Oude Libertas Amphitheatre Open air performances Nov - Mar	0800 220282 (021) 434-5423 (021) 881-3096 (021) 881-3321	33	C3	•		•	•	•	•		•	
Stellenbosch Farmer's Winery	(021) 808-7911/7569	28	C3	•		•			•			
Uiterwyk	(021) 881-3711	10	B2	•	•		•				•	
Verdun	(021) 886-5884	27	C3	•		•				•		
Vlottenberg	(021) 881-3828/9	29	C3	•		•						
Vredenheim	(021) 881-3878	31	C3	•						•		
Welmoed	(021) 881-3800/1	34	C3	•		•	•			•		•
Zevenwacht	(021) 903-5123	12	B2	•		•				•		
Delaire	(021) 885-1756	58	A4	•		•				•		
Delheim	(021) 882-2033	56	A3	•		•				•		
Lievland	(021) 875-5226	52	A3	•		•						
Muratie	(021) 882-2330/6	55	A3	•		•				•		
Neil Ellis Wines	(021) 887-0649	59	A4	•		•						
Thelema	(021) 885-1924	57	A3	•		•						
PAARL												
Paarl Wine Route Office	(021) 872 3605		B1									
Backsberg	(021) 875-5141	50	A2	•		•	•	•	•	•		
Belcher	(021) 863-2076	64	B2	•		•				•		
Boland #1	(021) 872-1747	41	A1	•		•					•	
Boland #2	(021) 862-6190	61	B1	•		•					•	
De Leeuwen Jagt	(021) 863-3495	45	A2	•		•	•					•
De Zoete Inval	(021) 863-2375	65	B2	•		•						
Fairview	(021) 863-2450	47	A2	•		•					•	•
Fredericksberg	(021) 874-1497	53	A3	•		•						
*KWV	(021) 807-3007/8	63	B2	•					•	•		
Laborie	(021) 807-3390	44	A2	•		•				•		•
Landskroon	(021) 863-1039	42	A2	•		•					•	
Nederberg	(021) 862-3104	62	B1		•	•	•				•	
Paarl Rock (Brandy cellars)	(021) 862-6159	60	B1	•		•					•	
Perdeberg	(021) 863-8112	39	A1	•		•				•		
Ruitersvlei	(021) 863-1517	43	A2	•		•						
Simondium	(021) 874-1659	51	A3	•		•						
Simonsvlei	(021) 863-3040	48	A2	•		•	•					
Villiera	(021) 882-2002	14	C1	•		•			•			
Welgemeend	(02211) 5210	49	A2	•		•				•		
Windmeul	(021) 863-8043	40	A1	•		•						
Zanddrift	(021) 863-2076	66	B2	•		•	•					
Zandwijk	(021) 863-2368	46	A2	•		•				•		

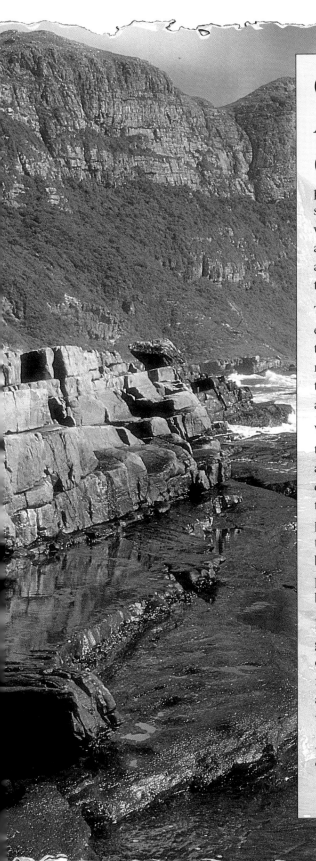

GEOLOGY AND CLIMATE

Geology and climate, principal architects of the Earth's stage, provide the basis for all natural scenes and phenomena. Climate, working on the Earth's structures around the Peninsula, has created an environment ideally suited to the unique Fynbos ecology.

The climate weakens, prepares, and even re-forms the Earth's surfaces, through weathering. Loosened material is washed or blown away to protected places where it accumulates in layers.

When these layers, in time, themselves turn to rock, they too are weathered, eroded and re-deposited. The enormous weight of this material, moving from one place to another, causes the Earth to buckle and strain in an effort to balance the forces. New rock is pushed up to replace rock that has been removed.

If the vast expanse of the Earth's geological time could be condensed, and viewed in fast motion, the land surfaces would appear as unstable as the surface of the sea.

And so the cycle of creation and re-creation continues.

Rock formation at Venus Pools, Cape Point

LAND AND ROCK

Many millions of years ago the Earth was a molten ball of lava. As the planet cooled, thin layers of rock formed a crust over its surface. The crust is continually being weathered by the temperatures, winds, water and chemicals of the atmosphere, seas, rivers, ice and plants. Weathering gradually breaks down the layers of rock, first into boulders, then into rocks and stones, and finally into sand and soil.

Lichen

The various pieces of weathered rock are carried away and eroded by gravity, wind, water and ice. Weathered material is washed and blown into sheltered areas where it collects in layers. If undisturbed, it will eventually be compressed back into rock.

Lichen

Weathering continues on these new rocks and they are again broken down, eroded, and deposited. This continual eroding and mixing produces the many different types of rock we have today. Depending on how they were formed, as cooled lava or as compressed weathered material, rocks weather at different rates. This unequal process makes the planet's many landscapes and land forms possible.

On and around the Peninsula are many examples of these processes, and Table Mountain is the most obvious. Its world-famous flat top is formed by an unbroken layer of very hard quartzite. See **ABSA Table Mountain - Discover the Magic**.

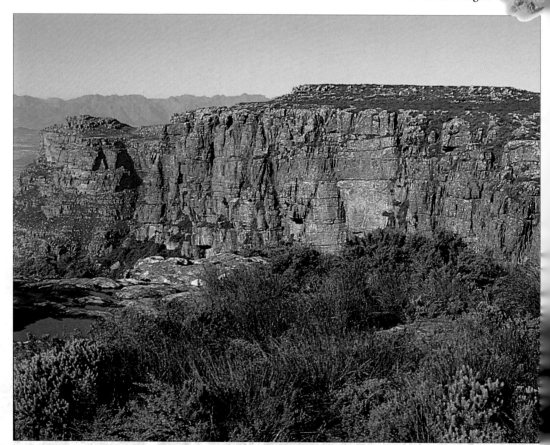
Horizontal layers of quartzite on top of Table Mountain

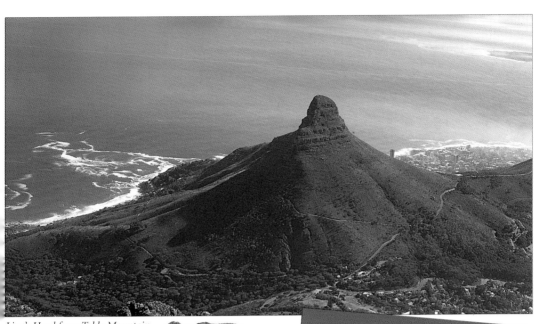

Lion's Head from Table Mountain

Originally deposited as pebbles and sand, this layer extended right across False Bay, and beyond. In places, the layer fractured and faulted, and the weather soon weakened these areas even more. Weathered material was then eroded, leaving behind the hard, rugged quartzite mountains of the Peninsula and Hottentots-Holland. As the rock between these two ranges was removed, the sea moved in to form False Bay.

Southern Rock Agama see page 98

Quartz pebbles

Lion's Head and Devil's Peak owe their distinctive shape to their 'caps' of small, localised layers of quartzite. The erosion-resistant quartzite continued to protect softer rocks below, while the surrounding mass was eroded.

Huge wave-washed, light-grey boulders are a feature between Clifton and Llandudno, and along the coast between Simon's Town and Cape Point. Composed of pure granite, the bottom-most layer of rock in the area, they were once molten lava.

The Twelve Apostles from Camps Bay

SOIL AND CLIMATE

The rocks of the Peninsula and its surroundings weather into the poor, coarse soils typical of the Fynbos.

Water from mist and rain runs freely through this material, preventing rotting plant material from lodging there and releasing vital nutriments. Weather and soil conditions are far from ideal. Plants hoard what little sustenance they find by becoming tough, dry and unpalatable. It is these very conditions that have forced the Fynbos into its many diverse forms and adaptations.

Between the Peninsula and the mountains further inland, we find extensive, flat plains of sea sand, complete with shells. These flats have a different origin from the mountain ranges. Over periods of tens of thousands of years the Earth's climate repeatedly warms and cools. When it warms, the ice caps melt, releasing water into the oceans and raising sea levels around the world. When the climate cools, the ice caps grow by freezing huge quantities of water, and sea levels drop. The sands of the Cape Flats were deposited during the Earth's most recent warm period. The sea rose to flood the area between False Bay and the Atlantic Ocean near Bloubergstrand. The Peninsula was an off-shore group of islands!

Beach sand

Pink-lipped Topshell (see page 111)

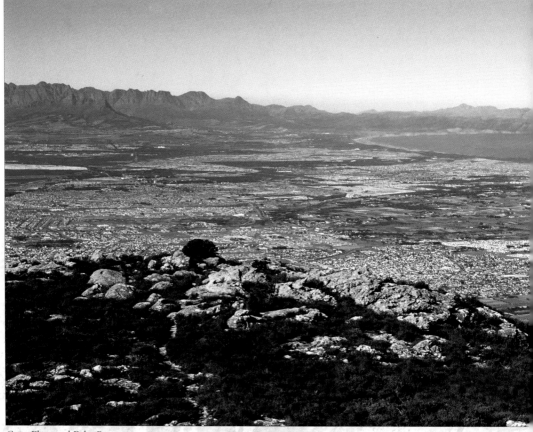

Cape Flats and False Bay

CLIMATE

Weather is produced by the daily interaction of air, its water vapour content, and temperature. The localised mists and clouds that are a daily feature of the Peninsula's weather are caused by rising, cooling air. As a body of air rises, for example up a mountain, it cools and shrinks. This 'squeezes' it like a sponge and some of the vapour it contains may 'ooze' out and become visible, as droplets of water. When air descends it warms and expands and, again like a sponge, it is then able to absorb water. Clouds and mist disappear. This is how the famous tablecloth on Table Mountain is formed.

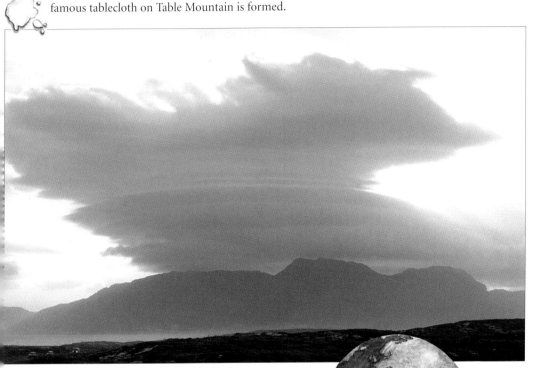

Cloud formation over Swartberg on the Cape Peninsula

SUMMER WEATHER

During the warm summers, the wind blows mainly from the south-east. The mountains are not generally high enough to force the moist air up to the condensation level, and therefore it does not cool sufficiently to form cloud. For this reason rain is infrequent, and not a feature of the Cape's summer weather. Sometimes there is a drop in temperature sufficient to bring the condensation level lower. When this happens clouds and mists form, and it may even rain.

Prevailing wind direction during Summer

WINTER WEATHER

In winter the prevailing wind is from the north-west and the condensation level is lower because of the colder temperatures. When the wind meets the huge, dense, cold, heavy, surface-hugging air masses moving up from the Antarctic, it is forced to rise over them. It quickly reaches the lower condensation level, where cloud forms, and it rains. Rain is thus a frequent and dominant feature of the Peninsula's winters.

Prevailing wind direction during Winter

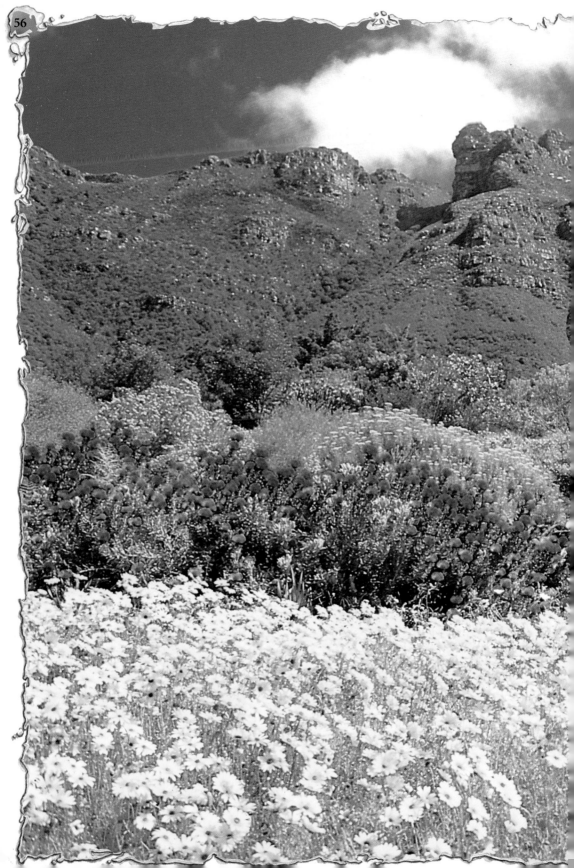

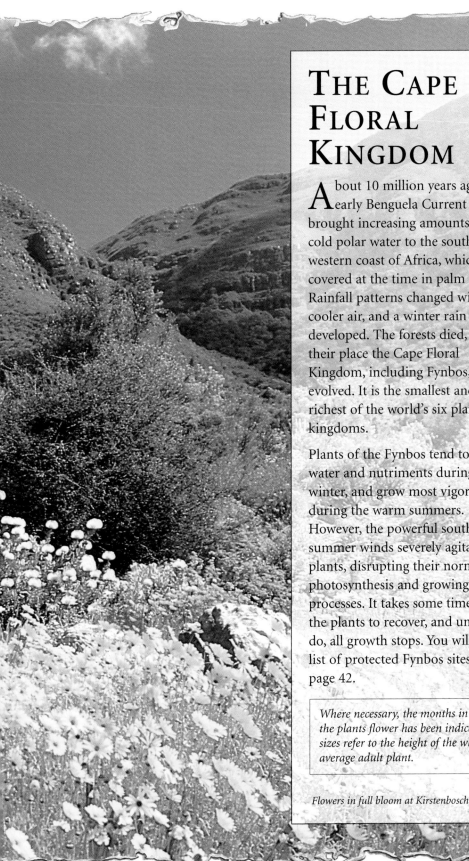

THE CAPE FLORAL KINGDOM

About 10 million years ago the early Benguela Current brought increasing amounts of cold polar water to the south-western coast of Africa, which was covered at the time in palm forests. Rainfall patterns changed with the cooler air, and a winter rain system developed. The forests died, and in their place the Cape Floral Kingdom, including Fynbos, evolved. It is the smallest and richest of the world's six plant kingdoms.

Plants of the Fynbos tend to hoard water and nutriments during winter, and grow most vigorously during the warm summers. However, the powerful south-east summer winds severely agitate plants, disrupting their normal photosynthesis and growing processes. It takes some time for the plants to recover, and until they do, all growth stops. You will find a list of protected Fynbos sites on page 42.

Where necessary, the months in which the plants flower has been indicated; sizes refer to the height of the whole average adult plant.

Flowers in full bloom at Kirstenbosch

FYNBOS

The Fynbos, referring to the profuse, small, fine leaves of the plants, is only 1/500 the size of the northern hemispherc's Arboreal Kingdom. However more than 5 780 of the 8 500 species that grow here grow nowhere else on earth. Restios, Ericas and Proteas are characteristic of Fynbos, and these are considered the three 'indicator' species.

The Fynbos is a unique community of many animal, plant, bird and insect species, interacting in ways that have both created and preserved this environment. Watch it closely and experience it gently, for it still has much to show and teach us.

Erica flowers, though sometimes small, occur in such profusion that they are a major feature of any Fynbos scene.

◄ **Vlakte Heath**
Erica coccinea
Apr - Aug
(60 cm - 1m)

Ker Ker/Raasheide ▲
Erica imbricata
Feb - Oct
(1,2 m)

◄ **Hangertjie**
Erica plukenetii
Mar - Sep (30 - 60 cm)

▼ **Citrus Swallowtail and Caterpillar** ▲
Papilio demodocus (80 - 90 mm)
This predominantly black butterfly can be seen at any time during the year, but more frequently during the warm summer months around December. Butterflies, attracted to the nectar in flowers, are major pollinating agents, while their caterpillars are found mainly on *citrus*.

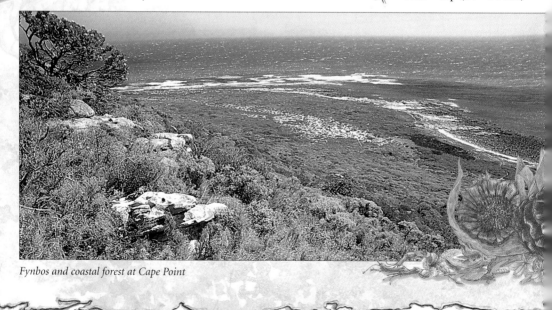

Fynbos and coastal forest at Cape Point

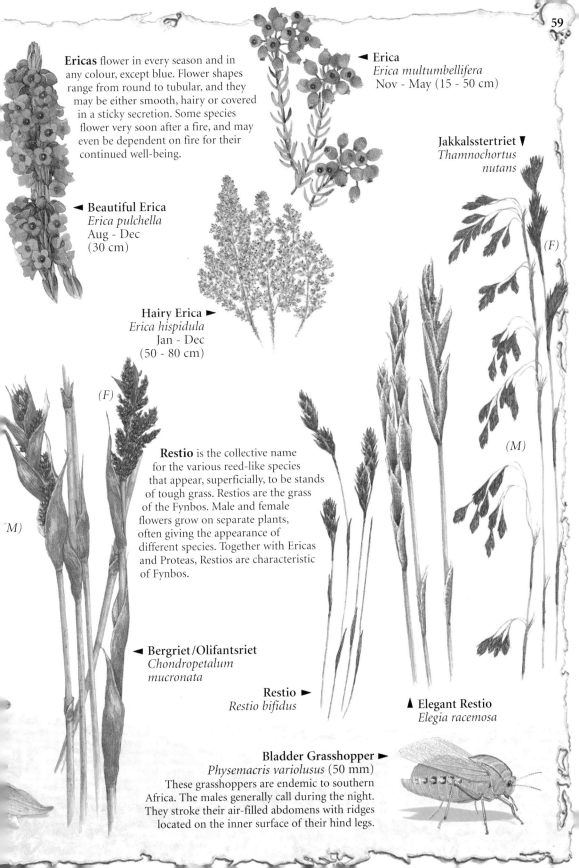

Ericas flower in every season and in any colour, except blue. Flower shapes range from round to tubular, and they may be either smooth, hairy or covered in a sticky secretion. Some species flower very soon after a fire, and may even be dependent on fire for their continued well-being.

◀ **Erica**
Erica multumbellifera
Nov - May (15 - 50 cm)

Jakkalsstertriet ▼
Thamnochortus nutans

(F)

◀ **Beautiful Erica**
Erica pulchella
Aug - Dec
(30 cm)

Hairy Erica ►
Erica hispidula
Jan - Dec
(50 - 80 cm)

(F)

(M)

(M)

Restio is the collective name for the various reed-like species that appear, superficially, to be stands of tough grass. Restios are the grass of the Fynbos. Male and female flowers grow on separate plants, often giving the appearance of different species. Together with Ericas and Proteas, Restios are characteristic of Fynbos.

◀ **Bergriet/Olifantsriet**
Chondropetalum mucronata

Restio ►
Restio bifidus

▲ **Elegant Restio**
Elegia racemosa

Bladder Grasshopper ►
Physemacris variolusus (50 mm)
These grasshoppers are endemic to southern Africa. The males generally call during the night. They stroke their air-filled abdomens with ridges located on the inner surface of their hind legs.

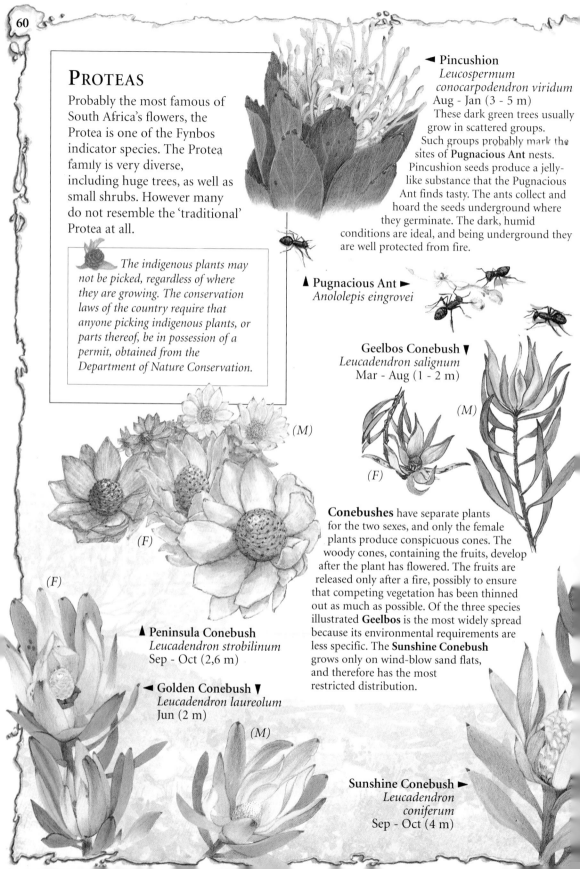

PROTEAS

Probably the most famous of South Africa's flowers, the Protea is one of the Fynbos indicator species. The Protea family is very diverse, including huge trees, as well as small shrubs. However many do not resemble the 'traditional' Protea at all.

The indigenous plants may not be picked, regardless of where they are growing. The conservation laws of the country require that anyone picking indigenous plants, or parts thereof, be in possession of a permit, obtained from the Department of Nature Conservation.

◄ **Pincushion**
Leucospermum conocarpodendron viridum
Aug - Jan (3 - 5 m)
These dark green trees usually grow in scattered groups. Such groups probably mark the sites of **Pugnacious Ant** nests. Pincushion seeds produce a jelly-like substance that the Pugnacious Ant finds tasty. The ants collect and hoard the seeds underground where they germinate. The dark, humid conditions are ideal, and being underground they are well protected from fire.

▲ **Pugnacious Ant** ►
Anololepis eingrovei

Geelbos Conebush ▼
Leucadendron salignum
Mar - Aug (1 - 2 m)

(M)

(F)

(M)

(F)

(F)

▲ **Peninsula Conebush**
Leucadendron strobilinum
Sep - Oct (2,6 m)

◄ **Golden Conebush** ▼
Leucadendron laureolum
Jun (2 m)

(M)

Conebushes have separate plants for the two sexes, and only the female plants produce conspicuous cones. The woody cones, containing the fruits, develop after the plant has flowered. The fruits are released only after a fire, possibly to ensure that competing vegetation has been thinned out as much as possible. Of the three species illustrated **Geelbos** is the most widely spread because its environmental requirements are less specific. The **Sunshine Conebush** grows only on wind-blow sand flats, and therefore has the most restricted distribution.

Sunshine Conebush ►
Leucadendron coniferum
Sep - Oct (4 m)

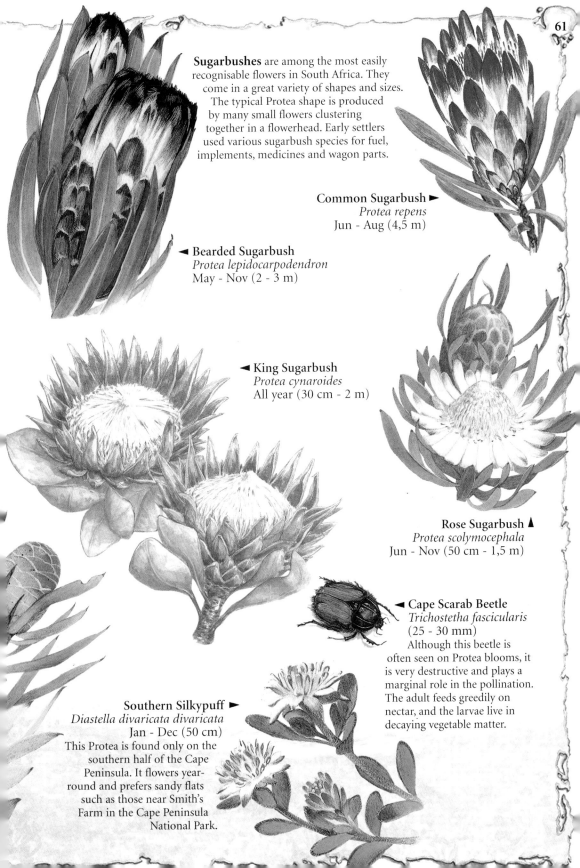

Sugarbushes are among the most easily recognisable flowers in South Africa. They come in a great variety of shapes and sizes. The typical Protea shape is produced by many small flowers clustering together in a flowerhead. Early settlers used various sugarbush species for fuel, implements, medicines and wagon parts.

Common Sugarbush ►
Protea repens
Jun - Aug (4,5 m)

◄ **Bearded Sugarbush**
Protea lepidocarpodendron
May - Nov (2 - 3 m)

◄ **King Sugarbush**
Protea cynaroides
All year (30 cm - 2 m)

Rose Sugarbush ▲
Protea scolymocephala
Jun - Nov (50 cm - 1,5 m)

◄ **Cape Scarab Beetle**
Trichostetha fascicularis
(25 - 30 mm)
Although this beetle is often seen on Protea blooms, it is very destructive and plays a marginal role in the pollination. The adult feeds greedily on nectar, and the larvae live in decaying vegetable matter.

Southern Silkypuff ►
Diastella divaricata divaricata
Jan - Dec (50 cm)
This Protea is found only on the southern half of the Cape Peninsula. It flowers year-round and prefers sandy flats such as those near Smith's Farm in the Cape Peninsula National Park.

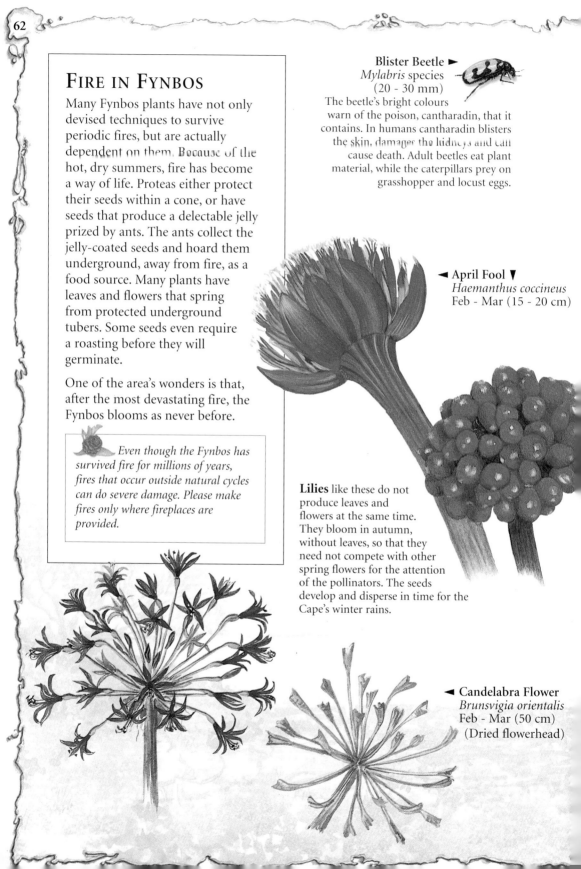

FIRE IN FYNBOS

Many Fynbos plants have not only devised techniques to survive periodic fires, but are actually dependent on them. Because of the hot, dry summers, fire has become a way of life. Proteas either protect their seeds within a cone, or have seeds that produce a delectable jelly prized by ants. The ants collect the jelly-coated seeds and hoard them underground, away from fire, as a food source. Many plants have leaves and flowers that spring from protected underground tubers. Some seeds even require a roasting before they will germinate.

One of the area's wonders is that, after the most devastating fire, the Fynbos blooms as never before.

Even though the Fynbos has survived fire for millions of years, fires that occur outside natural cycles can do severe damage. Please make fires only where fireplaces are provided.

Blister Beetle ►
Mylabris species
(20 - 30 mm)
The beetle's bright colours warn of the poison, cantharadin, that it contains. In humans cantharadin blisters the skin, damages the kidneys and can cause death. Adult beetles eat plant material, while the caterpillars prey on grasshopper and locust eggs.

◄ April Fool ▼
Haemanthus coccineus
Feb - Mar (15 - 20 cm)

Lilies like these do not produce leaves and flowers at the same time. They bloom in autumn, without leaves, so that they need not compete with other spring flowers for the attention of the pollinators. The seeds develop and disperse in time for the Cape's winter rains.

◄ Candelabra Flower
Brunsvigia orientalis
Feb - Mar (50 cm)
(Dried flowerhead)

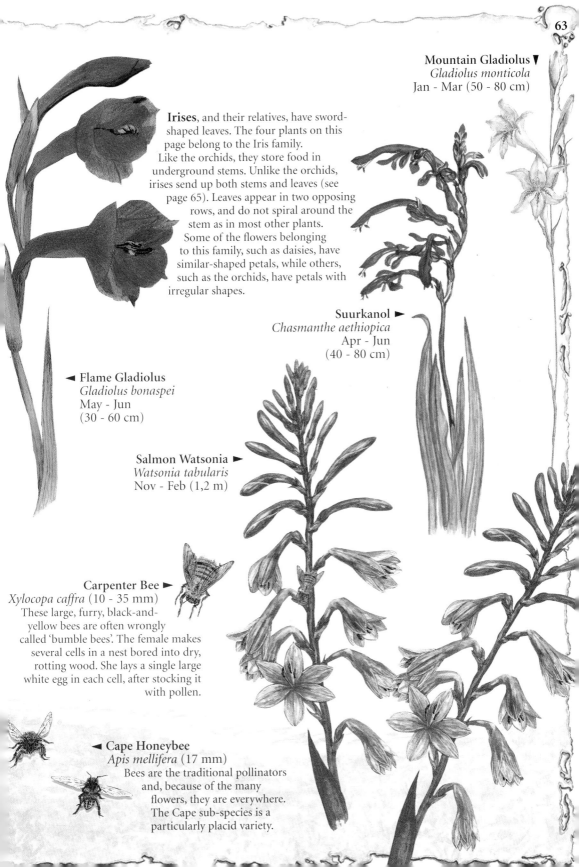

Mountain Gladiolus ▼
Gladiolus monticola
Jan - Mar (50 - 80 cm)

Irises, and their relatives, have sword-shaped leaves. The four plants on this page belong to the Iris family.
Like the orchids, they store food in underground stems. Unlike the orchids, irises send up both stems and leaves (see page 65). Leaves appear in two opposing rows, and do not spiral around the stem as in most other plants.
Some of the flowers belonging to this family, such as daisies, have similar-shaped petals, while others, such as the orchids, have petals with irregular shapes.

Suurkanol ►
Chasmanthe aethiopica
Apr - Jun
(40 - 80 cm)

◄ Flame Gladiolus
Gladiolus bonaspei
May - Jun
(30 - 60 cm)

Salmon Watsonia ►
Watsonia tabularis
Nov - Feb (1,2 m)

Carpenter Bee ►
Xylocopa caffra (10 - 35 mm)
These large, furry, black-and-yellow bees are often wrongly called 'bumble bees'. The female makes several cells in a nest bored into dry, rotting wood. She lays a single large white egg in each cell, after stocking it with pollen.

◄ Cape Honeybee
Apis mellifera (17 mm)
Bees are the traditional pollinators and, because of the many flowers, they are everywhere. The Cape sub-species is a particularly placid variety.

ROLE OF POLLINATORS

Plants have flowers to enable them to exchange pollen with other plants, which ensures that the species remains healthy. Some plants simply release their pollen to wind or water while others use the services of insects, birds and animals. Plants that use insects or birds as pollinators usually produce something such as nectar, which attracts the pollinator. Nectar is hidden deep within the flower, and in reaching it the animal becomes covered in pollen. Because it encounters the same situation at the next plant, the maximum amount of pollen is exchanged.

Not only bees pollinate plants. Butterflies and moths are as important, and some even work at night. A simple way to tell most butterflies from moths is by studying their antennae (feelers). Butterfly antennae are simple stalks with clubbed or swollen tips. Those of the moths are usually feathery and much more intricate.

Crassulas come in a wide range of colours, from white to yellow, orange to red, and green. The leaves appear at first glance to be arranged in fours around the stem. Each subsequent set forms directly above the previous one, and does not spiral around the stem as leaves do in most other plants. This gives the stem a somewhat square appearance. Compare the irises on page 63.

◄ **Cape Snowdrop**
Crassula capensis
May - Aug
(12 cm)

Red Crassula ►
Crassula coccinea
Jan - Mar (50 cm)

Long Proboscis Fly ▼
Lapeirousia species (10 mm)
These flies are vital to the pollination of many of the Fynbos plants. The flies have a specially adapted tongue, or proboscis, which may be up to 70 mm long. With it they can reach the nectar at the bottom of long-tubed flowers, like the pelargonium.

Geraniums and **pelargoniums** that decorate window boxes, containers and gardens in many European countries are all originally from South Africa. Early visitors took cuttings back to Europe, and the many hybrids are the result. The leaves of the geranium family are often quite hairy, and may be aromatic when crushed between the fingers.

Rose-scented Pelargonium ►
Pelargonium capitatum
Sep - Nov (30 - 90 cm)

◄ **Carpet Geranium**
Geranium incanum
Aug - Nov

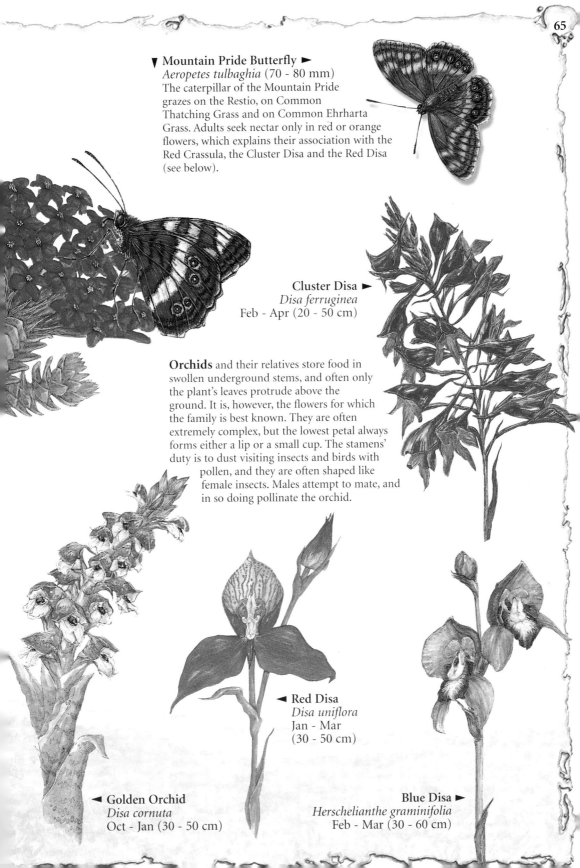

▼ **Mountain Pride Butterfly** ►
Aeropetes tulbaghia (70 - 80 mm)
The caterpillar of the Mountain Pride
grazes on the Restio, on Common
Thatching Grass and on Common Ehrharta
Grass. Adults seek nectar only in red or orange
flowers, which explains their association with the
Red Crassula, the Cluster Disa and the Red Disa
(see below).

Cluster Disa ►
Disa ferruginea
Feb - Apr (20 - 50 cm)

Orchids and their relatives store food in
swollen underground stems, and often only
the plant's leaves protrude above the
ground. It is, however, the flowers for which
the family is best known. They are often
extremely complex, but the lowest petal always
forms either a lip or a small cup. The stamens'
duty is to dust visiting insects and birds with
pollen, and they are often shaped like
female insects. Males attempt to mate, and
in so doing pollinate the orchid.

◄ **Red Disa**
Disa uniflora
Jan - Mar
(30 - 50 cm)

◄ **Golden Orchid**
Disa cornuta
Oct - Jan (30 - 50 cm)

Blue Disa ►
Herschelianthe graminifolia
Feb - Mar (30 - 60 cm)

MEDICINAL AND TRADITIONAL USES

From earliest times humans have looked first to the plant kingdom for their medicines. Traditional use of various plants is still widespread today. Originally it was the traditional healer who both collected the plants and dispensed the remedies. Unfortunately, collecting the appropriate plant parts has become a business opportunity for many, and certain species have been harvested to extinction.

Do not try to administer, or use, plant remedies without long and in-depth study, or the advice of a true expert. Such knowledge is passed on from teacher to pupil over many years. The fact that such treatment may be unfamiliar or less conventional does not mean it is ineffective, or that it can be taken lightly.

Buchus are woody members of the citrus family, and as such they release strongly-smelling oils, particularly when the leaves are crushed. Several species in this family form the basis of a small buchu-oil industry. The oils are used in perfumes and for flavouring jams, some berry drinks, and ice-cream. Certain patent medicines also use extracts to treat hangovers and indigestion.

▲ **Stone Buchu**
Coleonema album
Jul - Nov
(50 cm - 2 m)

Mountain Buchu ►
Agathosma ciliaris
Jun - Nov (40 cm)

◄ **Honey Tea**
Cyclopia galioides
Jan - May (1 m)
This delightful little three-petalled yellow flower is usually found in gentle, undulating country. The blooms appear among the narrow leaves at the ends of leaf-covered branches. The plant's twigs are used to produce a 'bush tea' which, it is claimed, aids digestion. The tea differs from, and is not as well known as, the commercially available 'rooibos tea'.

▲ **Septemberbossie**
Polygala myrtifolia
May - Dec (2 m)
The flowers of this strong shrub are misleading. The flower itself only has three petals. One is tasselled to resemble a small brush. Two of the small, green 'leaves', immediately below the bloom, are enlarged and coloured to resemble petals. The plant occurs in a variety of habitats, and is not confined to the Fynbos. The leaves were once used as a poultice to relieve the pain of gout. The soapy water derived from boiling the bark was used, by Muslims, to wash the dead before burial.

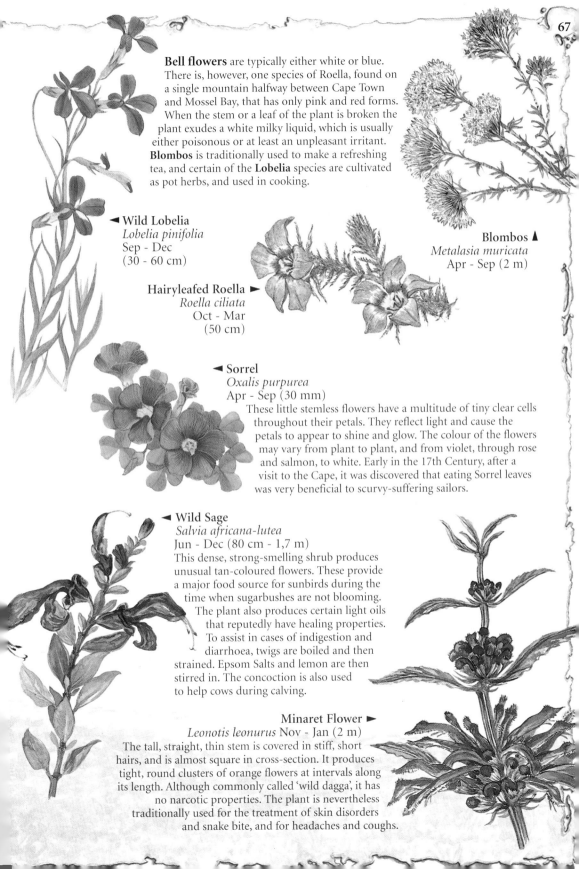

Bell flowers are typically either white or blue. There is, however, one species of Roella, found on a single mountain halfway between Cape Town and Mossel Bay, that has only pink and red forms. When the stem or a leaf of the plant is broken the plant exudes a white milky liquid, which is usually either poisonous or at least an unpleasant irritant. **Blombos** is traditionally used to make a refreshing tea, and certain of the **Lobelia** species are cultivated as pot herbs, and used in cooking.

◄ **Wild Lobelia**
Lobelia pinifolia
Sep - Dec
(30 - 60 cm)

Blombos ▲
Metalasia muricata
Apr - Sep (2 m)

Hairyleafed Roella ►
Roella ciliata
Oct - Mar
(50 cm)

◄ **Sorrel**
Oxalis purpurea
Apr - Sep (30 mm)
These little stemless flowers have a multitude of tiny clear cells throughout their petals. They reflect light and cause the petals to appear to shine and glow. The colour of the flowers may vary from plant to plant, and from violet, through rose and salmon, to white. Early in the 17th Century, after a visit to the Cape, it was discovered that eating Sorrel leaves was very beneficial to scurvy-suffering sailors.

◄ **Wild Sage**
Salvia africana-lutea
Jun - Dec (80 cm - 1,7 m)
This dense, strong-smelling shrub produces unusual tan-coloured flowers. These provide a major food source for sunbirds during the time when sugarbushes are not blooming. The plant also produces certain light oils that reputedly have healing properties. To assist in cases of indigestion and diarrhoea, twigs are boiled and then strained. Epsom Salts and lemon are then stirred in. The concoction is also used to help cows during calving.

Minaret Flower ►
Leonotis leonurus Nov - Jan (2 m)
The tall, straight, thin stem is covered in stiff, short hairs, and is almost square in cross-section. It produces tight, round clusters of orange flowers at intervals along its length. Although commonly called 'wild dagga', it has no narcotic properties. The plant is nevertheless traditionally used for the treatment of skin disorders and snake bite, and for headaches and coughs.

SPECIAL RELATIONSHIPS

Certain animals and plants have taken their adaptation to their environment to the extreme. The Fynbos has its fair share of these ultimate specialists, and because they occur nowhere else in the world they are called endemic species. There are also times when interaction between two non-endemic species may produce a relationship that is unique to an area. Bear in mind that related species which appear to be very different are in fact simply responding to different pressures within the same environment.

Try not to have a destination in mind when you visit the Fynbos. Dawdle, stop, browse and watch. Look and see. Its richness is not shared with the noisy or the hurried.

▼ Dodder
Cuscuta nitida
Dec - Jan
Dodder, a parasite, looks like thick, old, yellow, weathered fishing line intertwined through grass or a shrub's branchlets. Its tiny white, sweet-scented flowers may attract cockroaches to pollinate them, while its little red berries are enjoyed by birds.

◄ Cape Mountain Cockroach
Aptera cingulata (40 mm)
Ancestors of today's cockroach date from over 300 million years ago. The Cape Mountain Cockroach is most often found on the leaves of growing vegetation, behind tree bark, or under logs. It is vegetarian and may enjoy the berries of the parasitic Dodder.

◄ Sharppointed Penaea
Penaea mucronata
Mar - Oct (15 - 50 cm)
This is a very common shrub with deep red flowers, which appear at the ends of its branches. The *mucronata* refers to the characteristic, distinct points at the slightly in-curved tips of the leaves. The leaves are arranged like those of the Red Crassula (see page 64) but are not as densely packed. The plant prefers flat areas and the lower slopes of adjacent mountains.

Diamond Eyes ►
Staavia dodii
Apr - Sep (60 cm)
This charming plant of the rocky ridges, with its delicate little flowers, is rare almost to the point of extinction. Even more remarkable is that it grows only on the southern peninsula and nowhere else on Earth. The mauve-centred, white flowers appear at the ends of erect branches covered in small, uniform, pointed-oval leaves.

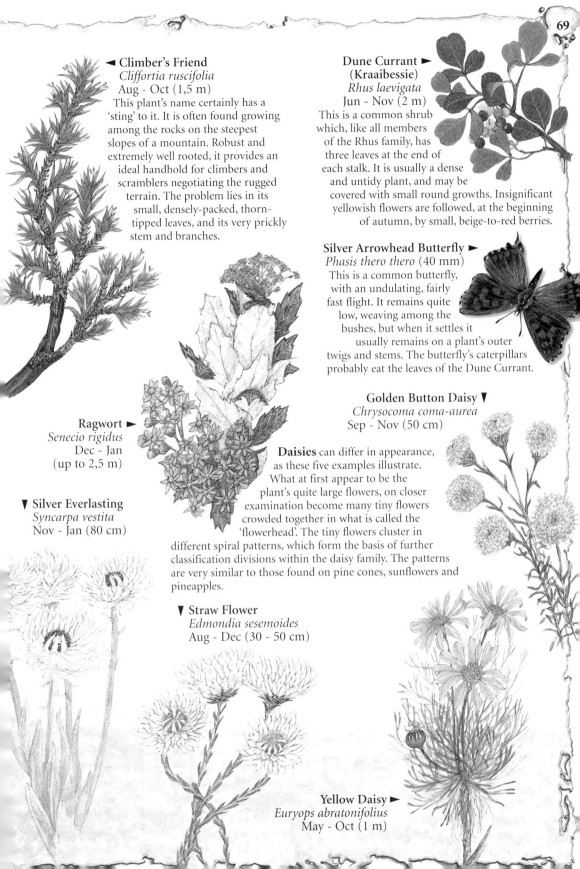

◄ **Climber's Friend**
Cliffortia ruscifolia
Aug - Oct (1,5 m)
This plant's name certainly has a
'sting' to it. It is often found growing
among the rocks on the steepest
slopes of a mountain. Robust and
extremely well rooted, it provides an
ideal handhold for climbers and
scramblers negotiating the rugged
terrain. The problem lies in its
small, densely-packed, thorn-
tipped leaves, and its very prickly
stem and branches.

Dune Currant ►
(Kraaibessie)
Rhus laevigata
Jun - Nov (2 m)
This is a common shrub
which, like all members
of the Rhus family, has
three leaves at the end of
each stalk. It is usually a dense
and untidy plant, and may be
covered with small round growths. Insignificant
yellowish flowers are followed, at the beginning
of autumn, by small, beige-to-red berries.

Silver Arrowhead Butterfly ►
Phasis thero thero (40 mm)
This is a common butterfly,
with an undulating, fairly
fast flight. It remains quite
low, weaving among the
bushes, but when it settles it
usually remains on a plant's outer
twigs and stems. The butterfly's caterpillars
probably eat the leaves of the Dune Currant.

Golden Button Daisy ▼
Chrysocoma coma-aurea
Sep - Nov (50 cm)

Ragwort ►
Senecio rigidus
Dec - Jan
(up to 2,5 m)

Daisies can differ in appearance,
as these five examples illustrate.
What at first appear to be the
plant's quite large flowers, on closer
examination become many tiny flowers
crowded together in what is called the
'flowerhead'. The tiny flowers cluster in
different spiral patterns, which form the basis of further
classification divisions within the daisy family. The patterns
are very similar to those found on pine cones, sunflowers and
pineapples.

▼ **Silver Everlasting**
Syncarpa vestita
Nov - Jan (80 cm)

▼ **Straw Flower**
Edmondia sesemoides
Aug - Dec (30 - 50 cm)

Yellow Daisy ►
Euryops abratonifolius
May - Oct (1 m)

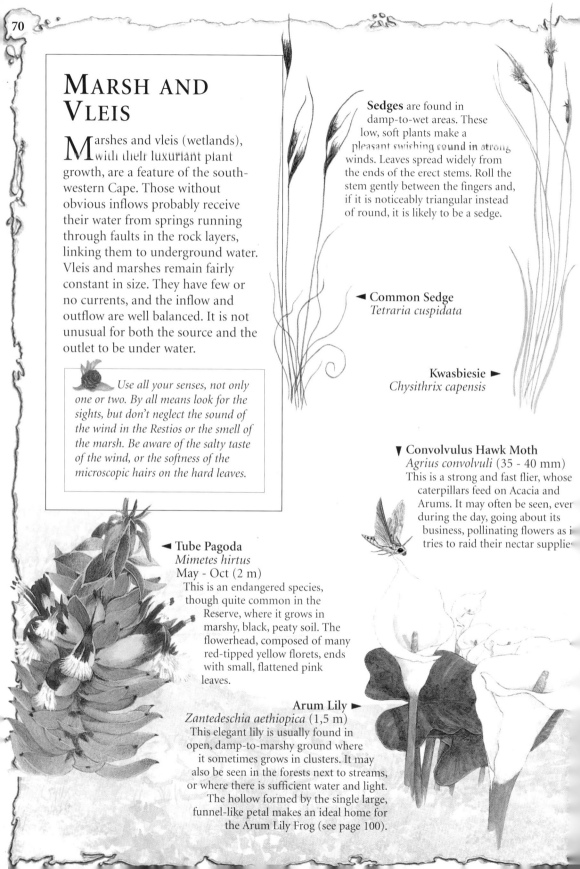

MARSH AND VLEIS

Marshes and vleis (wetlands), with their luxuriant plant growth, are a feature of the south-western Cape. Those without obvious inflows probably receive their water from springs running through faults in the rock layers, linking them to underground water. Vleis and marshes remain fairly constant in size. They have few or no currents, and the inflow and outflow are well balanced. It is not unusual for both the source and the outlet to be under water.

Use all your senses, not only one or two. By all means look for the sights, but don't neglect the sound of the wind in the Restios or the smell of the marsh. Be aware of the salty taste of the wind, or the softness of the microscopic hairs on the hard leaves.

Sedges are found in damp-to-wet areas. These low, soft plants make a pleasant swishing sound in strong winds. Leaves spread widely from the ends of the erect stems. Roll the stem gently between the fingers and, if it is noticeably triangular instead of round, it is likely to be a sedge.

◀ **Common Sedge**
Tetraria cuspidata

Kwasbiesie ▶
Chysithrix capensis

▼ **Convolvulus Hawk Moth**
Agrius convolvuli (35 - 40 mm)
This is a strong and fast flier, whose caterpillars feed on Acacia and Arums. It may often be seen, even during the day, going about its business, pollinating flowers as it tries to raid their nectar supplies

◀ **Tube Pagoda**
Mimetes hirtus
May - Oct (2 m)
This is an endangered species, though quite common in the Reserve, where it grows in marshy, black, peaty soil. The flowerhead, composed of many red-tipped yellow florets, ends with small, flattened pink leaves.

Arum Lily ▶
Zantedeschia aethiopica (1,5 m)
This elegant lily is usually found in open, damp-to-marshy ground where it sometimes grows in clusters. It may also be seen in the forests next to streams, or where there is sufficient water and light.
The hollow formed by the single large, funnel-like petal makes an ideal home for the Arum Lily Frog (see page 100).

◄ **Pom-pom Shrub**
Berzelia abratanoides
Aug - Jan (1 - 1,5 m)
The pom-poms are ball-shaped
flower-heads that are pollinated
by beetles and flies eating the
pollen. This soft-leafed plant
grows in marshy ground,
often in association with the
Marsh Daisy (see below).

Little Sundew ▲
Drosera trinervia (10 - 20 cm)
This small, common flower is most
easily found after a fire. It grows from
a cluster of stalkless 10 mm long
leaves, grouped on the ground in a
rosette. The plants, which usually
grow in damp, marshy, nitrate-
poor soils, are carnivorous. The
leaves, covered in sticky hairs,
trap insects, which are slowly
digested for their
nitrate nutrients.

Bokmakierie's Tail ►
Witsenia maurea
Apr - Jun (2 m)
Look for this plant in localised
clumps in marshy areas. The
flowers, which are black and
yellow and resemble the tail
feathers of the Bokmakierie bird,
are pollinated by the large,
metallic-green Malachite Sunbirds
(see page 79).

Marsh Daisy ►
Osmitopsis astericoides
Aug - Nov (1 - 1,5 m)
This marsh-loving shrub
produces crowded, velvety
leaves and white daisy-like
flowers with yellow centres.
Unlike true daisies, these flowers
grow along the stems, not at the tip.

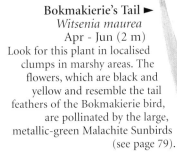

◄ **Sunshine Daisy**
Ursinia nudicaulis
(1 m)
This daisy usually flowers after a fire,
and grows very quickly to produce
many small seeds that will then lie in
the soil, waiting for the next fire.

DUNE PLANTS

Dune sand is very inhospitable to plants, and those that colonise this habitat have very special adaptations. These plants are able to grow in very poor sand, and in the process bind and stabilise it. Landscapers use them extensively whenever groundcovers are needed to cover loose, poor soils. The leaves are wax- or hair-coated as protection from flying sand, and to reduce evaporation. Wind blowing over the dunes must slow down to get around the leaves, and in so doing it drops its load of sand, helping to build the dune.

Dunes are fragile and very susceptible to the slightest disturbance, whether from walking or from 4x4 vehicles. Making the sand 'flow' down the slope is bad enough, but uprooting or damaging the plants that are trying to stabilise their environment should be avoided at all costs.

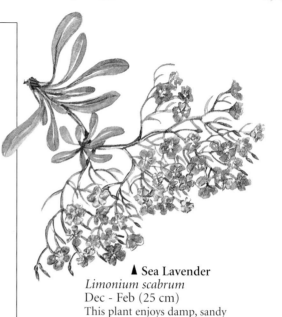

▲ Sea Lavender
Limonium scabrum
Dec - Feb (25 cm)
This plant enjoys damp, sandy locations near the sea.

Common Opal Butterfly ►
Poecilmitis thysbe (30 mm)
This butterfly is one of the most beautiful of its species. Adults can most easily be seen among the sand dune bushes. The caterpillars feed on the Bietou (see opposite), and the *Aspalathus* species, from which 'rooibos' tea is made.

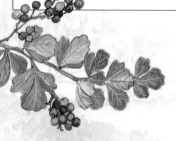

Dune Crow-berry ▲
Rhus crenata (2 m)
This small tree loves dune sand, and will grow in quite dense clumps. The tough leaves are dark green above and paler underneath, with a russet-brown central vein protruding below. Like all Rhus, the leaves occur in groups of three.

Christmas Berry ▼
Chironia baccifera
Nov - Feb (50 cm)
A tightly-packed little shrub, with long, narrow leaves. This plant grows in poor soils and extracts the necessary potassium from the sea winds.

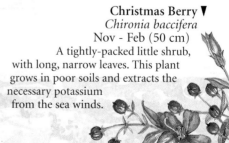

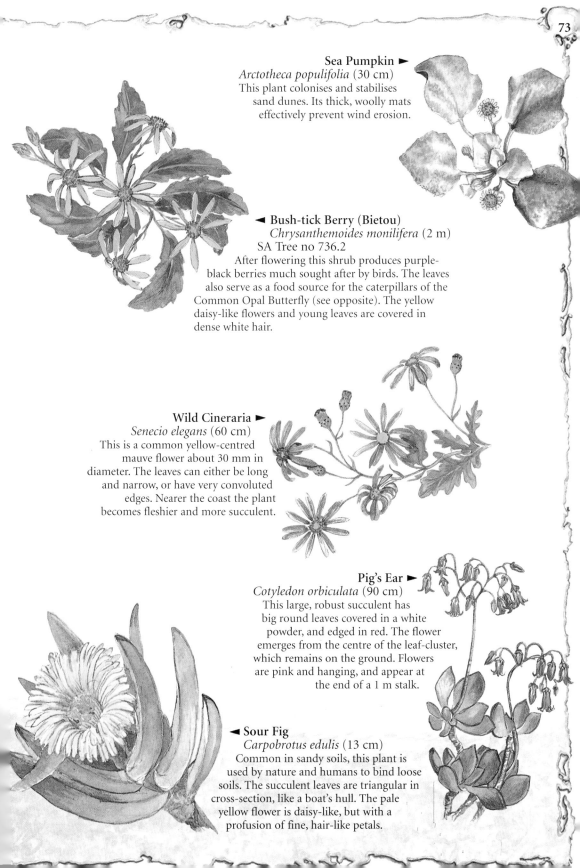

Sea Pumpkin ►
Arctotheca populifolia (30 cm)
This plant colonises and stabilises
sand dunes. Its thick, woolly mats
effectively prevent wind erosion.

◄ **Bush-tick Berry (Bietou)**
Chrysanthemoides monilifera (2 m)
SA Tree no 736.2
After flowering this shrub produces purple-
black berries much sought after by birds. The leaves
also serve as a food source for the caterpillars of the
Common Opal Butterfly (see opposite). The yellow
daisy-like flowers and young leaves are covered in
dense white hair.

Wild Cineraria ►
Senecio elegans (60 cm)
This is a common yellow-centred
mauve flower about 30 mm in
diameter. The leaves can either be long
and narrow, or have very convoluted
edges. Nearer the coast the plant
becomes fleshier and more succulent.

Pig's Ear ►
Cotyledon orbiculata (90 cm)
This large, robust succulent has
big round leaves covered in a white
powder, and edged in red. The flower
emerges from the centre of the leaf-cluster,
which remains on the ground. Flowers
are pink and hanging, and appear at
the end of a 1 m stalk.

◄ **Sour Fig**
Carpobrotus edulis (13 cm)
Common in sandy soils, this plant is
used by nature and humans to bind loose
soils. The succulent leaves are triangular in
cross-section, like a boat's hull. The pale
yellow flower is daisy-like, but with a
profusion of fine, hair-like petals.

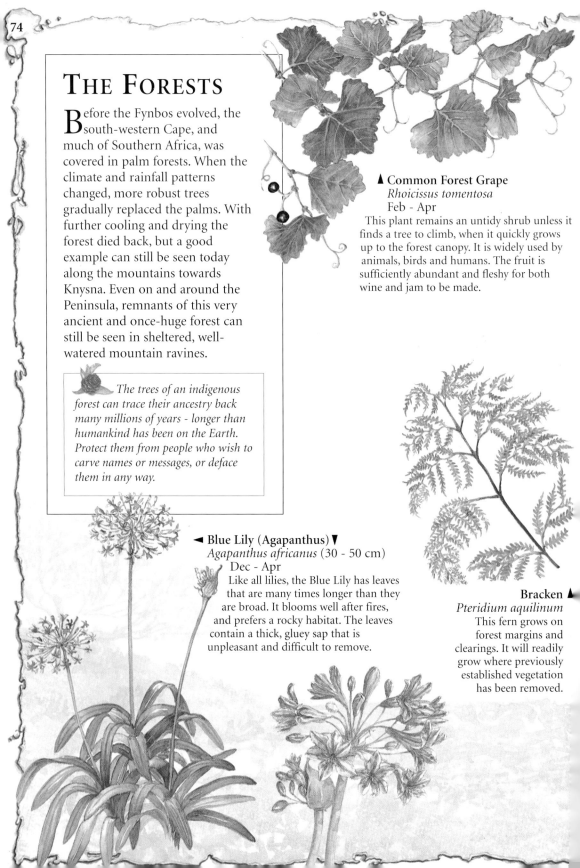

THE FORESTS

Before the Fynbos evolved, the south-western Cape, and much of Southern Africa, was covered in palm forests. When the climate and rainfall patterns changed, more robust trees gradually replaced the palms. With further cooling and drying the forest died back, but a good example can still be seen today along the mountains towards Knysna. Even on and around the Peninsula, remnants of this very ancient and once-huge forest can still be seen in sheltered, well-watered mountain ravines.

The trees of an indigenous forest can trace their ancestry back many millions of years - longer than humankind has been on the Earth. Protect them from people who wish to carve names or messages, or deface them in any way.

▲ **Common Forest Grape**
Rhoicissus tomentosa
Feb - Apr
This plant remains an untidy shrub unless it finds a tree to climb, when it quickly grows up to the forest canopy. It is widely used by animals, birds and humans. The fruit is sufficiently abundant and fleshy for both wine and jam to be made.

◄ **Blue Lily (Agapanthus)** ▼
Agapanthus africanus (30 - 50 cm)
Dec - Apr
Like all lilies, the Blue Lily has leaves that are many times longer than they are broad. It blooms well after fires, and prefers a rocky habitat. The leaves contain a thick, gluey sap that is unpleasant and difficult to remove.

Bracken ▲
Pteridium aquilinum
This fern grows on forest margins and clearings. It will readily grow where previously established vegetation has been removed.

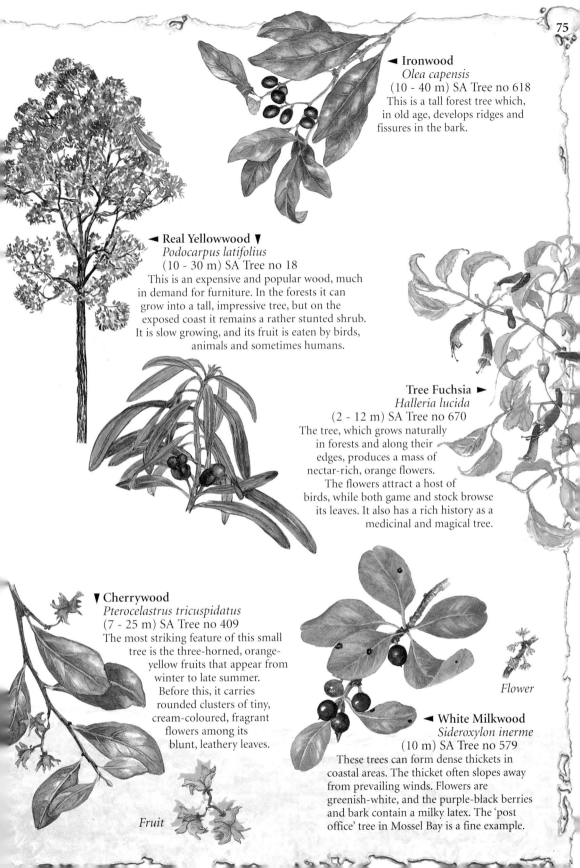

◄ Ironwood
Olea capensis
(10 - 40 m) SA Tree no 618
This is a tall forest tree which, in old age, develops ridges and fissures in the bark.

◄ Real Yellowwood ▼
Podocarpus latifolius
(10 - 30 m) SA Tree no 18
This is an expensive and popular wood, much in demand for furniture. In the forests it can grow into a tall, impressive tree, but on the exposed coast it remains a rather stunted shrub. It is slow growing, and its fruit is eaten by birds, animals and sometimes humans.

Tree Fuchsia ►
Halleria lucida
(2 - 12 m) SA Tree no 670
The tree, which grows naturally in forests and along their edges, produces a mass of nectar-rich, orange flowers. The flowers attract a host of birds, while both game and stock browse its leaves. It also has a rich history as a medicinal and magical tree.

▼ Cherrywood
Pterocelastrus tricuspidatus
(7 - 25 m) SA Tree no 409
The most striking feature of this small tree is the three-horned, orange-yellow fruits that appear from winter to late summer. Before this, it carries rounded clusters of tiny, cream-coloured, fragrant flowers among its blunt, leathery leaves.

Flower

◄ White Milkwood
Sideroxylon inerme
(10 m) SA Tree no 579
These trees can form dense thickets in coastal areas. The thicket often slopes away from prevailing winds. Flowers are greenish-white, and the purple-black berries and bark contain a milky latex. The 'post office' tree in Mossel Bay is a fine example.

Fruit

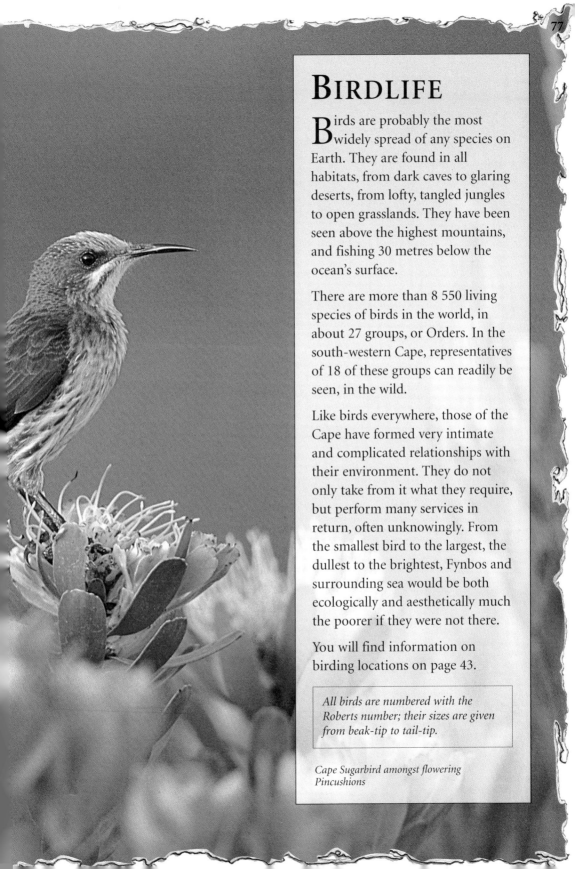

BIRDLIFE

Birds are probably the most widely spread of any species on Earth. They are found in all habitats, from dark caves to glaring deserts, from lofty, tangled jungles to open grasslands. They have been seen above the highest mountains, and fishing 30 metres below the ocean's surface.

There are more than 8 550 living species of birds in the world, in about 27 groups, or Orders. In the south-western Cape, representatives of 18 of these groups can readily be seen, in the wild.

Like birds everywhere, those of the Cape have formed very intimate and complicated relationships with their environment. They do not only take from it what they require, but perform many services in return, often unknowingly. From the smallest bird to the largest, the dullest to the brightest, Fynbos and surrounding sea would be both ecologically and aesthetically much the poorer if they were not there.

You will find information on birding locations on page 43.

All birds are numbered with the Roberts number; their sizes are given from beak-tip to tail-tip.

Cape Sugarbird amongst flowering Pincushions

LAND BIRDS

Birds usually spend their lives closely associated with their own particular surroundings. The habitat determines not only how they feed and nest, but also what special adaptations they may develop. These adaptations contribute to the survival, general well-being and success of the birds.

FYNBOS

The Fynbos offers two very different habitats. Above the bushes birds require strong toes, insect-catching beaks or curved, flower-probing beaks; in the bushes some birds need more robust, seed-cracking beaks, while others need the insect-catching variety.

◄ **Grassbird**
Sphenoeacus afer (19 - 23 cm) 661
A fairly large, streaky-brown bird with a rufous crown and long pointed tail. When it is not hunting spiders and insects in the dense vegetation, it can often be seen sitting on a conspicuous perch.

◄ **Spotted Prinia**
Prinia maculosa (13 - 15 cm) 686
This small bird is found in a variety of habitats. It is most easily recognised as it flicks its long tail up over its back. It forages for insects low down in grass, and is therefore sometimes difficult to see but, when disturbed, takes up a vantage point on a tall plant.

▼ **Ground Woodpecker**
Geocolaptes olivaceus (23 - 30 cm) 480
Although common, this bird is very well camouflaged as it forages in small groups along the ground. Its diet is mainly ants, which are collected as the bird probes cracks and holes with its long, sticky tongue.

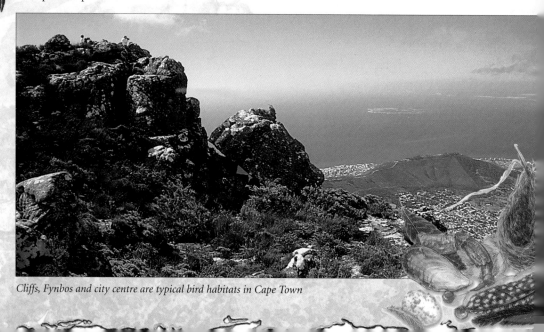

Cliffs, Fynbos and city centre are typical bird habitats in Cape Town

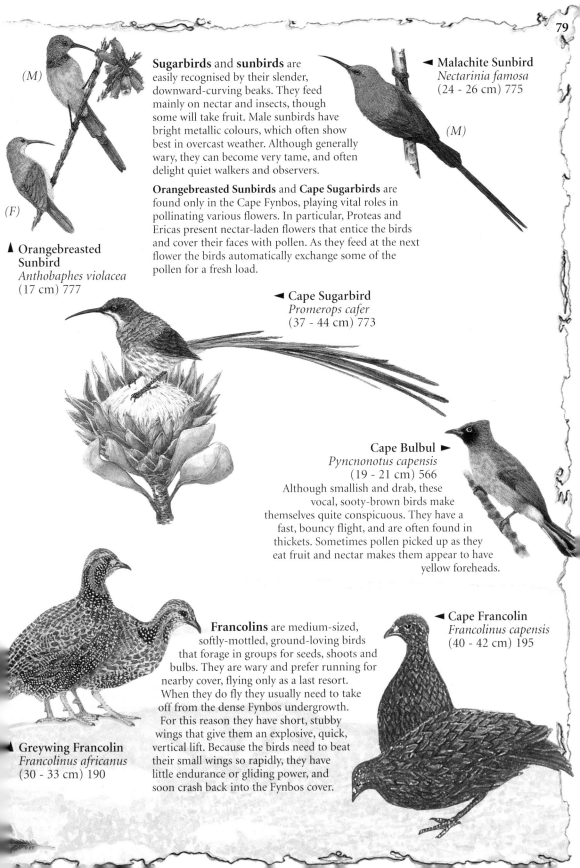

(M)

(F)

▲ Orangebreasted
Sunbird
Anthobaphes violacea
(17 cm) 777

Sugarbirds and sunbirds are easily recognised by their slender, downward-curving beaks. They feed mainly on nectar and insects, though some will take fruit. Male sunbirds have bright metallic colours, which often show best in overcast weather. Although generally wary, they can become very tame, and often delight quiet walkers and observers.

Orangebreasted Sunbirds and Cape Sugarbirds are found only in the Cape Fynbos, playing vital roles in pollinating various flowers. In particular, Proteas and Ericas present nectar-laden flowers that entice the birds and cover their faces with pollen. As they feed at the next flower the birds automatically exchange some of the pollen for a fresh load.

◄ Malachite Sunbird
Nectarinia famosa
(24 - 26 cm) 775

(M)

◄ Cape Sugarbird
Promerops cafer
(37 - 44 cm) 773

Cape Bulbul ►
Pyncnonotus capensis
(19 - 21 cm) 566
Although smallish and drab, these vocal, sooty-brown birds make themselves quite conspicuous. They have a fast, bouncy flight, and are often found in thickets. Sometimes pollen picked up as they eat fruit and nectar makes them appear to have yellow foreheads.

◄ Cape Francolin
Francolinus capensis
(40 - 42 cm) 195

Francolins are medium-sized, softly-mottled, ground-loving birds that forage in groups for seeds, shoots and bulbs. They are wary and prefer running for nearby cover, flying only as a last resort. When they do fly they usually need to take off from the dense Fynbos undergrowth. For this reason they have short, stubby wings that give them an explosive, quick, vertical lift. Because the birds need to beat their small wings so rapidly, they have little endurance or gliding power, and soon crash back into the Fynbos cover.

◄ Greywing Francolin
Francolinus africanus
(30 - 33 cm) 190

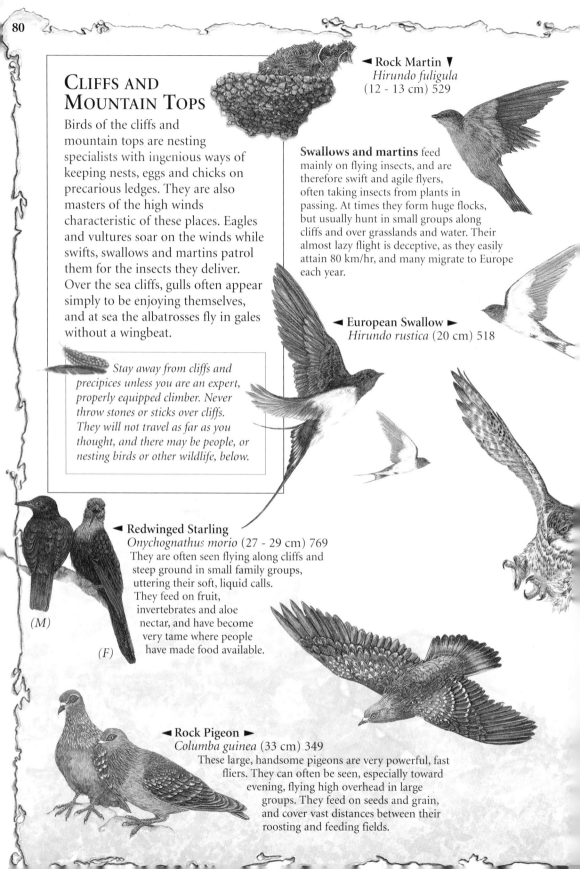

CLIFFS AND MOUNTAIN TOPS

Birds of the cliffs and mountain tops are nesting specialists with ingenious ways of keeping nests, eggs and chicks on precarious ledges. They are also masters of the high winds characteristic of these places. Eagles and vultures soar on the winds while swifts, swallows and martins patrol them for the insects they deliver. Over the sea cliffs, gulls often appear simply to be enjoying themselves, and at sea the albatrosses fly in gales without a wingbeat.

Stay away from cliffs and precipices unless you are an expert, properly equipped climber. Never throw stones or sticks over cliffs. They will not travel as far as you thought, and there may be people, or nesting birds or other wildlife, below.

◄ Rock Martin ▼
Hirundo fuligula
(12 - 13 cm) 529

Swallows and martins feed mainly on flying insects, and are therefore swift and agile flyers, often taking insects from plants in passing. At times they form huge flocks, but usually hunt in small groups along cliffs and over grasslands and water. Their almost lazy flight is deceptive, as they easily attain 80 km/hr, and many migrate to Europe each year.

◄ European Swallow ►
Hirundo rustica (20 cm) 518

◄ Redwinged Starling
Onychognathus morio (27 - 29 cm) 769
They are often seen flying along cliffs and steep ground in small family groups, uttering their soft, liquid calls. They feed on fruit, invertebrates and aloe nectar, and have become very tame where people have made food available.

(M)

(F)

◄ Rock Pigeon ►
Columba guinea (33 cm) 349
These large, handsome pigeons are very powerful, fast fliers. They can often be seen, especially toward evening, flying high overhead in large groups. They feed on seeds and grain, and cover vast distances between their roosting and feeding fields.

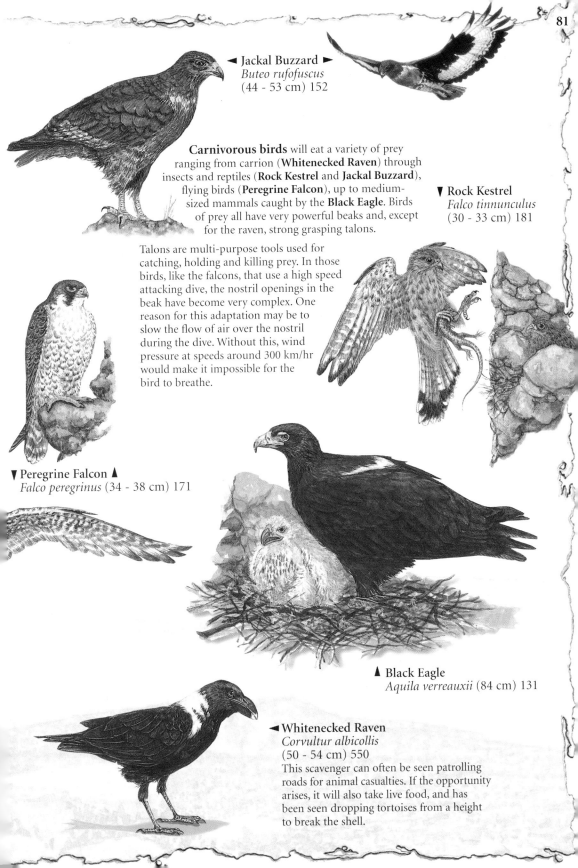

◄ Jackal Buzzard ►
Buteo rufofuscus
(44 - 53 cm) 152

Carnivorous birds will eat a variety of prey ranging from carrion (**Whitenecked Raven**) through insects and reptiles (**Rock Kestrel** and **Jackal Buzzard**), flying birds (**Peregrine Falcon**), up to medium-sized mammals caught by the **Black Eagle**. Birds of prey all have very powerful beaks and, except for the raven, strong grasping talons.

▼ Rock Kestrel
Falco tinnunculus
(30 - 33 cm) 181

Talons are multi-purpose tools used for catching, holding and killing prey. In those birds, like the falcons, that use a high speed attacking dive, the nostril openings in the beak have become very complex. One reason for this adaptation may be to slow the flow of air over the nostril during the dive. Without this, wind pressure at speeds around 300 km/hr would make it impossible for the bird to breathe.

▼ Peregrine Falcon ▲
Falco peregrinus (34 - 38 cm) 171

▲ Black Eagle
Aquila verreauxii (84 cm) 131

◄ Whitenecked Raven
Corvultur albicollis
(50 - 54 cm) 550
This scavenger can often be seen patrolling roads for animal casualties. If the opportunity arises, it will also take live food, and has been seen dropping tortoises from a height to break the shell.

FOREST, GARDENS AND CITY PARKS

These three habitats are quite similar. They have areas of dense, bushy growth surrounded by more open areas. Trees provide shade and shelter, and a protected, secluded and sometimes humid atmosphere. Birds found in one of these areas will probably occur in the others, provided human disturbance is kept to a minimum.

Birds found here are often extremely vocal. Because the vegetation keeps them hidden, not only from the bird watcher but also from each other, they use their calls to keep in touch. Sometimes, what sounds like a single song is actually a duet, performed by a pair of birds.

Many species of birds can be attracted to feeding trays and regularly scattered crumbs. Fruit, sugar water and bone meal will cater for those that don't eat seed. However, if you start feeding, be sure to continue through the winter.

▲ **Sombre Bulbul**
Andropadus importunus (19 - 23 cm) 572
This drably-coloured bulbul is quite vocal and its call, which sounds like 'Willy', usually gives it away. It forages in the densest undergrowth for insects and small fruits, and is difficult to see.

(M)

Paradise Flycatcher ▲
Terpsiphone viridis
(23 - 41 cm) 710

(M)

Forest flycatchers are one of the delights of forest birdwatching. The **Cape Batis** is often difficult to see as it collects insects from leaves and twigs in the dense undergrowth. **Paradise Flycatchers**, breeding migrants from the north, offer a surprising flash of colour in the dimly lit forests. The tiny nest, camouflaged with plant fibres and lichen, and secured to little more than a twig, is well worth searching for.

(F)

◄ **Cape Batis**
Batis capensis (12 - 13 cm) 700

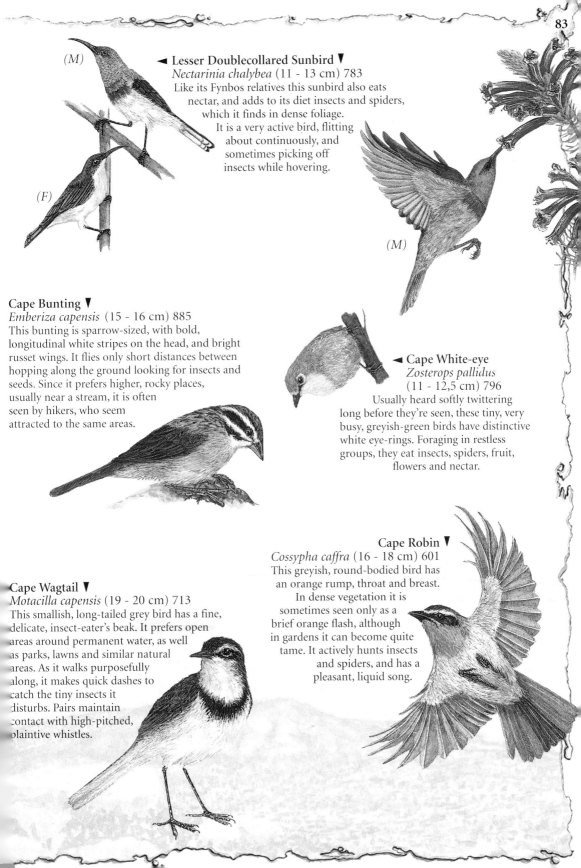

(M)

◄ Lesser Doublecollared Sunbird ▼
Nectarinia chalybea (11 - 13 cm) 783
Like its Fynbos relatives this sunbird also eats
nectar, and adds to its diet insects and spiders,
which it finds in dense foliage.
It is a very active bird, flitting
about continuously, and
sometimes picking off
insects while hovering.

(F)

(M)

Cape Bunting ▼
Emberiza capensis (15 - 16 cm) 885
This bunting is sparrow-sized, with bold,
longitudinal white stripes on the head, and bright
russet wings. It flies only short distances between
hopping along the ground looking for insects and
seeds. Since it prefers higher, rocky places,
usually near a stream, it is often
seen by hikers, who seem
attracted to the same areas.

◄ Cape White-eye
Zosterops pallidus
(11 - 12,5 cm) 796
Usually heard softly twittering
long before they're seen, these tiny, very
busy, greyish-green birds have distinctive
white eye-rings. Foraging in restless
groups, they eat insects, spiders, fruit,
flowers and nectar.

Cape Robin ▼
Cossypha caffra (16 - 18 cm) 601
This greyish, round-bodied bird has
an orange rump, throat and breast.
In dense vegetation it is
sometimes seen only as a
brief orange flash, although
in gardens it can become quite
tame. It actively hunts insects
and spiders, and has a
pleasant, liquid song.

Cape Wagtail ▼
Motacilla capensis (19 - 20 cm) 713
This smallish, long-tailed grey bird has a fine,
delicate, insect-eater's beak. It prefers open
areas around permanent water, as well
as parks, lawns and similar natural
areas. As it walks purposefully
along, it makes quick dashes to
catch the tiny insects it
disturbs. Pairs maintain
contact with high-pitched,
plaintive whistles.

OPEN FIELDS, FARMLANDS AND GRASSLANDS

This habitat is exposed and generally unprotected. Birds living here are well camouflaged, have keen eyesight, and often gather in significant numbers. Nests, whether simple hollows on the ground or elaborate constructions in trees or bushes, are all strongly defended by ever-watchful parents.

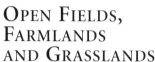

If birds become very excited by your presence, they probably have a nest nearby. Move away, rather than cause stress for the parents and endanger the eggs or chicks.

◀ **Cape Weaver**
Ploceus capensis
(17 - 18 cm) 813
These weavers move in small groups as they seek both seeds and insects. They are noisy and quite aggressive, and both characteristics become more intense in the breeding season. Their woven hanging nests are an engineering wonder.

(M)

Helmeted Guineafowl ▶
Numida meleagris (53 - 58 cm) 203
The fowl-sized, white-speckled guineafowl prefers to spend its time on the ground. Highly gregarious, the noisy groups frequent open areas where they scratch for seeds, bulbs and tubers. They are very wary, but will fly strongly when disturbed, although not far.

Plovers are extremely vocal when disturbed. These fairly large, long-legged, ground-loving birds hunt worms and insects in a variety of habitats. The **Blacksmith Plover** prefers moist grasslands and the shores of dams and vleis. **Crowned Plovers** prefer drier areas, from burnt or dry veld to semi-desert. Both will raucously dive-bomb any intruders that approach too near their nests.

▲ **Blacksmith Plover**
Vanellus armatus
(30 cm) 258

Crowned Plover ▶
Stephanibyx coronatus
(30 cm) 255

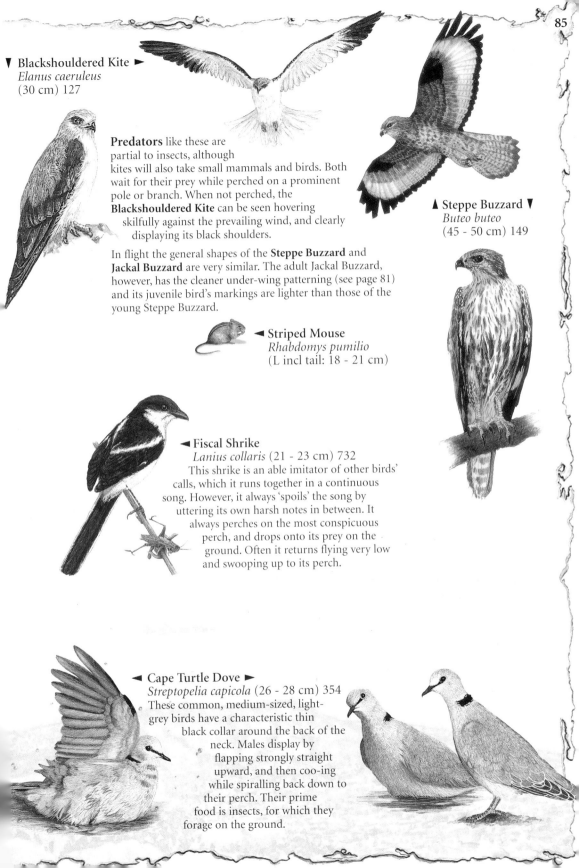

▼ Blackshouldered Kite ►
Elanus caeruleus
(30 cm) 127

Predators like these are partial to insects, although kites will also take small mammals and birds. Both wait for their prey while perched on a prominent pole or branch. When not perched, the **Blackshouldered Kite** can be seen hovering skilfully against the prevailing wind, and clearly displaying its black shoulders.

In flight the general shapes of the **Steppe Buzzard** and **Jackal Buzzard** are very similar. The adult Jackal Buzzard, however, has the cleaner under-wing patterning (see page 81) and its juvenile bird's markings are lighter than those of the young Steppe Buzzard.

▲ Steppe Buzzard ▼
Buteo buteo
(45 - 50 cm) 149

◄ Striped Mouse
Rhabdomys pumilio
(L incl tail: 18 - 21 cm)

◄ Fiscal Shrike
Lanius collaris (21 - 23 cm) 732
This shrike is an able imitator of other birds' calls, which it runs together in a continuous song. However, it always 'spoils' the song by uttering its own harsh notes in between. It always perches on the most conspicuous perch, and drops onto its prey on the ground. Often it returns flying very low and swooping up to its perch.

◄ Cape Turtle Dove ►
Streptopelia capicola (26 - 28 cm) 354
These common, medium-sized, light-grey birds have a characteristic thin black collar around the back of the neck. Males display by flapping strongly straight upward, and then coo-ing while spiralling back down to their perch. Their prime food is insects, for which they forage on the ground.

WATER BIRDS

Permanent expanses of fresh water nearly always have luxuriant vegetation growing on their banks. This growth, together with the food available from both the water and the surroundings, makes an ideal and pleasant bird habitat.

MARSH AND VLEIS

These habitats are permanently flooded areas where shallow water, vegetation and/or mud are the dominant features. Most birds that live here need long legs, and beaks suitable for probing mud or plucking food from relatively shallow water.

The best way to see birds around marshes and pans is either to conceal yourself or to sit very still. Binoculars and/or telescopes are almost essential. Wear suitable shoes if you intend walking around.

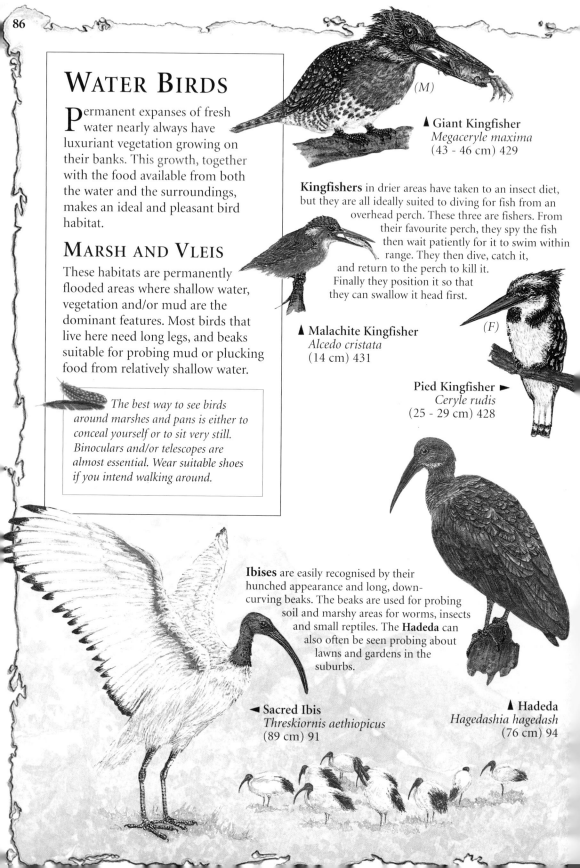

(M)

▲ **Giant Kingfisher**
Megaceryle maxima
(43 - 46 cm) 429

Kingfishers in drier areas have taken to an insect diet, but they are all ideally suited to diving for fish from an overhead perch. These three are fishers. From their favourite perch, they spy the fish then wait patiently for it to swim within range. They then dive, catch it, and return to the perch to kill it. Finally they position it so that they can swallow it head first.

▲ **Malachite Kingfisher**
Alcedo cristata
(14 cm) 431

(F)

Pied Kingfisher ►
Ceryle rudis
(25 - 29 cm) 428

Ibises are easily recognised by their hunched appearance and long, down-curving beaks. The beaks are used for probing soil and marshy areas for worms, insects and small reptiles. The **Hadeda** can also often be seen probing about lawns and gardens in the suburbs.

◄ **Sacred Ibis**
Threskiornis aethiopicus
(89 cm) 91

▲ **Hadeda**
Hagedashia hagedash
(76 cm) 94

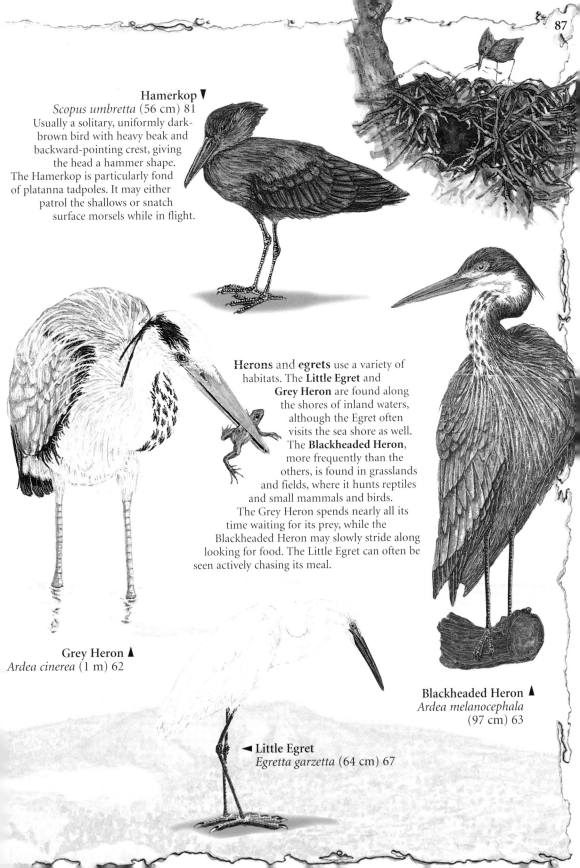

Hamerkop ▼
Scopus umbretta (56 cm) 81
Usually a solitary, uniformly dark-
brown bird with heavy beak and
backward-pointing crest, giving
the head a hammer shape.
The Hamerkop is particularly fond
of platanna tadpoles. It may either
patrol the shallows or snatch
surface morsels while in flight.

Herons and **egrets** use a variety of
habitats. The **Little Egret** and
Grey Heron are found along
the shores of inland waters,
although the Egret often
visits the sea shore as well.
The **Blackheaded Heron**,
more frequently than the
others, is found in grasslands
and fields, where it hunts reptiles
and small mammals and birds.
The Grey Heron spends nearly all its
time waiting for its prey, while the
Blackheaded Heron may slowly stride along
looking for food. The Little Egret can often be
seen actively chasing its meal.

Grey Heron ▲
Ardea cinerea (1 m) 62

Blackheaded Heron ▲
Ardea melanocephala
(97 cm) 63

◀ **Little Egret**
Egretta garzetta (64 cm) 67

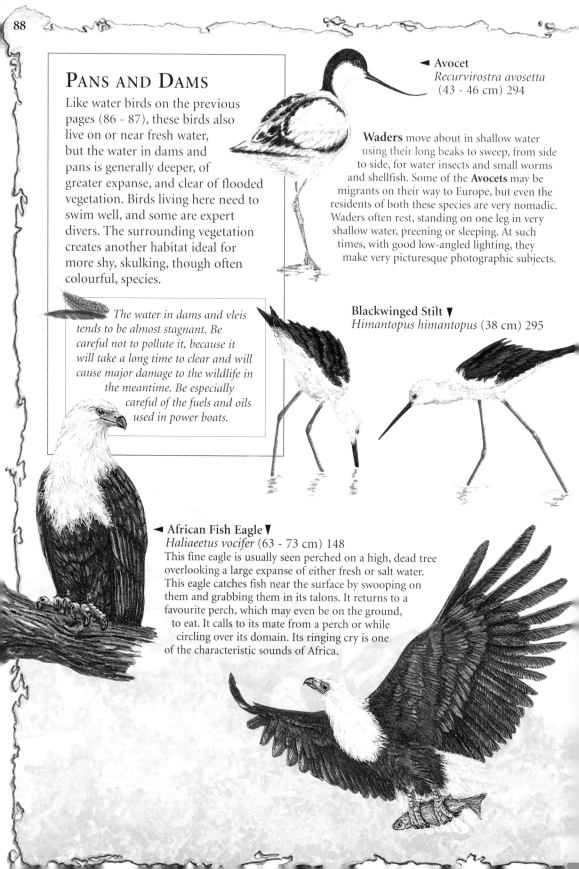

PANS AND DAMS

Like water birds on the previous pages (86 - 87), these birds also live on or near fresh water, but the water in dams and pans is generally deeper, of greater expanse, and clear of flooded vegetation. Birds living here need to swim well, and some are expert divers. The surrounding vegetation creates another habitat ideal for more shy, skulking, though often colourful, species.

The water in dams and vleis tends to be almost stagnant. Be careful not to pollute it, because it will take a long time to clear and will cause major damage to the wildlife in the meantime. Be especially careful of the fuels and oils used in power boats.

◀ **Avocet**
Recurvirostra avosetta
(43 - 46 cm) 294

Waders move about in shallow water using their long beaks to sweep, from side to side, for water insects and small worms and shellfish. Some of the **Avocets** may be migrants on their way to Europe, but even the residents of both these species are very nomadic. Waders often rest, standing on one leg in very shallow water, preening or sleeping. At such times, with good low-angled lighting, they make very picturesque photographic subjects.

Blackwinged Stilt ▼
Himantopus himantopus (38 cm) 295

◀ **African Fish Eagle** ▼
Haliaeetus vocifer (63 - 73 cm) 148
This fine eagle is usually seen perched on a high, dead tree overlooking a large expanse of either fresh or salt water. This eagle catches fish near the surface by swooping on them and grabbing them in its talons. It returns to a favourite perch, which may even be on the ground, to eat. It calls to its mate from a perch or while circling over its domain. Its ringing cry is one of the characteristic sounds of Africa.

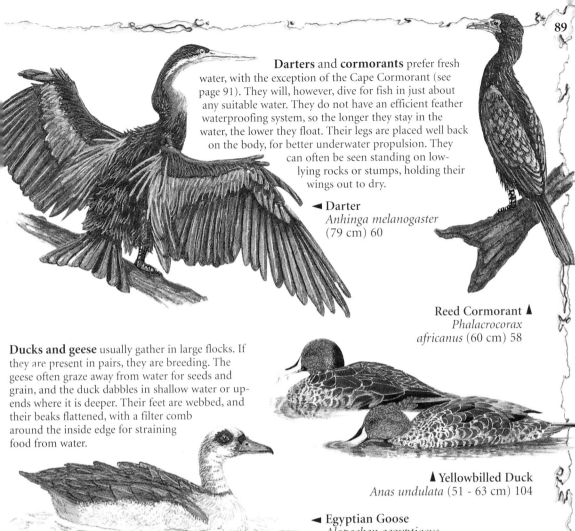

Darters and **cormorants** prefer fresh water, with the exception of the Cape Cormorant (see page 91). They will, however, dive for fish in just about any suitable water. They do not have an efficient feather waterproofing system, so the longer they stay in the water, the lower they float. Their legs are placed well back on the body, for better underwater propulsion. They can often be seen standing on low-lying rocks or stumps, holding their wings out to dry.

◄ **Darter**
Anhinga melanogaster
(79 cm) 60

Reed Cormorant ▲
Phalacrocorax africanus (60 cm) 58

Ducks and geese usually gather in large flocks. If they are present in pairs, they are breeding. The geese often graze away from water for seeds and grain, and the duck dabbles in shallow water or up-ends where it is deeper. Their feet are webbed, and their beaks flattened, with a filter comb around the inside edge for straining food from water.

▲ **Yellowbilled Duck**
Anas undulata (51 - 63 cm) 104

◄ **Egyptian Goose**
Alopochen aegyptiacus
(63 - 73 cm) 102

Dabchick (Little Grebe) ▼
Tachybaptus ruficollis (20 cm) 8
The Dabchick's small size and round shape give it the appearance of other species' young. It dives well, and can cover 50 metres or more underwater, hunting for frogs and small fish. It often flaps its wings, raising itself very high in the water, then settling back with a vigorous body-shake.

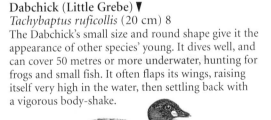

▲ **Redknobbed Coot**
Fulica cristata (43 cm) 228
These very common birds can be seen on many of South Africa's inland waters. They usually dabble, or dive, for plant food, often bringing it to the surface in their beaks. Individuals chase each other by running on the surface of the water on their partially webbed, over-sized feet.

SEASHORE

The shore offers many habitats to many different species. The birds of the shore have devised their own ways of exploiting these rich food sources. The gulls and terns are usually the most obvious, but the waders are often the more industrious. When the divers are fishing in numbers, they provide the greatest spectacle.

Fishermen should not leave their line, hooks, sinkers or plastic bags lying around. If birds and other animals become entangled in discarded fishing tackle, it will probably endanger their lives. They have enough natural hazards to contend with without people introducing any more.

Cape Gannet ▲
Morus capensis (84 - 94 cm) 53
This large, predominantly white, beautifully streamlined seabird fishes in deep water. From the shore, large flocks can often be seen plunging for fish from great heights. Like many other birds and predatory fish, it follows the 'sardine run' up the east coast of South Africa each year.

◀ **Jackass Penguin** ▶
Spheniscus demersus (60 cm) 3
Penguins are ungainly and vulnerable on land, but they swim strongly, swiftly and gracefully. They sleep ashore, and fish at sea between dawn and dusk, usually covering great distances. This species is named for its noisy, donkey-like braying. It is a threatened species, due to excessive commercial fishing reducing its food supply. (See grid pages 13 and 29).

Seashore waders are found in both the rocky and sandy zones along the shore. Because the shore is particularly rich in food, other less common waders may use even more specialised food sources. The threatened and endangered **African Black Oystercatcher**, as its name implies, prefers mussels, limpets, whelks and worms, while the **Whimbrel**, a visiting migrant, probes the sand for buried shellfish.

▲ **African Black Oystercatcher**
Haematopus moquini
(41 cm) 244

Whimbrel ▲
Numenius phaeopus (43 cm) 29(

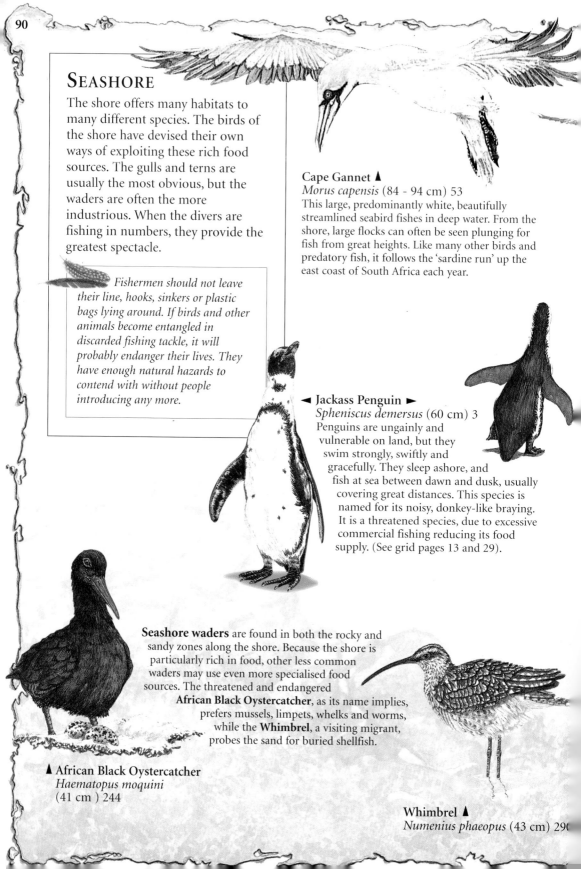

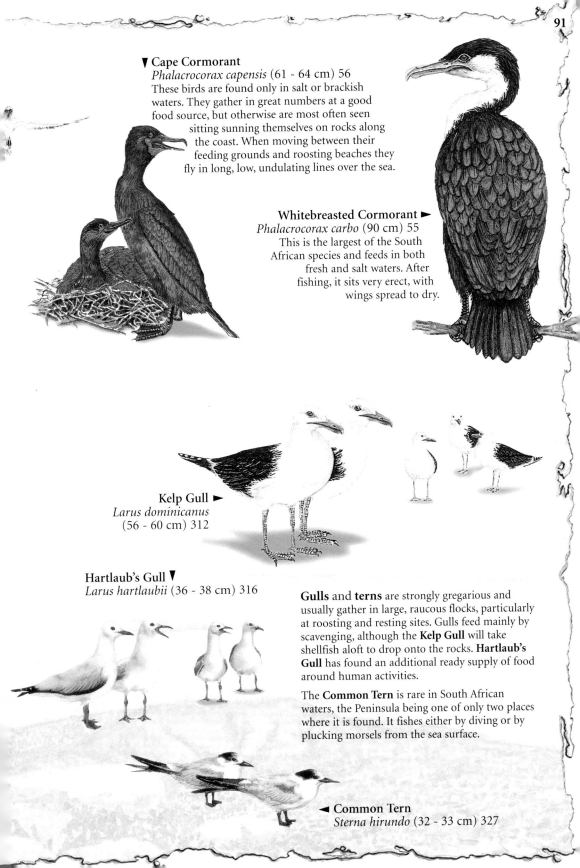

▼ **Cape Cormorant**
Phalacrocorax capensis (61 - 64 cm) 56
These birds are found only in salt or brackish
waters. They gather in great numbers at a good
food source, but otherwise are most often seen
sitting sunning themselves on rocks along
the coast. When moving between their
feeding grounds and roosting beaches they
fly in long, low, undulating lines over the sea.

Whitebreasted Cormorant ►
Phalacrocorax carbo (90 cm) 55
This is the largest of the South
African species and feeds in both
fresh and salt waters. After
fishing, it sits very erect, with
wings spread to dry.

Kelp Gull ►
Larus dominicanus
(56 - 60 cm) 312

Hartlaub's Gull ▼
Larus hartlaubii (36 - 38 cm) 316

Gulls and **terns** are strongly gregarious and
usually gather in large, raucous flocks, particularly
at roosting and resting sites. Gulls feed mainly by
scavenging, although the **Kelp Gull** will take
shellfish aloft to drop onto the rocks. **Hartlaub's
Gull** has found an additional ready supply of food
around human activities.

The **Common Tern** is rare in South African
waters, the Peninsula being one of only two places
where it is found. It fishes either by diving or by
plucking morsels from the sea surface.

◄ **Common Tern**
Sterna hirundo (32 - 33 cm) 327

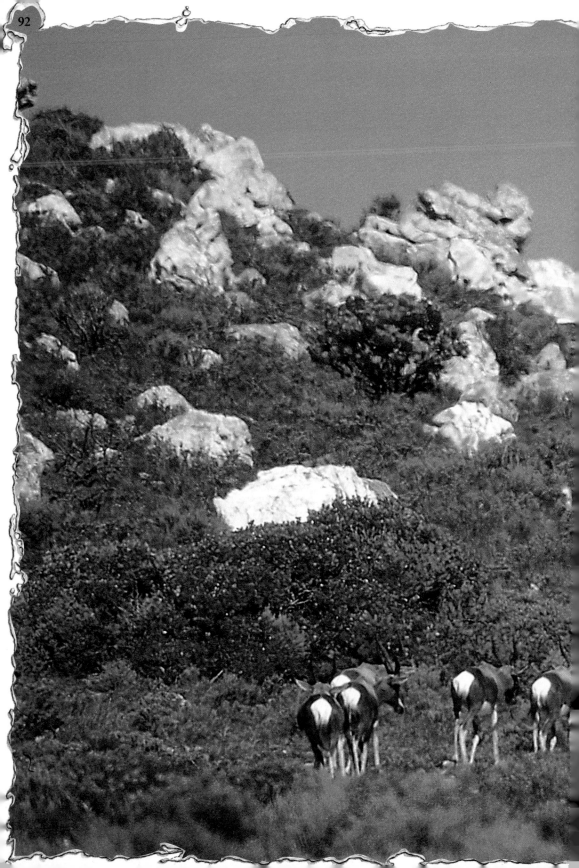

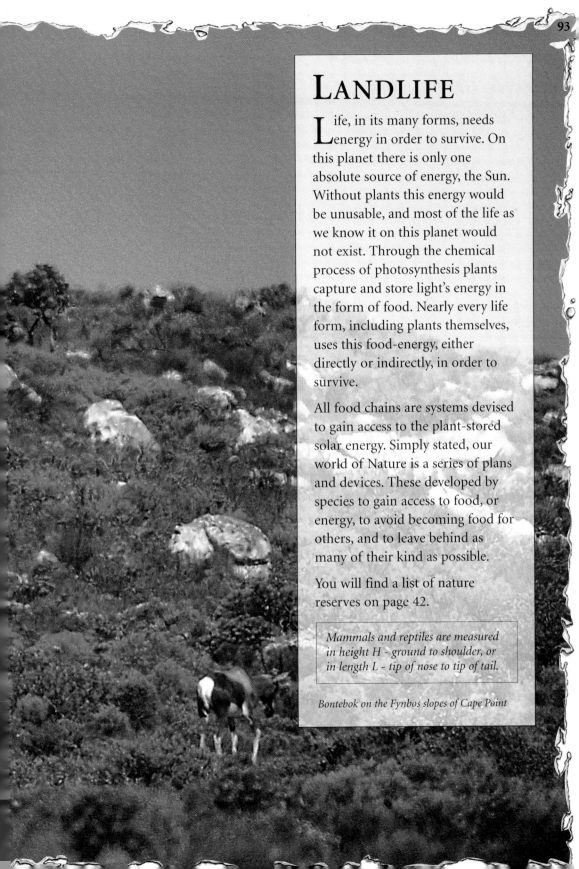

LANDLIFE

Life, in its many forms, needs energy in order to survive. On this planet there is only one absolute source of energy, the Sun. Without plants this energy would be unusable, and most of the life as we know it on this planet would not exist. Through the chemical process of photosynthesis plants capture and store light's energy in the form of food. Nearly every life form, including plants themselves, uses this food-energy, either directly or indirectly, in order to survive.

All food chains are systems devised to gain access to the plant-stored solar energy. Simply stated, our world of Nature is a series of plans and devices. These developed by species to gain access to food, or energy, to avoid becoming food for others, and to leave behind as many of their kind as possible.

You will find a list of nature reserves on page 42.

Mammals and reptiles are measured in height H - ground to shoulder, or in length L - tip of nose to tip of tail.

Bontebok on the Fynbos slopes of Cape Point

MAMMALS

The plant eaters extract food from plants, with the help of cellulose-breaking bacteria in their stomachs. Their digestion is not efficient, and plant eaters must feed almost continuously in order to take in sufficient quantities of plant material.

Extracted food-energy, stored by an animal, becomes available to animals in the next link of the food chain. These are usually the meat-eaters. There is also that group of opportunist feeders capable of deriving benefit from both plants and meat, the omnivores.

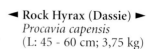

◄ **Rock Hyrax (Dassie)** ►
Procavia capensis
(L: 45 - 60 cm; 3,75 kg)

Herbivores are animals that eat plants. They are the primary consumers. Plants produce a very tough fibre called cellulose. In order to digest it, an animal requires a very specialised digestive system, and a lot of food. Some animals specialise, like the **Striped Mouse**, which eats mainly seeds; and the **Porcupine**, which digs up tubers and bulbs at night. The **Rock Hyrax** eats a very wide range of plant parts, from the bark to the leaves, twigs and fruit.

Striped Mouse ▲
Rhabdomys pumilio
(L incl tail: 18 - 21 cm;
32 - 55 g)

◄ **Porcupine**
Hystrix africaeaustralis
(L: 75 cm; 15 kg)

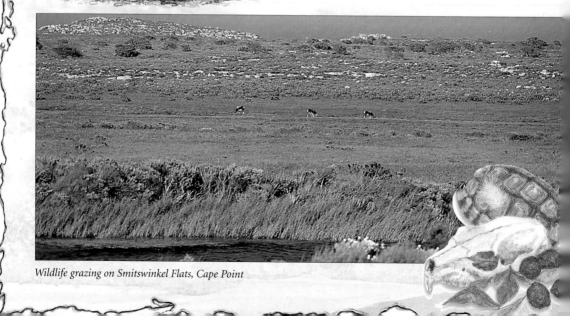

Wildlife grazing on Smitswinkel Flats, Cape Point

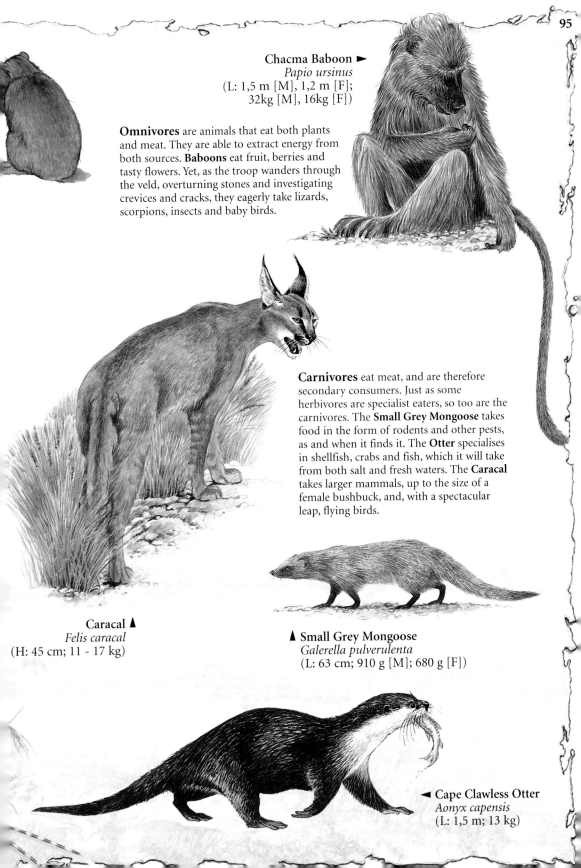

Chacma Baboon ►
Papio ursinus
(L: 1,5 m [M], 1,2 m [F];
32kg [M], 16kg [F])

Omnivores are animals that eat both plants and meat. They are able to extract energy from both sources. **Baboons** eat fruit, berries and tasty flowers. Yet, as the troop wanders through the veld, overturning stones and investigating crevices and cracks, they eagerly take lizards, scorpions, insects and baby birds.

Carnivores eat meat, and are therefore secondary consumers. Just as some herbivores are specialist eaters, so too are the carnivores. The **Small Grey Mongoose** takes food in the form of rodents and other pests, as and when it finds it. The **Otter** specialises in shellfish, crabs and fish, which it will take from both salt and fresh waters. The **Caracal** takes larger mammals, up to the size of a female bushbuck, and, with a spectacular leap, flying birds.

Caracal ▲
Felis caracal
(H: 45 cm; 11 - 17 kg)

▲ Small Grey Mongoose
Galerella pulverulenta
(L: 63 cm; 910 g [M]; 680 g [F])

◄ Cape Clawless Otter
Aonyx capensis
(L: 1,5 m; 13 kg)

GRAZERS AND BROWSERS

All animals are specialists, and among those that eat only plants are the browsers of leaves, and the grass grazers. Certain grazers (like the Mountain Zebra) prefer long grass. Others, like the Red Hartebeest, are grazers of short grass. This is why zebra and hartebeest (or, in other areas, wildebeest) are often found grazing together, sharing the same grazing ground. This specialisation spreads the load of providing food more evenly over the various plant types.

Grazers will often graze in one area for some time. Browsers tend to move through an area more quickly. Many browsed bushes can increase their levels of tannin. Because tannin is bitter, browsers keep moving, and do not over-browse the plants.

Steenbok ►
Raphicerus campestris
(H: 50 cm; 11 kg)

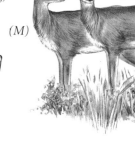

(F)

(M)

◄ Grysbok
Raphicerus melanotis
(H: 50 cm; 10 kg)

Browsers eat only the leaves of trees and bushes, and are also specially adapted to their chosen habitats. The **Steenbok** is active during the day, and more widely spread than its relative the Grysbok. It is a highly selective browser, feeding only on young, tender, green shoots, flowers and fruit. The **Grysbok** is a nocturnal browser, and endemic to the southern and south-western Cape. **Eland** are the world's largest antelope and can be totally independent of water. They allow their temperature to rise during the day by not sweating, and then browse at night when plants contain maximum water. The **Grey Rhebok** can also, if need be, derive all its water requirements from its leaf diet.

(F)

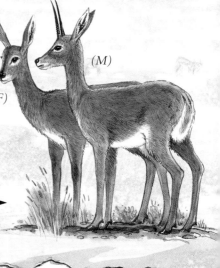

(M)

(F)

Eland ▲
Taurotragus oryx livingstonii
(H: 1,7 m [M], 1,5 m [F];
650 kg [M], 460 kg [F])

Grey Rhebok ►
Pelea capreolus
(H: 75 cm; 20 kg)

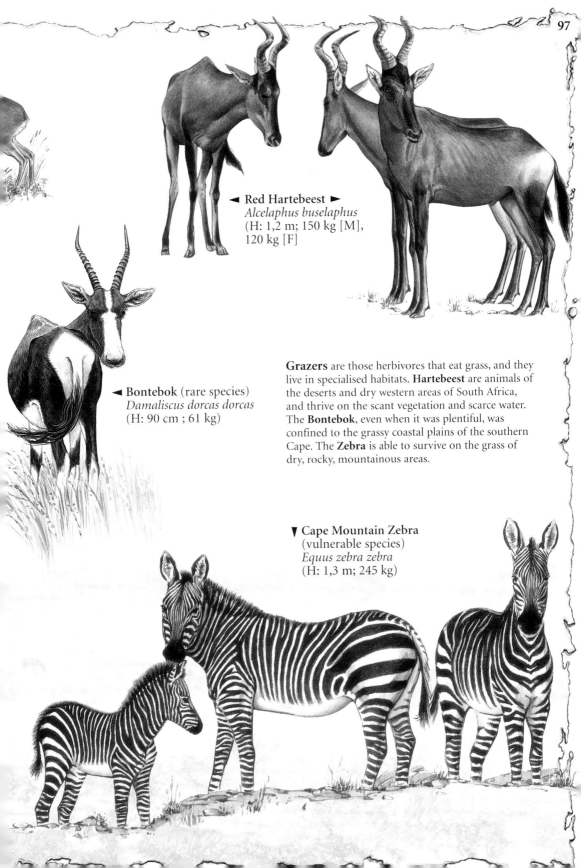

◄ **Red Hartebeest** ►
Alcelaphus buselaphus
(H: 1,2 m; 150 kg [M],
120 kg [F]

◄ **Bontebok** (rare species)
Damaliscus dorcas dorcas
(H: 90 cm ; 61 kg)

Grazers are those herbivores that eat grass, and they live in specialised habitats. **Hartebeest** are animals of the deserts and dry western areas of South Africa, and thrive on the scant vegetation and scarce water. The **Bontebok**, even when it was plentiful, was confined to the grassy coastal plains of the southern Cape. The **Zebra** is able to survive on the grass of dry, rocky, mountainous areas.

▼ **Cape Mountain Zebra**
(vulnerable species)
Equus zebra zebra
(H: 1,3 m; 245 kg)

REPTILES AND AMPHIBIANS

(M)

Unlike mammals and birds, reptiles' body temperature is usually that of their surroundings. They, together with fish and amphibians, are 'cold blooded'. During winter they may even hibernate in order to conserve body reserves. Prior to hunting they need to raise their body temperature in order to become sufficiently active. Lying in a sunny spot or draped over a sun-drenched rock is thus an essential pastime.

> A snake's tongue is not poisonous, nor can it 'sting'. They investigate their surroundings by smelling with their tongues.

▲ **Southern Rock Agama ▼**
Agama atra (20 - 25 cm)
During the breeding season, males of this large, spiny lizard develop an ultramarine head, throat and belly. They may be able to subdue this colouring when danger threatens. A male's territory will include the home ranges of several females. The Agama feeds predominantly on ants and termites.

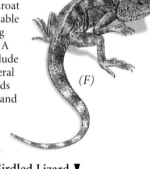

(F)

Cape Girdled Lizard ▼
Cordylus niger (13 - 19 cm)
This lizard has well-clawed feed and 'hands' and a heavily-spined tail. A totally black sub-species is found in the Cape Peninsula National Park. Its triangular head, flattened body and distinct, shiny black scales give it a decidedly prehistoric appearance. Plentiful and quite tame, it spends its time waiting for insects, and sunbathing.

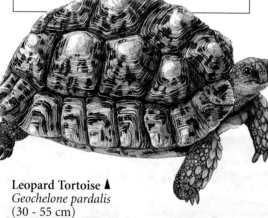

Leopard Tortoise ▲
Geochelone pardalis
(30 - 55 cm)
This is the largest and widest-ranging tortoise in southern Africa. However, it is not indigenous to the southern peninsula, although many have been introduced there. Males actively defend their females against other males. The buried eggs hatch after four to fourteen months, when the young dig their way out, usually after ground-softening rain.

▼ Angulate Tortoise
Chersina angulata (15 - 25 cm)
Individuals that occur toward Cape Point are coloured red below, a condition that may be habitat related. Mainly vegetarians, they will also partake of the occasional small corpse. Males are aggressive, and often attempt to overturn other males during disputes over females. Incubation period varies from three to seven months.

Tortoises can withdraw their heads into their shells, because their necks can bend into a tight S-shape. Once the head is withdrawn, the front feet safely block the opening. Hind feet are padded, and their front feet are armoured. Southern Africa has the greatest variety of tortoises, including the world's smallest species.

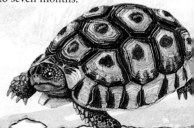

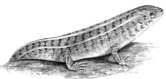

Cape Skink ▲
Mabuya capensis (20 - 25 cm)
This fat, smooth, shiny-brown 'lizard' has three pale stripes running along its body. Unlike many other reptiles, it has moveable eyelids. Its long toes and fingers all have distinct claws, and it eats insects. Depending on prevailing conditions, it can either lay eggs or give birth to live young.

Sand Rain Frog ▼
Breviceps rosei (25 mm)
Slightly bigger than a man's thumbnail, this large-eyed, podgy little frog lives in its own tunnels beneath sand dunes or Fynbos. The series of 'cheeps' uttered by the difficult-to-see male is a sound heard often throughout the region.

Puffadder ▼
Bitis arietans (60 cm - 1 m)
This is the most widely distributed venomous snake in Africa. Its sluggishness and excellent camouflage contribute to the frequency with which it is encountered, especially by hikers and walkers. When hunting, it bites and immediately releases its prey. It then follows the dying animal, to swallow it later at leisure.

Spotted Skaapsteker ▼
Psammophylax rhombeatus (80 - 90 cm)
This colourful snake actively pursues lizards, frogs, rodents, birds and other snakes. The female may lay up to 30 eggs. She then wraps her coils around the eggs to guard and protect them until they hatch.

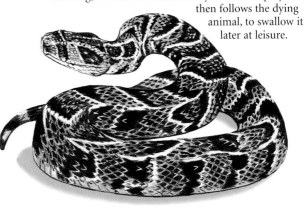

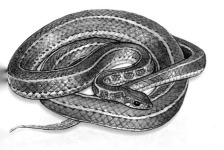

Snakes contribute enormously to preserving a healthy and vital environment. Always be aware of where you place your feet, and what you may disturb. Should you come across a snake, stand still and allow it to go on its way. There are no naturally aggressive snakes.

Cape Cobra ►
Naja nivea (1 - 2 m)
This snake is extremely dangerous when it feels threatened, though given the chance it would rather escape. It carries a venom potentially lethal to humans. In defence it may spread its hood, advance and strike. Colour varies from yellow to deep mustard, although it always looks shiny and plastic. It hunts rodents and toads by day, and prefers arid habitats.

WATERBASED

Frogs and toads usually lay eggs that do not have a tough, protective, waterproof shell. To keep them moist, they are laid in water, and most adults remain largely dependent on water. These more common amphibians can be recognised by their squat appearance and strong hind legs, adapted to swimming and jumping.

Eggs hatch into small fish-like creatures that, when disturbed, frantically wriggle their way around the pond or stream. They eventually change into adults, covered in a sticky, distasteful mucus that helps to keep their skin moist when they are out of water.

Frogs and toads do not cause warts if they are touched. Although the slime covering some of the brightly coloured ones is poisonous, it is dangerous only if eaten.

◄ **Arum Lily Frog**
Hyperocus horstockii
(35 mm)

Marsh frogs find marshes, which offer many hiding places and lots of water, ideal habitats. **Arum Lily Frogs** have adapted to living in Arum Lilies (see page 70), which often grow in marshes. On an Arum, the frog's colour becomes whiter and the pink-coloured legs are kept well tucked in. The **Common Caco** calls from the base of vegetation near very shallow water. For this reason it enjoys marshy wetlands or recently inundated grasslands. Cacos are very abundant, particularly after rains.

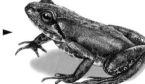

Common Caco ►
Cacosternum boettgeri
(21 mm)

◄ **Cape Chirping Frog**
Arthroleptella lightfootii (20 mm)
Little bigger than a finger nail, this fellow produces a mysterious, cricket-like chirp from beneath moss, dead vegetable matter or a mud cavity. Eggs are laid on moss, and tadpoles complete most of their development, in the eggs, before hatching.

Tadpole stage

◄ **Common Platanna** ►
Xenopus laevis (70 mm)
This aquatic frog has neither eyelids, ears nor tongue, and in order to swallow draws its eyes back into its head, to push the food into the throat. From young, it will eat anything it can manage including worms, fish, tadpoles and even other frogs. The Cape Platanna (60 mm) is a rare and endangered relative, confined mainly to the Cape Peninsula National Park. It lives in dark, acidic ponds and is more distinctly patterned.

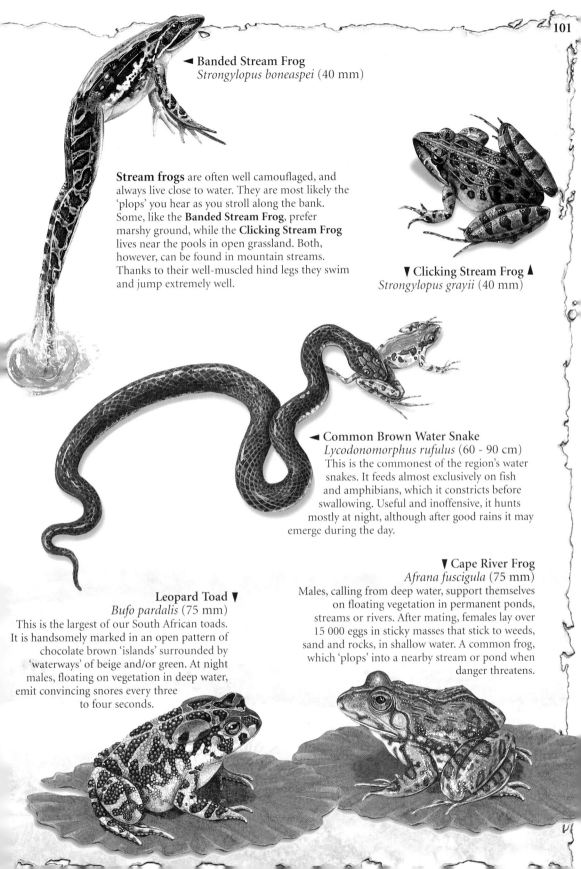

◄ **Banded Stream Frog**
Strongylopus boneaspei (40 mm)

Stream frogs are often well camouflaged, and always live close to water. They are most likely the 'plops' you hear as you stroll along the bank. Some, like the **Banded Stream Frog**, prefer marshy ground, while the **Clicking Stream Frog** lives near the pools in open grassland. Both, however, can be found in mountain streams. Thanks to their well-muscled hind legs they swim and jump extremely well.

▼ **Clicking Stream Frog** ▲
Strongylopus grayii (40 mm)

◄ **Common Brown Water Snake**
Lycodonomorphus rufulus (60 - 90 cm)
This is the commonest of the region's water snakes. It feeds almost exclusively on fish and amphibians, which it constricts before swallowing. Useful and inoffensive, it hunts mostly at night, although after good rains it may emerge during the day.

▼ **Cape River Frog**
Afrana fuscigula (75 mm)
Males, calling from deep water, support themselves on floating vegetation in permanent ponds, streams or rivers. After mating, females lay over 15 000 eggs in sticky masses that stick to weeds, sand and rocks, in shallow water. A common frog, which 'plops' into a nearby stream or pond when danger threatens.

Leopard Toad ▼
Bufo pardalis (75 mm)
This is the largest of our South African toads. It is handsomely marked in an open pattern of chocolate brown 'islands' surrounded by 'waterways' of beige and/or green. At night males, floating on vegetation in deep water, emit convincing snores every three to four seconds.

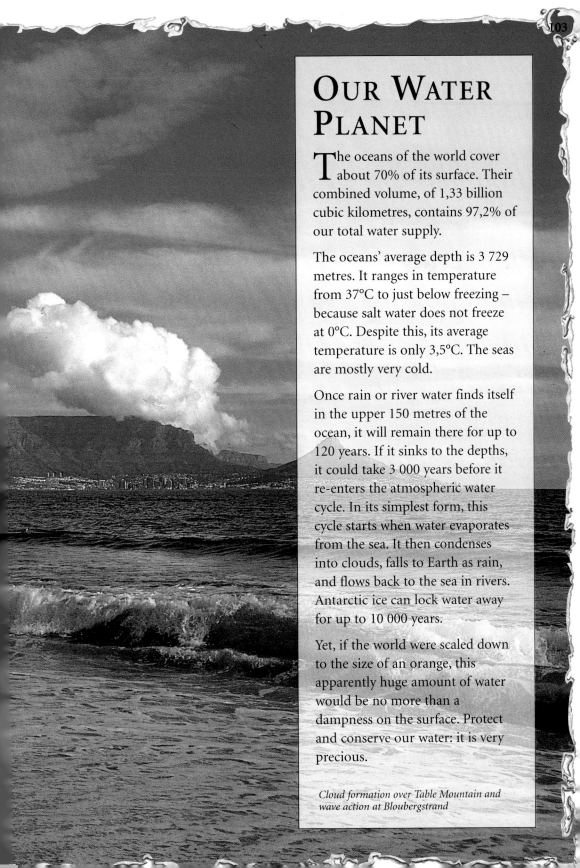

OUR WATER PLANET

The oceans of the world cover about 70% of its surface. Their combined volume, of 1,33 billion cubic kilometres, contains 97,2% of our total water supply.

The oceans' average depth is 3 729 metres. It ranges in temperature from 37°C to just below freezing – because salt water does not freeze at 0°C. Despite this, its average temperature is only 3,5°C. The seas are mostly very cold.

Once rain or river water finds itself in the upper 150 metres of the ocean, it will remain there for up to 120 years. If it sinks to the depths, it could take 3 000 years before it re-enters the atmospheric water cycle. In its simplest form, this cycle starts when water evaporates from the sea. It then condenses into clouds, falls to Earth as rain, and flows back to the sea in rivers. Antarctic ice can lock water away for up to 10 000 years.

Yet, if the world were scaled down to the size of an orange, this apparently huge amount of water would be no more than a dampness on the surface. Protect and conserve our water: it is very precious.

Cloud formation over Table Mountain and wave action at Bloubergstrand

OCEANOGRAPHY

The sea around the Peninsula is a place of complex currents, and nowhere else on Earth are two major ocean currents separated by such a narrow peninsula. On the west side of this strip of land lies the cold Atlantic Ocean, where the local water temperature averages about 9°C. The water in False Bay, on the eastern side, is somewhat warmer, and can at times reach 15°C.

The Peninsula's Atlantic coastal waters are cooled by the slow, northward movement of the Benguela Current that originates off the continent of Antarctica. The warmer waters of False Bay are brought by the Indian Ocean's Agulhas Current, a huge marine river that flows down the eastern and southern coasts of South Africa. Because of this warmer water, many more fish species occur in False Bay than off the Peninsula's cold, Atlantic, west coast.

Currents southern Af

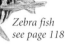

Zebra fish see page 118

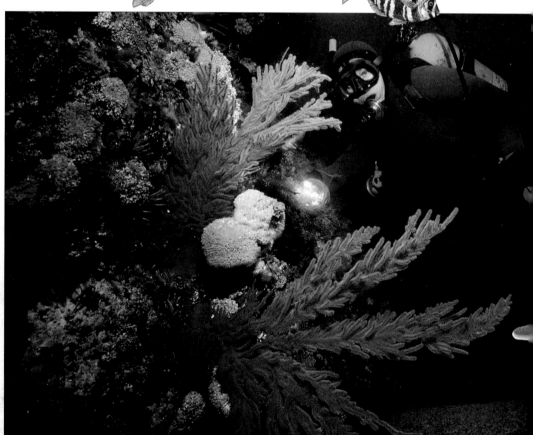

Diverse sealife in False Bay

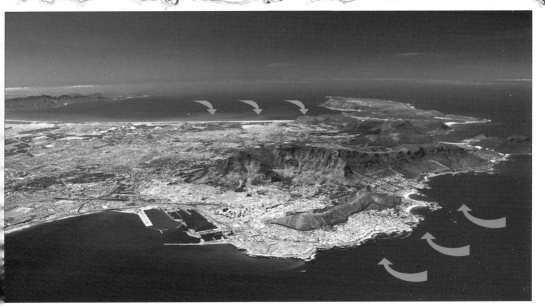

Down-welling in False Bay and up-welling off the west coast

The movement of these two huge bodies of water along the coasts produces two more important phenomena. Down-welling and up-welling regulate and control the animal life in these seas. They are at their most noticeable, and strongest, when the summer South-Easter blows.

Down-welling occurs when the wind blows warmer water from the Indian Ocean against the southern Cape coast, and into False Bay. This brings unusually warm, surface water and some deep-water fish much closer in-shore, and accounts for the good angling in False Bay. As it encounters the coast this wind-blown surface water is forced to down-well, or 'dive', against the coast in order to return to the ocean along the bottom.

Off the Peninsula's west coast in the colder Atlantic Ocean, the same south-east wind moves surface water away from the land and out to sea. Very cold water is then able to rise, or well up, from the depths, causing surface temperatures to plummet. This water is particularly clear and sparkling, and very rich in the nutriments it collected along the bottom.

Red Starfish see page 113

During those times when up-welling occurs only for short periods, and remains gentle, the system remains in balance. However, when excessive amounts of nutriments are raised for prolonged periods, microscopic marine plants (algae) over-multiply, become toxic, and are visible as a 'red tide'. At such times, shellfish consume these plants in excessive numbers and accumulate the toxins in their flesh. They are then poisonous themselves, and must not be eaten. The algae also reduce the amount of oxygen dissolved in the water, thereby causing other sea animals and plants to suffocate and die.

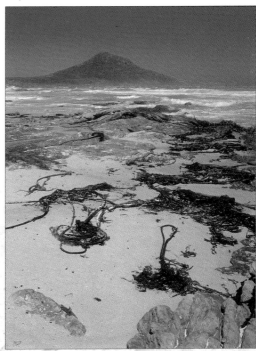

Kelp at Platboom, Cape Point

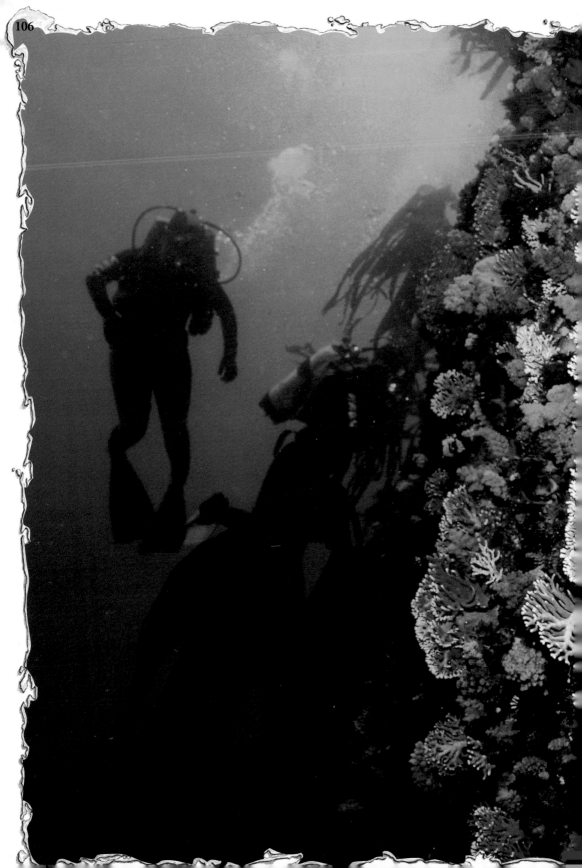

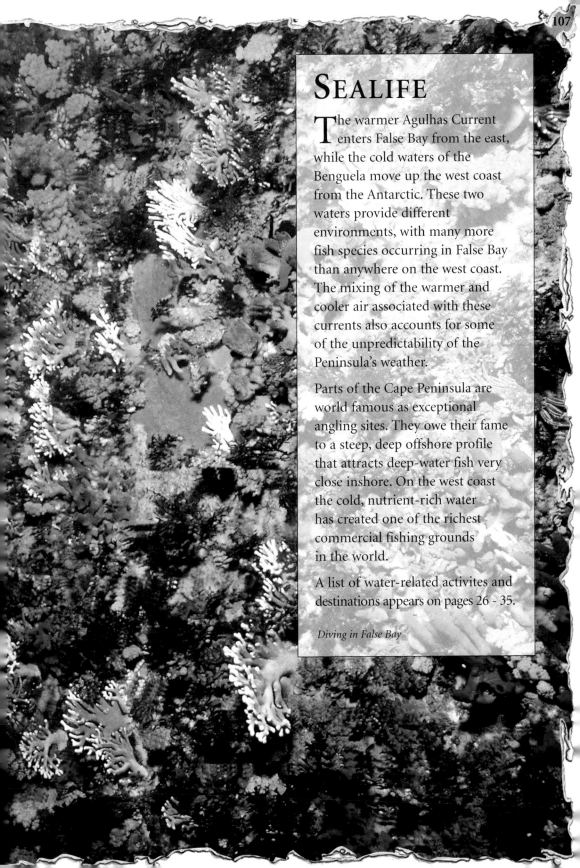

SEALIFE

The warmer Agulhas Current enters False Bay from the east, while the cold waters of the Benguela move up the west coast from the Antarctic. These two waters provide different environments, with many more fish species occurring in False Bay than anywhere on the west coast. The mixing of the warmer and cooler air associated with these currents also accounts for some of the unpredictability of the Peninsula's weather.

Parts of the Cape Peninsula are world famous as exceptional angling sites. They owe their fame to a steep, deep offshore profile that attracts deep-water fish very close inshore. On the west coast the cold, nutrient-rich water has created one of the richest commercial fishing grounds in the world.

A list of water-related activites and destinations appears on pages 26 - 35.

Diving in False Bay

THE DRIFTLINE

The driftline is where the sea offers tantalising glimpses into the lives of its creatures, both living and dead. Some finds become common, while others are rare, but all will yield secrets to quiet, patient and inquisitive observation.

The driftline tells of what is happening in deeper water, and sometimes even of what has occurred out of sight of land. Not only the shells, plants, fish and animals that are washed ashore give information. The nature of the waves themselves depends on the storms, winds and currents that caused them.

Kelp ▲
Brown Seaweed - Division *Phaeophyta*
Kelp is plentiful along the driftline. The stalks, or stems, are sometimes several metres long, and often still have their fronds (leaves) at one end. The other end may have a mass of roots, the size of a baseball or football, that anchors the growing kelp to the ocean floor.

Violet Shell (Bubble Raft Shell) ▼
Janthina janthina (up to 34 mm)
The live animal that creates this Violet Shell feeds on Bluebottles, which it finds while drifting at sea. At sea it hangs upside-down, suspended from a raft of bubbles and, like its prey, drifts where the wind blows it.

◀ **Sea-slater**
Ligia dilatata (up to 22 mm)
These animals are very common on the west coast of the Peninsula. They gather in huge numbers to feed on the kelp washed up on the shores. As you approach these large, massed groups, they appear to flow away from you, washing over rocks and kelp in an attempt to get out of the way.

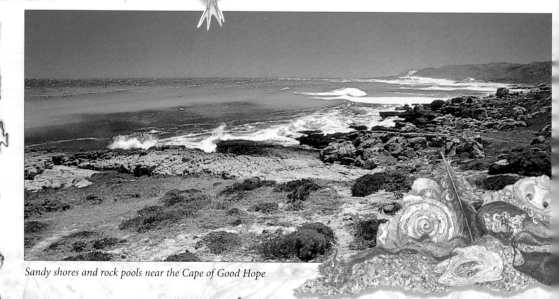

Sandy shores and rock pools near the Cape of Good Hope

◄ Shore Crab
Cyclograpsus punctatus
(30 mm)

Crabs are adapted to different zones along the shore. Those that occupy the drier areas, like the **Shore Crab**, breathe from small quantities of water stored in their gill cavities. Others, like the **Three-spot Swimming Crab**, are able to swim, and the tip of each back leg has become flattened into a paddle. Easily recognised by the 'sad face' pattern on its back, it spends a lot of time in the sand hunting for Plough Shells and White Mussels.

Mermaid's Purse (60 mm) ▲
These tough, black bags of skin usually have twisted lengths of dried 'string' attached to one or more of their four points. These are the 'shells' of the eggs of the 60 cm long Dark Shyshark, *Haploblepharus pictus*, which inhabits our shallow coastal waters.

◄ Ram's Horn
Spirula spirula (25 mm)
This delicate, flat, white spiral shell is the skeleton of a small, squid-like animal that lives at sea. It is seldom seen alive, but judging from the numbers of shells found, it must be very plentiful indeed. In life, the animal probably uses the shell as a gas-filled flotation chamber, to regulate the depth at which it floats.

Three-spot Swimming Crab ►
Ovalipes trimaculatus
(40 mm)

Bluebottle (Portuguese Man-of-War) ►
Physalia utriculus (float 50 mm; tentacle up to 10 m)
Although this 'animal' appears to be a float with trailing, stinging tentacles, it is actually a very successful colony of specialised individuals. Without a means of propelling itself, it is often blown ashore to be either popped by destructive humans, eaten by food-seeking Plough Shells, or dried out and blown away.

Papery Burnupena ▼
Burnupena pubescens (50 mm)

Whelks are generally scavengers, like the **Finger Plough Shell** which searches sandy shores and eats stranded Bluebottles. Others, like **Scaly Dogwhelks**, are active carnivores, drilling holes into mussels, limpets and barnacles, using their specially adapted tongue. **Papery Burnupena** takes its common name from the papery mass of eggs it attaches to a submerged rock.

▲ Finger Plough Shell
Bullia digitalis
(up to 60 mm)

◄ Scaly Dogwhelk
Nucella squamosa (35 mm)

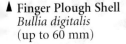

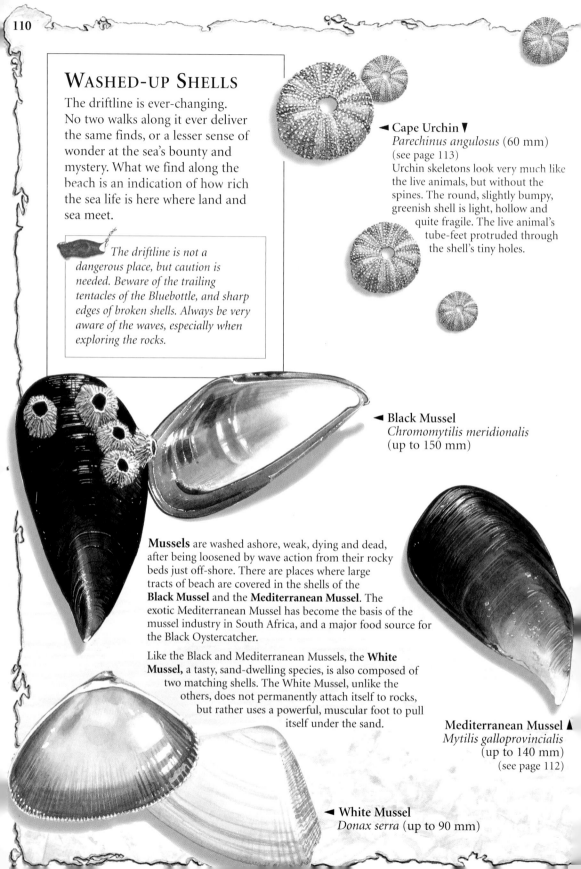

WASHED-UP SHELLS

The driftline is ever-changing. No two walks along it ever deliver the same finds, or a lesser sense of wonder at the sea's bounty and mystery. What we find along the beach is an indication of how rich the sea life is here where land and sea meet.

The driftline is not a dangerous place, but caution is needed. Beware of the trailing tentacles of the Bluebottle, and sharp edges of broken shells. Always be very aware of the waves, especially when exploring the rocks.

◀ **Cape Urchin** ▼
Parechinus angulosus (60 mm)
(see page 113)
Urchin skeletons look very much like the live animals, but without the spines. The round, slightly bumpy, greenish shell is light, hollow and quite fragile. The live animal's tube-feet protruded through the shell's tiny holes.

◀ **Black Mussel**
Chromomytilis meridionalis
(up to 150 mm)

Mussels are washed ashore, weak, dying and dead, after being loosened by wave action from their rocky beds just off-shore. There are places where large tracts of beach are covered in the shells of the **Black Mussel** and the **Mediterranean Mussel**. The exotic Mediterranean Mussel has become the basis of the mussel industry in South Africa, and a major food source for the Black Oystercatcher.

Like the Black and Mediterranean Mussels, the **White Mussel,** a tasty, sand-dwelling species, is also composed of two matching shells. The White Mussel, unlike the others, does not permanently attach itself to rocks, but rather uses a powerful, muscular foot to pull itself under the sand.

Mediterranean Mussel ▲
Mytilis galloprovincialis
(up to 140 mm)
(see page 112)

◀ **White Mussel**
Donax serra (up to 90 mm)

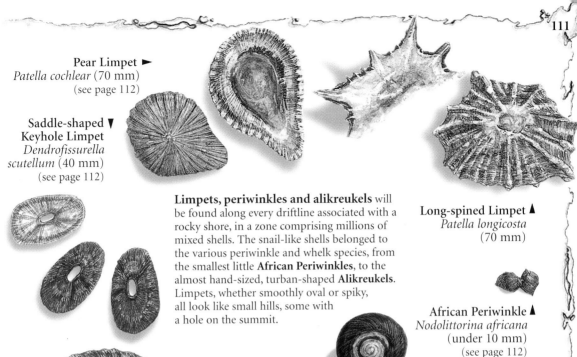

◄ Pear Limpet
Patella cochlear (70 mm)
(see page 112)

**Saddle-shaped ▼
Keyhole Limpet**
*Dendrofissurella
scutellum* (40 mm)
(see page 112)

Long-spined Limpet ▲
Patella longicosta
(70 mm)

Limpets, periwinkles and alikreukels will
be found along every driftline associated with a
rocky shore, in a zone comprising millions of
mixed shells. The snail-like shells belonged to
the various periwinkle and whelk species, from
the smallest little **African Periwinkles**, to the
almost hand-sized, turban-shaped **Alikreukels**.
Limpets, whether smoothly oval or spiky,
all look like small hills, some with
a hole on the summit.

African Periwinkle ▲
Nodolittorina africana
(under 10 mm)
(see page 112)

Pink-lipped Topshell ►
Oxystele sinensis
(45 mm)

◄ Giant Periwinkle (Alikreukel)
Turbo sarmaticus
(100 mm)

◄ Operculum

Cuttlebone ▼
Sepia vermiculata (150 mm)
(see page 115)
The skeleton of a squid-like animal, found on
almost every driftline, is the Cuttlebone. Many
are collected and taken home for budgies and
canaries to nibble on. When alive, the squid
uses this light, white plate to control its
buoyancy in the same way as a fish uses its gas-
filled swim bladder.

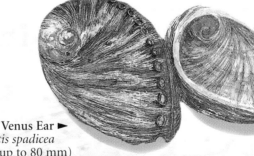

Venus Ear ►
Haliotis spadicea
(up to 80 mm)
The Venus Ear is similar to the
larger Abalone (Perlemoen), which is a favoured seafood
and the basis of a major industry. Venus Ear, depicted
here, scrapes algae off the rock surfaces at low water,
while Abalone eats kelp, trapping the leaves beneath its
shell. The live animal looks like a flat, fat, tentacled,
hairy mouse, with a shell on its back!

ROCK POOLS

Life in rock pools is dominated by the tides and waves. Even those pools that remain totally submerged experience two high-tide periods each day, of strong currents and pounding, agitated water. At low tide the pools are usually still and clear. Depending on where the pool is situated, some animals and plants are exposed to wind and sun for shorter or longer periods, when the water recedes. They need to be able to protect themselves from these drying agents.

Try to place your own shadow over the pool you are investigating. This will help to reduce the reflections and you will see more clearly. Revisit pools when the tide is at different stages. You will find different animals emerging.

◄ **Volcano Barnacle**
Tetraclita serrata (20 mm)

Barnacle shells all comprise a number of individual plates. In one type, all the plates are fused into a single little volcano-like tower. In the second type each plate is separate, but attached to an inner membrane that surrounds the animal. All barnacles are filter feeders, using an elaborate comb to extract particles from the water.

▲ **Saddle-shaped Keyhole Limpet**
Dendrofissurella scutellum (40 mm)
(see page 111)

Limpets and periwinkles are related, and both scrape their plant food off the rocks with powerful, rasp-like tongues. Each species has a characteristic shape and a favourite food, and some, like the **Pear Limpet**, actively defend the areas where they graze. Snails have successfully colonised a wide range of habitats, and occur in many sizes. The tiny **African Periwinkle** resists the drying, hot sun, and grazes where the rocks are seldom wet. The **Pink-lipped Topshell** (see page 111) is more typical of the marine snails, grazing rocks that are mostly under water. The **Giant Periwinkle** (see page 111) is the largest of the periwinkles, and the 'door' to its shell (operculum) is often washed up along the driftline.

African Periwinkle ▼
Nodolittorina africana
(under 10 mm)
(see page 111)

▼ **Pear Limpet**
Patella cochlear (70 mm)
(see page 111)

Eight-shell Barnacle ▲
Octomeris angulosa (10 - 25 mm)

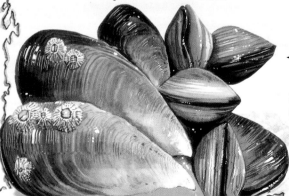

◄ **Mediterranean Mussel**
Mytilis galloprovincialis (up to 140 mm)
(see page 110)
Mussels live between two matched shells which they draw strongly together in times of danger. The Mediterranean Mussel was accidentally introduced to South Africa, and has become the basis of the mussel industry. Mussels feed by parting their shells slightly, then filtering the water for tiny particles of food.

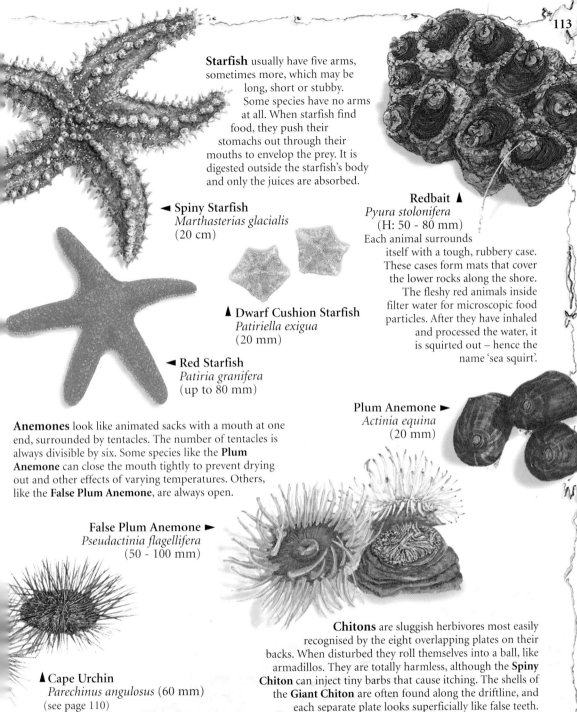

Starfish usually have five arms, sometimes more, which may be long, short or stubby. Some species have no arms at all. When starfish find food, they push their stomachs out through their mouths to envelop the prey. It is digested outside the starfish's body and only the juices are absorbed.

◄ **Spiny Starfish**
Marthasterias glacialis
(20 cm)

▲ **Dwarf Cushion Starfish**
Patiriella exigua
(20 mm)

◄ **Red Starfish**
Patiria granifera
(up to 80 mm)

Redbait ▲
Pyura stolonifera
(H: 50 - 80 mm)
Each animal surrounds itself with a tough, rubbery case. These cases form mats that cover the lower rocks along the shore. The fleshy red animals inside filter water for microscopic food particles. After they have inhaled and processed the water, it is squirted out – hence the name 'sea squirt'.

Anemones look like animated sacks with a mouth at one end, surrounded by tentacles. The number of tentacles is always divisible by six. Some species like the **Plum Anemone** can close the mouth tightly to prevent drying out and other effects of varying temperatures. Others, like the **False Plum Anemone**, are always open.

Plum Anemone ►
Actinia equina
(20 mm)

False Plum Anemone ►
Pseudactinia flagellifera
(50 - 100 mm)

Chitons are sluggish herbivores most easily recognised by the eight overlapping plates on their backs. When disturbed they roll themselves into a ball, like armadillos. They are totally harmless, although the **Spiny Chiton** can inject tiny barbs that cause itching. The shells of the **Giant Chiton** are often found along the driftline, and each separate plate looks superficially like false teeth.

▲ **Cape Urchin**
Parechinus angulosus (60 mm)
(see page 110)
Looking vaguely like spiky, purple marbles, or golf or tennis balls, these urchins move about on a mat of thin, jelly-like feet. Their diet consists mainly of algae, but some can bore holes into rock, or even steel. They usually try to avoid direct sunlight and, if they cannot find shade, will place discarded shells on their uppermost spines as sunshades.

Spiny Chiton ►
Acanthochiton garnoti
(30 - 45 mm)

◄ **Giant Chiton**
Dinoplax gigas
(70 - 100 mm)

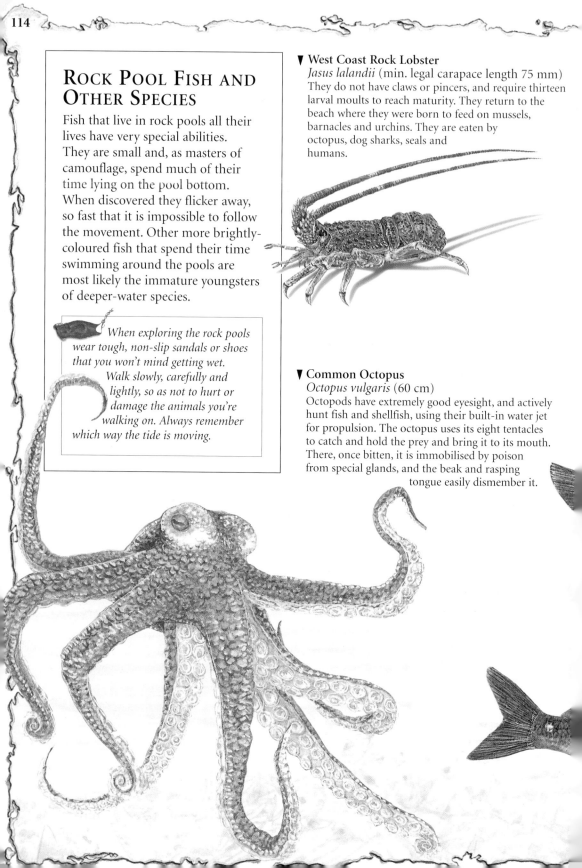

ROCK POOL FISH AND OTHER SPECIES

Fish that live in rock pools all their lives have very special abilities. They are small and, as masters of camouflage, spend much of their time lying on the pool bottom. When discovered they flicker away, so fast that it is impossible to follow the movement. Other more brightly-coloured fish that spend their time swimming around the pools are most likely the immature youngsters of deeper-water species.

When exploring the rock pools wear tough, non-slip sandals or shoes that you won't mind getting wet. Walk slowly, carefully and lightly, so as not to hurt or damage the animals you're walking on. Always remember which way the tide is moving.

▼ **West Coast Rock Lobster**
Jasus lalandii (min. legal carapace length 75 mm)
They do not have claws or pincers, and require thirteen larval moults to reach maturity. They return to the beach where they were born to feed on mussels, barnacles and urchins. They are eaten by octopus, dog sharks, seals and humans.

▼ **Common Octopus**
Octopus vulgaris (60 cm)
Octopods have extremely good eyesight, and actively hunt fish and shellfish, using their built-in water jet for propulsion. The octopus uses its eight tentacles to catch and hold the prey and bring it to its mouth. There, once bitten, it is immobilised by poison from special glands, and the beak and rasping tongue easily dismember it.

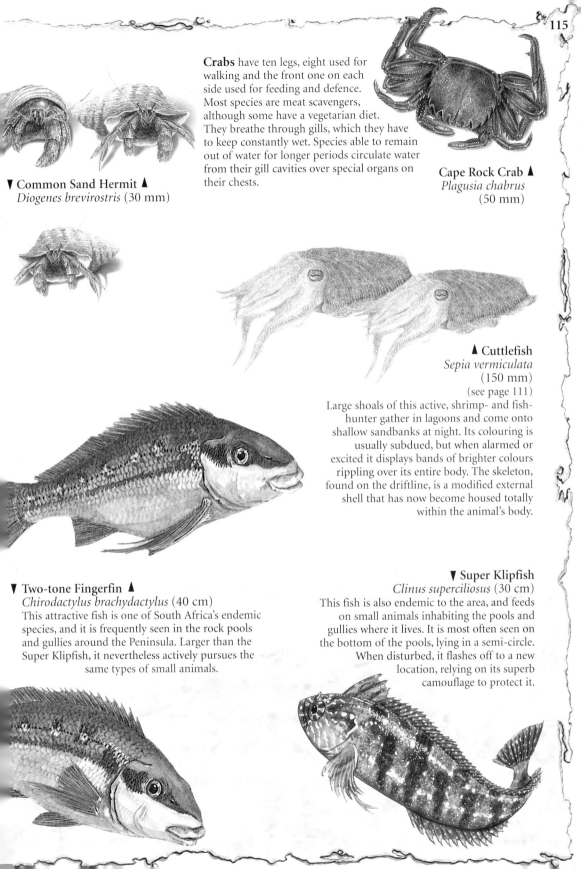

Crabs have ten legs, eight used for walking and the front one on each side used for feeding and defence. Most species are meat scavengers, although some have a vegetarian diet. They breathe through gills, which they have to keep constantly wet. Species able to remain out of water for longer periods circulate water from their gill cavities over special organs on their chests.

▼ **Common Sand Hermit** ▲
Diogenes brevirostris (30 mm)

Cape Rock Crab ▲
Plagusia chabrus
(50 mm)

▲ **Cuttlefish**
Sepia vermiculata
(150 mm)
(see page 111)
Large shoals of this active, shrimp- and fish-hunter gather in lagoons and come onto shallow sandbanks at night. Its colouring is usually subdued, but when alarmed or excited it displays bands of brighter colours rippling over its entire body. The skeleton, found on the driftline, is a modified external shell that has now become housed totally within the animal's body.

▼ **Two-tone Fingerfin** ▲
Chirodactylus brachydactylus (40 cm)
This attractive fish is one of South Africa's endemic species, and it is frequently seen in the rock pools and gullies around the Peninsula. Larger than the Super Klipfish, it nevertheless actively pursues the same types of small animals.

▼ **Super Klipfish**
Clinus superciliosus (30 cm)
This fish is also endemic to the area, and feeds on small animals inhabiting the pools and gullies where it lives. It is most often seen on the bottom of the pools, lying in a semi-circle. When disturbed, it flashes off to a new location, relying on its superb camouflage to protect it.

MARINE FISH

The sea is the oldest inhabited environment in the world. By closely observing the animals, you will gather clues as to how and where they live and feed. Some brightly coloured animals actively search for their food, while stationary, camouflaged animals wait to ambush prey.

Filter feeders sweep water into their mouths with feathery feelers and animals that graze over the rocks need strong protective shells on their backs. Surface-feeding fish have mouths pointing upward, while the mid-water hunters use mouths pointing straight forward. Bottom-feeders may have feelers to help them locate their food.

If you are not going to eat your catch, rather release it immediately back into the sea. Remove the hook carefully so as not to damage the fish unduly.

Blacktail ▼
Diplodus sargus capensis (45 cm; 3 kg)
An omnivorous sea bream that inhabits a wide variety of habitats. Juveniles, which have several thin vertical bars along their sides, are common in rock pools and estuaries. Spawning occurs throughout the year with peaks in winter and spring.

Galjoen ▼
Dichistius capensis (80 cm; 6 kg)
Small scales cover even the fins of this browny-black, deep-bodied fish. South Africa's national fish, it is found in turbulent water off both rocky and sandy shores. It is omnivorous and spawns in summer.

White Steenbras ►
Lithognathus lithognathus (1 m; 30 kg)
A long, sloping forehead and a pig-like snout identify this fish. Because it feeds on sand-dwelling organisms, it is usually caught off sandy beaches and in estuaries. It migrates up the east coast to spawn.

◄ Red Roman ▼
Chrysoblephus laticeps (50 cm; 4 kg)
A solid fish, easily recognised by the white saddle, the line over the gill cover and the blue line between the eyes. Females become males when they reach about 30 cm. They prey on bottom-dwelling organisms along rocky reefs, and are most often caught by ski-boaters and spearfishermen.

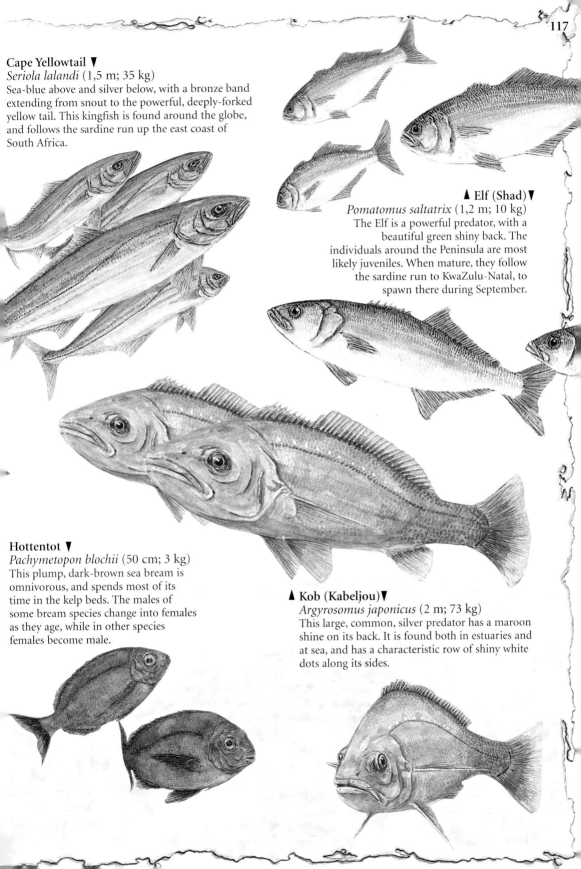

Cape Yellowtail ▼
Seriola lalandi (1,5 m; 35 kg)
Sea-blue above and silver below, with a bronze band extending from snout to the powerful, deeply-forked yellow tail. This kingfish is found around the globe, and follows the sardine run up the east coast of South Africa.

▲ Elf (Shad) ▼
Pomatomus saltatrix (1,2 m; 10 kg)
The Elf is a powerful predator, with a beautiful green shiny back. The individuals around the Peninsula are most likely juveniles. When mature, they follow the sardine run to KwaZulu-Natal, to spawn there during September.

Hottentot ▼
Pachymetopon blochii (50 cm; 3 kg)
This plump, dark-brown sea bream is omnivorous, and spends most of its time in the kelp beds. The males of some bream species change into females as they age, while in other species females become male.

▲ Kob (Kabeljou) ▼
Argyrosomus japonicus (2 m; 73 kg)
This large, common, silver predator has a maroon shine on its back. It is found both in estuaries and at sea, and has a characteristic row of shiny white dots along its sides.

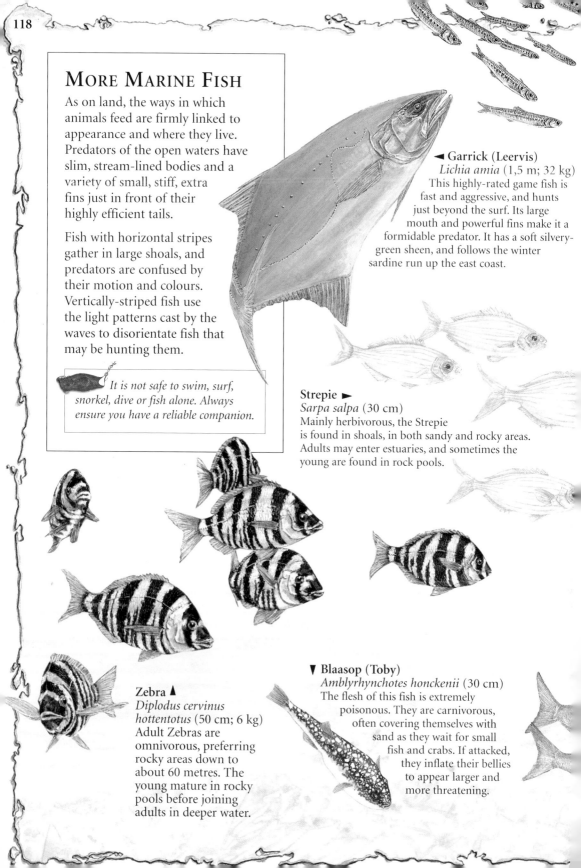

MORE MARINE FISH

As on land, the ways in which animals feed are firmly linked to appearance and where they live. Predators of the open waters have slim, stream-lined bodies and a variety of small, stiff, extra fins just in front of their highly efficient tails.

Fish with horizontal stripes gather in large shoals, and predators are confused by their motion and colours. Vertically-striped fish use the light patterns cast by the waves to disorientate fish that may be hunting them.

It is not safe to swim, surf, snorkel, dive or fish alone. Always ensure you have a reliable companion.

◄ **Garrick (Leervis)**
Lichia amia (1,5 m; 32 kg)
This highly-rated game fish is fast and aggressive, and hunts just beyond the surf. Its large mouth and powerful fins make it a formidable predator. It has a soft silvery-green sheen, and follows the winter sardine run up the east coast.

Strepie ►
Sarpa salpa (30 cm)
Mainly herbivorous, the Strepie is found in shoals, in both sandy and rocky areas. Adults may enter estuaries, and sometimes the young are found in rock pools.

Zebra ▲
Diplodus cervinus hottentotus (50 cm; 6 kg)
Adult Zebras are omnivorous, preferring rocky areas down to about 60 metres. The young mature in rocky pools before joining adults in deeper water.

▼ **Blaasop (Toby)**
Amblyrhynchotes honckenii (30 cm)
The flesh of this fish is extremely poisonous. They are carnivorous, often covering themselves with sand as they wait for small fish and crabs. If attacked, they inflate their bellies to appear larger and more threatening.

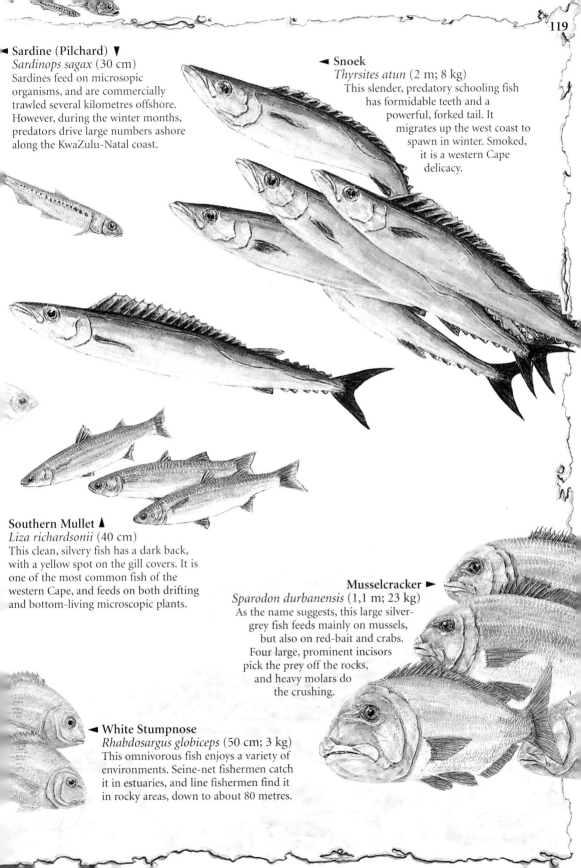

◄ Sardine (Pilchard) ▼
Sardinops sagax (30 cm)
Sardines feed on microsopic
organisms, and are commercially
trawled several kilometres offshore.
However, during the winter months,
predators drive large numbers ashore
along the KwaZulu-Natal coast.

◄ Snoek
Thyrsites atun (2 m; 8 kg)
This slender, predatory schooling fish
has formidable teeth and a
powerful, forked tail. It
migrates up the west coast to
spawn in winter. Smoked,
it is a western Cape
delicacy.

Southern Mullet ▲
Liza richardsonii (40 cm)
This clean, silvery fish has a dark back,
with a yellow spot on the gill covers. It is
one of the most common fish of the
western Cape, and feeds on both drifting
and bottom-living microscopic plants.

Musselcracker ►
Sparodon durbanensis (1,1 m; 23 kg)
As the name suggests, this large silver-
grey fish feeds mainly on mussels,
but also on red-bait and crabs.
Four large, prominent incisors
pick the prey off the rocks,
and heavy molars do
the crushing.

◄ White Stumpnose
Rhabdosargus globiceps (50 cm; 3 kg)
This omnivorous fish enjoys a variety of
environments. Seine-net fishermen catch
it in estuaries, and line fishermen find it
in rocky areas, down to about 80 metres.

THE BIG BLUE

The sea offers an extremely rich environment for the many species we find there. As on land, the food chains are usually dependent on sunlight, which provides the energy plants require. These microscopic plants, totally dependent on the ocean currents for their distribution, account for the richer sea life found in some marine areas.

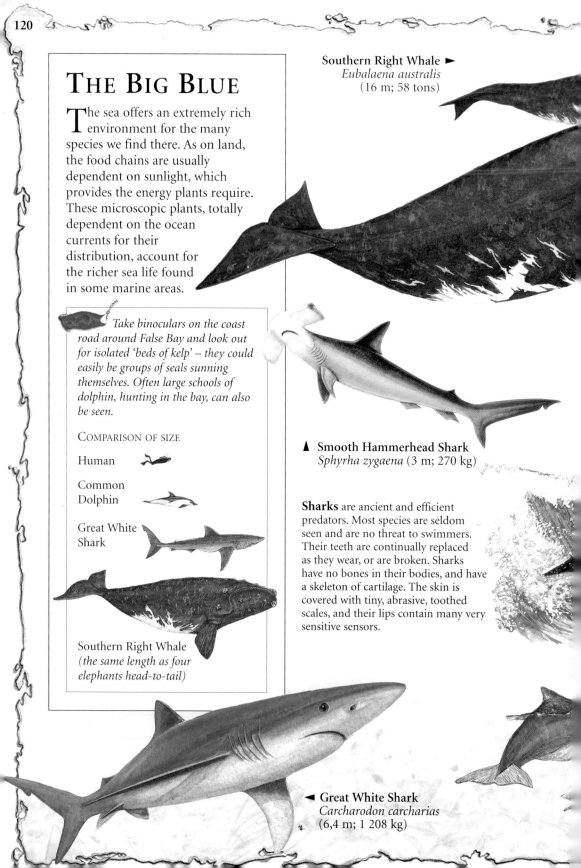

Take binoculars on the coast road around False Bay and look out for isolated 'beds of kelp' – they could easily be groups of seals sunning themselves. Often large schools of dolphin, hunting in the bay, can also be seen.

COMPARISON OF SIZE

Human

Common Dolphin

Great White Shark

Southern Right Whale
(the same length as four elephants head-to-tail)

Southern Right Whale ►
Eubalaena australis
(16 m; 58 tons)

▲ **Smooth Hammerhead Shark**
Sphyrha zygaena (3 m; 270 kg)

Sharks are ancient and efficient predators. Most species are seldom seen and are no threat to swimmers. Their teeth are continually replaced as they wear, or are broken. Sharks have no bones in their bodies, and have a skeleton of cartilage. The skin is covered with tiny, abrasive, toothed scales, and their lips contain many very sensitive sensors.

◄ **Great White Shark**
Carcharodon carcharias
(6,4 m; 1 208 kg)

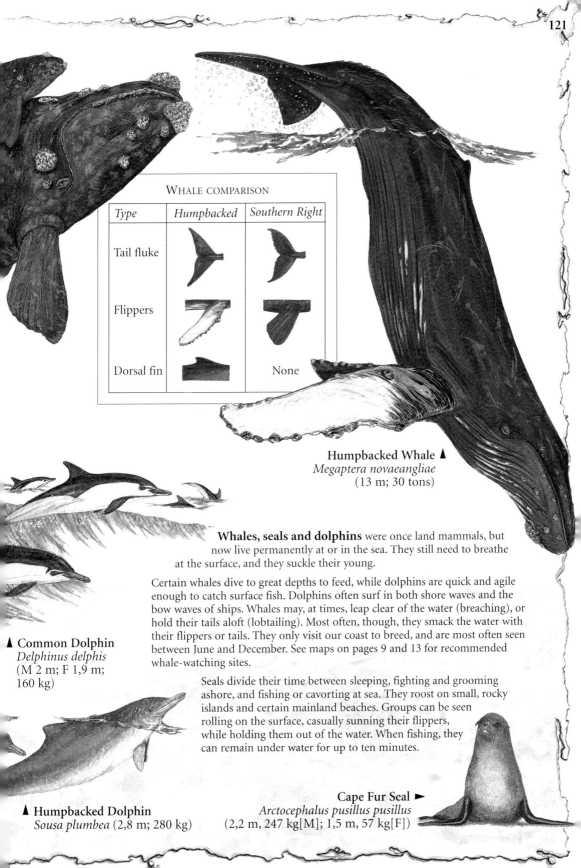

Whale comparison

Type	Humpbacked	Southern Right
Tail fluke		
Flippers		
Dorsal fin		None

Humpbacked Whale ▲
Megaptera novaeangliae
(13 m; 30 tons)

Whales, seals and dolphins were once land mammals, but now live permanently at or in the sea. They still need to breathe at the surface, and they suckle their young.

Certain whales dive to great depths to feed, while dolphins are quick and agile enough to catch surface fish. Dolphins often surf in both shore waves and the bow waves of ships. Whales may, at times, leap clear of the water (breaching), or hold their tails aloft (lobtailing). Most often, though, they smack the water with their flippers or tails. They only visit our coast to breed, and are most often seen between June and December. See maps on pages 9 and 13 for recommended whale-watching sites.

Seals divide their time between sleeping, fighting and grooming ashore, and fishing or cavorting at sea. They roost on small, rocky islands and certain mainland beaches. Groups can be seen rolling on the surface, casually sunning their flippers, while holding them out of the water. When fishing, they can remain under water for up to ten minutes.

▲ **Common Dolphin**
Delphinus delphis
(M 2 m; F 1,9 m; 160 kg)

▲ **Humpbacked Dolphin**
Sousa plumbea (2,8 m; 280 kg)

Cape Fur Seal ►
Arctocephalus pusillus pusillus
(2,2 m, 247 kg[M]; 1,5 m, 57 kg[F])

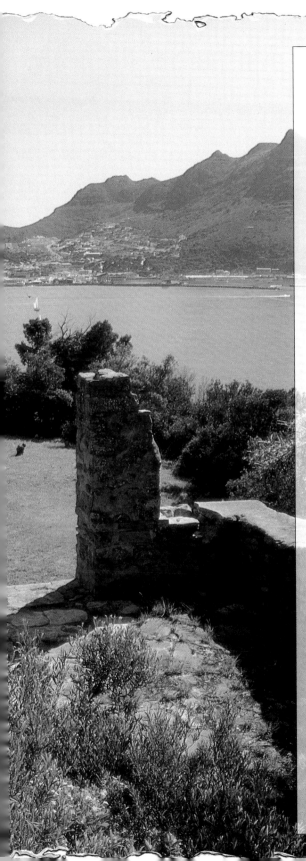

HUMAN HISTORY

The history of human endeavour in the south-western Cape is a fascinating one. The land has supported human activity as far back as the Earlier Stone Age, when small bands of *Homo erectus* roamed the area. Between 120 000 and 50 000 years ago hunter-gatherers were living along the Peninsula. These were the ancestors of the San people. Around 2 000 years ago Khoekhoe herders arrived from further north with sheep and cattle, and camped on the site of present-day Cape Town.

European exploration and settlement brought dramatic changes to the land and the indigenous peoples of the south-western Cape. Rapid colonisation and development were coupled with the exploitation of both human and natural resources. The patterns of confrontation and resistance that emerged laid the foundations for subsequent struggles over centuries that have shaped present-day South African society. Today the area is enriched by the colourful heritages of its people, and by the beauty of the land that continues to provide for their survival.

Historical sites and monuments are listed on pages 44 - 47.

Old ruin looking out to Hout Bay

EARLY INHABITANTS

The south-western Peninsula of the Cape has featured significantly in the histories of many communities of people in South Africa. Until recently the stories of the earliest inhabitants and their descendants, the San and Khoekhoe, were overshadowed, distorted or ignored. Yet the lives of these peoples have, for millenia, been intimately linked with the mountains, the sea and the fertile valleys around present-day Cape Town. Their histories are integral to an understanding of the region and the broader history of South Africa.

Archaeological evidence suggests that early inhabitants lived along the Peninsula and on the fertile plains further inland. Remains of tools made by ancestors of the San people have been found at a number of archaeological sites in the area. These people had a diet of meat and various wild plants.

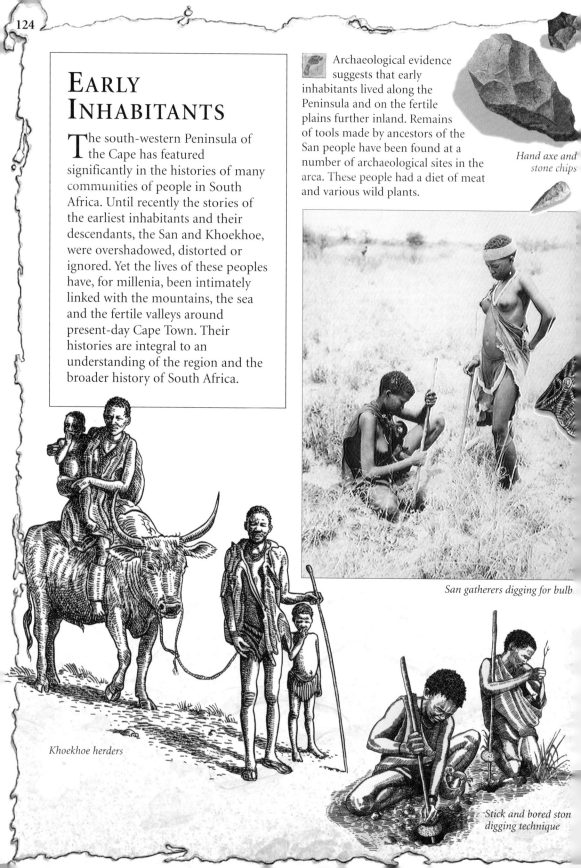

Hand axe and stone chips

San gatherers digging for bulb

Khoekhoe herders

Stick and bored ston digging technique

Shellfish found in middens

During the Later Stone Age the sea level rose. Fish and shellfish made up a large part of the diet of people living along the coastline. Shell middens are the ancient dumping grounds of Later Stone Age people. They are visible in places along the Peninsula coastline.

The rocky shoreline at Buffelsbaai was ideal for the construction of tidal fish traps. Low stone walls were built across gullies at low tide. As the tide rose, the fish would swim over the walls to feed in the shallows, only to be trapped behind the stone barriers when the tide went out again. The rocky shore of Buffelsbaai is pictured above.

Rocky gullies at Buffelsbaai

Other evidence of human activity has been found in coastal caves. At Smitswinkel Bay Cave many artifacts were found, including a bored stone used by San women to weight their digging sticks, ostrich eggshell beads, pieces of tortoiseshell bowl and earthenware pottery.

Bored stone used for digging out bulbs

San tortoiseshell container and shell necklace

The San were taught to make pottery by another group of people called the Khoekhoe. These herders migrated from northern Botswana to the south-western Cape in search of grazing land for their sheep and, later, domestic cattle.

The Khoekhoe soon inhabited large areas of the Cape. They lived in village settlements (kraals) in mat huts made from reeds and branches. The huts could be easily dismantled and taken to other grazing areas.

Broken pottery pieces

The arrival of the Khoekhoe changed the social life and environment of the San hunters. Domestic herds took over much of the grazing land of wild game. The San were forced to find new hunting grounds or adapt to the herders' way of life. The arrival of the European explorers around the late 1400s further affected the lives of indigenous people, and changed the face of the Cape forever.

Smitswinkel Bay Cave

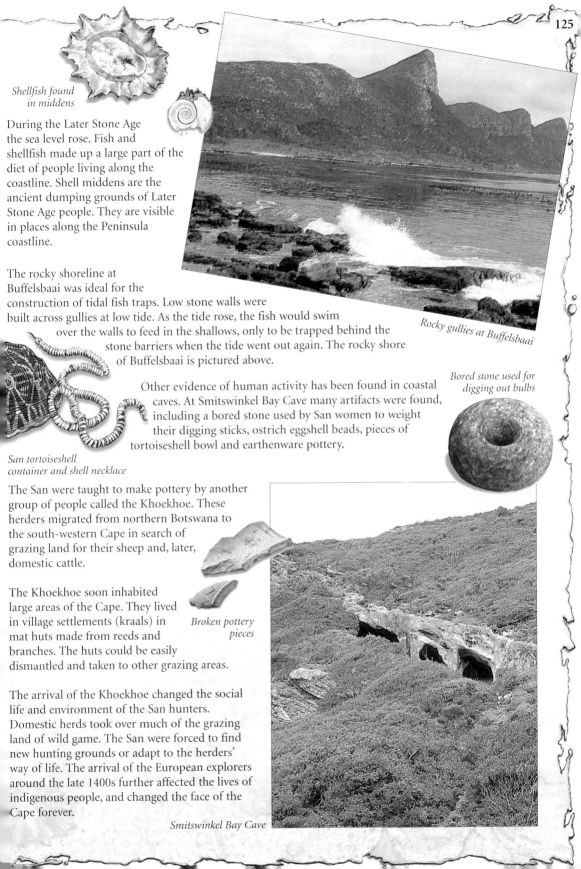

EXPLORERS AND WRECKS

European exploration and expansion depended on sea travel. The south-western Cape coastline was one of the most dangerous sections of the sea route that linked Europe with the trading centres of India and the Orient. Written evidence from the Greeks indicates that a Phoenician expedition rounded the Cape as early as 600 BC. Yet not until the 15th Century, when Europe needed a trade route to the Far East, did the exploration of Southern Africa really begin.

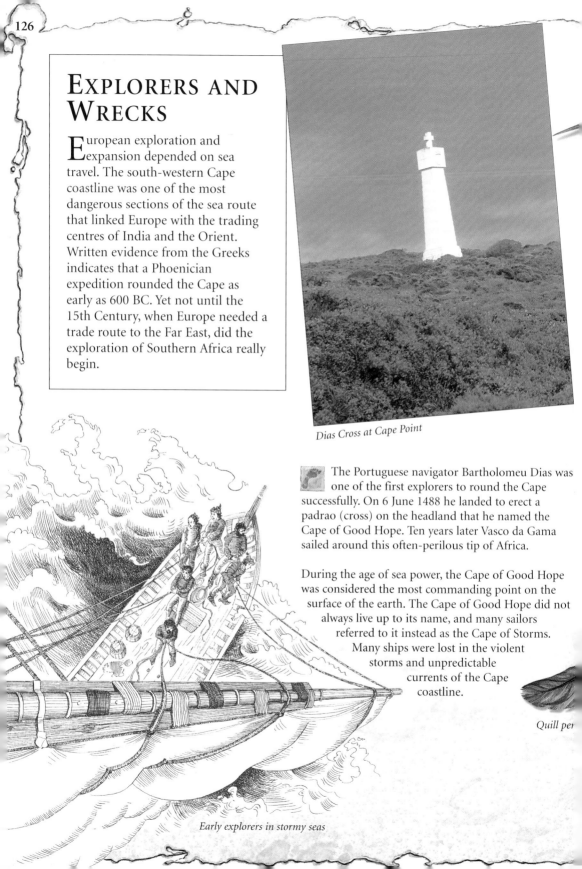

Dias Cross at Cape Point

The Portuguese navigator Bartholomeu Dias was one of the first explorers to round the Cape successfully. On 6 June 1488 he landed to erect a padrao (cross) on the headland that he named the Cape of Good Hope. Ten years later Vasco da Gama sailed around this often-perilous tip of Africa.

During the age of sea power, the Cape of Good Hope was considered the most commanding point on the surface of the earth. The Cape of Good Hope did not always live up to its name, and many sailors referred to it instead as the Cape of Storms. Many ships were lost in the violent storms and unpredictable currents of the Cape coastline.

Quill per

Early explorers in stormy seas

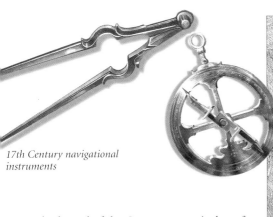

17th Century navigational instruments

A popular legend of the Cape sea route is that of the Flying Dutchman. The ghost of a Dutch captain, Van der Decken, whose ship sank in a storm off the coast in 1641, is said to haunt the waters off the Cape of Good Hope. Sailors believed that all who caught sight of the ghost ship would perish.

The most famous sighting was on 11 July 1881 when the Royal Navy ship *Bacchante* was rounding the Cape in a heavy storm. A young sailor recorded in his diary:

Shipwreck at Table Bay

"At 4·00am the Flying Dutchman crossed our bows... a strange red light as of a phantom ship all aglow, in the midst of which light the mast ... and sails of a brig 200 yards distant stood out in strong relief."

Legend has it that soon after the sighting the lookout fell from the mast to his death.

The sinking of the *Lusitania* off Bellows Rock in 1911 was another dramatic event. The luxury Portuguese liner carrying 780 passengers struck the rock just after midnight on April 18. Some passengers tried to get ashore to Dias Beach, and although 50 succeeded, eight lives were lost when a lifeboat capsized. The remaining crew and passengers were rescued from the ship the next day.

Following this near disaster the Cape Point lighthouse was moved to its present position, where it is not hidden by the thick cloud common to the area.

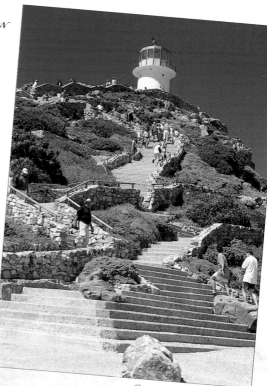

Cape Point lighthouse today

COLONISTS AT THE CAPE AND INLAND

When the Dutch East India Company controlled the sea route to the East, they needed a source of fresh water along the way. They established a refreshment station at the Cape. In 1652 Jan van Riebeeck arrived with a small group of Dutch people to settle on the shores of Table Bay. They planted vegetable gardens and began to trade with the various San and Khoekhoe clans.

Trade between the groups was strictly regulated. It favoured the Dutch colonists, who wanted unlimited access to livestock and pasturelands. In 1672, only twenty years after the arrival of Van Riebeeck, the Dutch had secured large areas of land for farming and settlement. The Khoekhoe received only a fraction of the payments promised for this land, and lost control of traditional pastures.

The Dutch moved steadily inland. By the late 1600s, new centres of government had been set up at Stellenbosch and Paarl. Stellenbosch was named after the Governor of the Cape, Simon van der Stel, who first visited the area in 1679.

Dutch East India Company seal

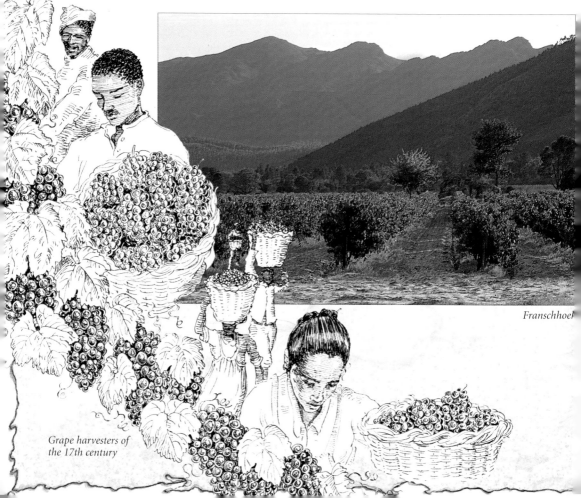

Franschhoek

Grape harvesters of the 17th century

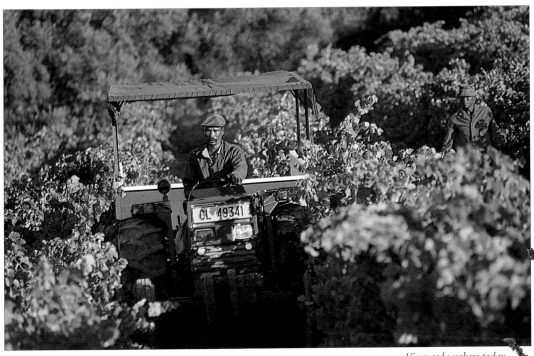

Vineyard workers today

Settlers arrived from Cape Town, and soon houses were being built from the local trees like Yellowwood and Stinkwood. Thatching grass was used for roofing.

In 1688 the Huguenot people, fleeing persecution in France, arrived in the Cape. They settled in the mountain valley near the present-day town of Franschhoek.

Stinkwood

.This area, with its rugged mountain passes and lush valleys, became famous in the mid-19th Century for its vineyards and as the main centre for the construction of carts and wagons. The handmade furniture of the early settlers is still popular among collectors.

As the farming community grew, so did the demand for labour. The Dutch East India Company began importing slaves from the East Indian colonies, and later from West and East Africa, to work on farms and as domestic servants. Most of the people who arrived as slaves were of the Muslim faith. Their influence, culturally and economically, is still evident throughout the area.

In 1798 the British took control of the Cape. Throughout the next century the area continued to develop steadily. In 1814 the port of Simon's Town became Britain's naval base at the Cape. Railways were built inland, harbours improved, and reservoirs built to supply the growing population's ever-increasing demands for water.

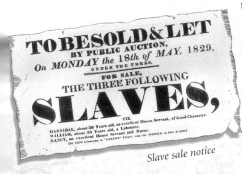

Slave sale notice

Restios used for thatching

EARLY 20TH CENTURY TO TODAY

During the early years of the 20th Century there was significant exploitation of human and natural resources. British colonial authorities made use of cheap labour. Control of the land in both urban and rural areas remained firmly in the hands of the white population.

Cape Town was by now a bustling port city. More and more immigrants arrived, and Victorian suburbs grew all around the base of Table Mountain. The inner city of Cape Town was home to a cosmopolitan community from many different ethnic and religious backgrounds.

19th century fob watch

The photograph of the harbour around 1900 shows the port full of ships, with railways and dockyards nearby. A large part of the original port was reclaimed in the 1940s and filled in to provide land for commercial development.

The harbour in the 1900s

Landfill was dug out of an area east of the city, creating a shallow pan that is known today as Rietvlei (reed pan). Rietvlei is now a popular place for birding and walking.

19th Century Cape Town market place

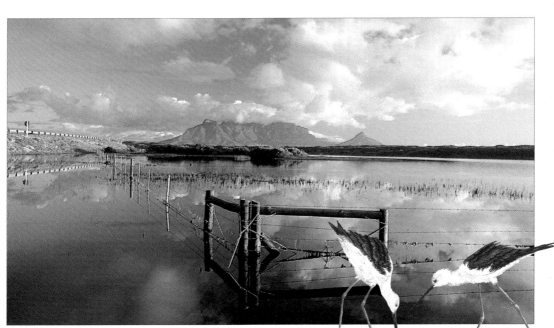

Rietvlei

Blackwinged Stilts
(see page 88)

Political and social tension that had existed for centuries increased under the rule of 'apartheid' governments. Over the next four decades many communities in central Cape Town suffered upheaval. Entire neighbourhoods were rezoned for 'whites only', and Black, Coloured and Indian people were forcibly removed from their homes to undeveloped areas on the sandswept and barren Cape Flats.

District Six was one of these communities, where people of many different origins lived together. District Six was famous for its street life, especially around New Year when, as a former resident remembers:
'Malay choirs paraded the streets singing Dutch "liedjies", and celebrations would last until the 2nd of January'.

Between 1966 and 1982, 60 000 people were removed from District Six, and houses were demolished. In 1994 former residents established the District Six Museum to begin the process of preserving the history of the area and of its people.

The valleys around Stellenbosch, Franschhoek and Paarl have remained at the heart of the farming and wine industries during this century. The first wine was produced in 1659 by Jan van Riebeeck, and Cape wines are now enjoyed all over the world.

Cape 'Coon' carnival still celebrated today

HUMAN IMPACT

The development of Cape Town and the surrounding area has had an enormous effect on the natural environment. The human desire for expansion and wealth has often overshadowed environmental awareness or consideration for the magnificent and unique natural assets of the area.

Ancient forests in the region have been used for fuel and building materials.

Once this indigenous vegetation was cleared, farmers introduced alien plants such as Acacia, Wattle, Hakea and Pinus.

These foreign plants were not adapted to the regional climate, and so they seriously diminished the natural water reserves. They spread rapidly, and in many areas overran the indigenous plants. Today a costly campaign is taking place to clear alien vegetation to ensure the survival of the indigenous plants and species of the Cape Peninsula.

*Silky Hakea
(Hakea sericea)*

*Rooikrans
(Acacia cyclops)*

*Cluster Pine
(Pinus pinaster)*

Cluster Pine cone

Workers eradicating aliens

*Woodcutters in
indigenous forests in
the early 20th century*

Although many Fynbos plants require occasional fire for seeds to germinate, over-frequent and out-of-season wild fires are extremely destructive. The range and variety of the Fynbos has declined over years as a result of man-made fires. Natural vegetation cover is destroyed, which accelerates soil erosion. Animal communities also suffer during fires. Vital food sources for animals, such as insects, seeds and fruit, are destroyed. Reptiles and nesting birds are killed by ground fires.

Mountain Pride Butterfly and Red Crassula (see page 65)

Fire starter

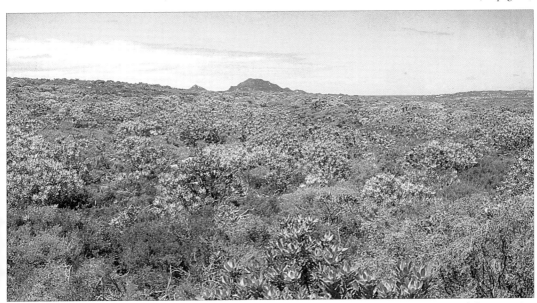

Pristine vegetation

The effects of human activity are a cause for growing concern. Rapid urban growth has increased industrial pollution. The many local and foreign visitors have put more pressure on the environment. Litter is unfortunately a common problem.

By observing the following code of ethics, visitors to this magnificent area of South Africa can help to preserve it for generations to come:

- Leave plants, flowers and seeds in their natural environment.
- Never kill, collect or disturb the animals and insects.
- Do not feed the animals.
- When hiking, stay on marked footpaths.
- Do not pollute the water.
 - Do not leave your litter for others to clean up.
 - Help the National Parks Board to manage the Cape Peninsula National Park for everyone's benefit by observing all official signage.

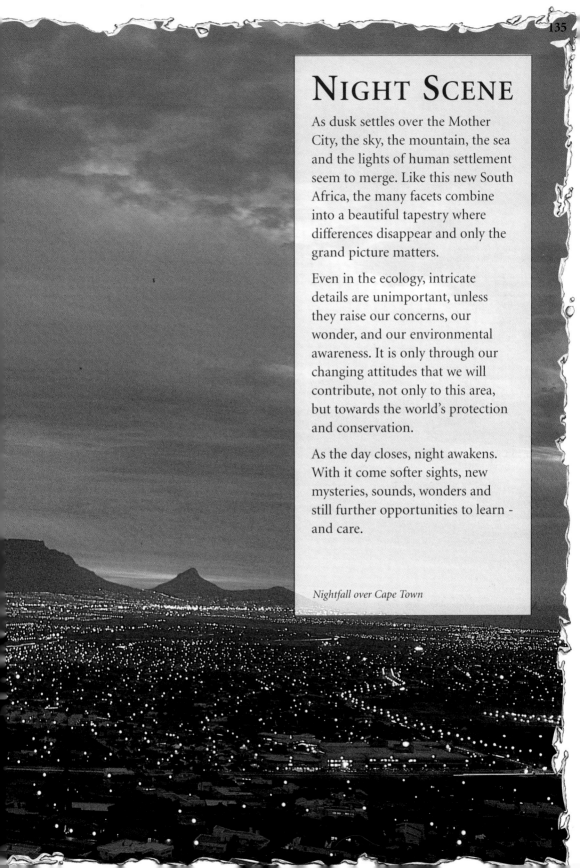

NIGHT SCENE

As dusk settles over the Mother City, the sky, the mountain, the sea and the lights of human settlement seem to merge. Like this new South Africa, the many facets combine into a beautiful tapestry where differences disappear and only the grand picture matters.

Even in the ecology, intricate details are unimportant, unless they raise our concerns, our wonder, and our environmental awareness. It is only through our changing attitudes that we will contribute, not only to this area, but towards the world's protection and conservation.

As the day closes, night awakens. With it come softer sights, new mysteries, sounds, wonders and still further opportunities to learn - and care.

Nightfall over Cape Town

INDEX